Black & Brown Waves

Black & Brown Waves

The Cultural Politics of Young Women of Color and Feminism

Regina Andrea Bernard, PhD
City University of New York

SENSE PUBLISHERS
ROTTERDAM/BOSTON/TAIPEI

A C.I.P. record for this book is available from the Library of Congress.

ISBN: 978-90-8790-808-9 (Paperback)
ISBN: 978-90-8790-809-6 (Hardback)
ISBN: 978-90-8790-810-2 (ebook)

Published by: Sense Publishers,
P.O. Box 21858, 3001 AW
Rotterdam, The Netherlands

Printed on acid-free paper

DEDICATION

This book is dedicated to Joe L. Kincheloe, my friend, my mentor; you will forever stay tattooed on my heart.

TABLE OF CONTENTS

ACKNOWLEDGEMENTS

There are so many people to thank for the publication of this book. First, without the help of my friend, professor, intellectual, scholar, and mentor, Joe L. Kincheloe, no one would have this book in their hands to read, critique and perhaps celebrate, without you. His sudden passing hit me like a ton of bricks, and my heart aches that he never got to see it finally completed. In my heart, I know that he is still with me, and hope that wherever he may be resting and relaxing, that he has a copy of this nearby. His tireless friendship and mentorship brought me through many academic waters, and to him for this, and many of the opportunities he gave me, I will continue my promise of being eternally grateful. They don't make cultural workers and critical pedagogues like you. Another big thank you to Professor Shirley Steinberg, who shares with me, her wit, her endless friendship, and mentorship, and her countless pieces of advice on just how okay everything will be, no matter what kind of face I need to wear on any given day in any given place. You will always stay close to my heart, eventhough we are miles apart.

To my family who has put forward every timeless effort they could conceive having to offer. Lending and offering me an ear, a shoulder, a reaction, a smile, and a word of encouragement, just when I thought I was falling, you all did your individual things to pick me up, and place back on the pedestal you hold me on. My mother, "mama bear," the first feminist I ever met. As she stands strong besides me, she has created something fearless in me. I could take the same amount of pages this entire book consists of, and write a thank you just to her for all that she has done for me, with me, and continues to do on a daily basis, as though caring that much requires no effort. Everyone should encompass your skill at doing this so flawlessly. If it were not for your pedagogy mom, I would have none of my own, and would never come to know about liberation as more than just a theory. I owe her more than what this life can ever offer to us, and then some. Never could I properly articulate my love for you mom. To my dad who always warned me about crossing my Ts and dotting my Is, and questioning teachers as to whether or not my silence in the classroom was indeed an "illness" or rather silent inquiry. None of those lessons have gone to waste, and rather than just take it as parental advice, I have since applied it to my own teachings for others. It has gone a long way with me, and my students, and for this I thank you more than I can let you know. To my sister, who strutted me around the streets of New York City as though I was her own child. I could not have grown up to be the girl I am without your guidance and leadership. It was you, who reinforced the lessons of what a young girl should be or could be, and comforted me when I just wasn't cutting it in my own prepubescent attempts, using all the time your own beautiful model. You are a star in my sky. To my brother who taught me about a life outside of the norm, in my thirties, I still desire to be the man that you are. You made me feel cool among my "friends," and taught me how to develop a thick skin while removing scars that this world decided to inflict on me. You give me courage. If anyone thinks I'm cool and collected, you can thank him for this; and if there is ever a moment I switch

into a diva-like type of girl, it is all because he taught me to do this skilfully. You stand besides Jen as a star in my sky, brighter than I could ever show either of you. I would like to give a special thanks to my abuelas, my Guyanese one, and my Dominican one. Through my nana, I learned how to read, write, speak and love in Spanish. I learned to translate all the good and bad in my life in dual languages, and express myself through a universal one. Without them by my side, I could not claim nor pull a multicultural card as my representative social ID, and is one that I carry with me at all times. They both taught me special and particular lessons about old school ladies, one that I hope to enact when the time comes to greet me. A special thanks to my husband, who went through the trials by several fires to help me get this into the hands of my publisher. Although many feminists will say that marriage is overrated and another way of keeping women oppressed, I have had a completely different experience. Through such a partnership with my best friend, our marriage has been a component to my desire to keep the world just, and every step of the way, he has supported this kind of work. Your endless strength, and your picking up of where I tend to neglect has been a lesson itself, so much so, that words fail to accurately describe my thanks to you properly. You were there when this was in the making, and still hanging tight, as the completed pages have been produced, still you smile. My small family, mom, dad, sister, brother, grandmothers and my husband prepared me for all the Black and Brown Waves I've encountered, and you all make that ocean very accepting of me. To my one friend, since Junior High School we have remained attached to each other's ribs. Thanks for your encouragement and hysterical words of wisdom at getting this finally done.

Thank you to Dr. Linda Perkins who presented me with my first teaching job. Just when I thought I had jumped into a lake with no bottom, you pulled me out and explained to me that it is because "Regina, you are a good educator, for this, you'll always end up being questioned." Thank you for all your work with me as a graduate student, even from afar as I longed for your presence to guide me, your words via telephone and email always made everything better. To Professor Adam McKible, who spent time with me during my undergraduate studies forcing me to "write better" or "write more" and giving me an opportunity to work on his own book while in my senior year at John Jay. Your friendship will always be kept in my heart, even though we chat from a distance these days. A thank you to Professors Marcellous Blount and Robert O'Meally who saw me as an individual not just another graduate student at Columbia University. You both taking me under your wing, and helping me to concentrate on my writing has been an experience I reflect on every time I sit before a blank page. A special thank you to two of my early mentors at the Graduate Center, Dr. Philip Anderson and Dr. Hester Eisenstein. Dr. Anderson, your lessons in pedagogical structure and your guidance with my early writing(s) have been a treasure, one that I always open up and sit with in my quiet moments. Dr. Eisenstein, your work on feminist thought and practice, inspired me to take your classroom with me for a long time. Thank you to my new mentors, Dr. Arthur Lewin, Dr. Clarence Taylor and Dr. Stanton Biddle. My experience as a junior faculty is made easier every time I visit any of you, even when my world is crashing, you make it sound feasible to escape and do

something about it. Your taking the time to help me has been invaluable, and every time I teach, I thank people like you for that kind of opportunity. To this end, I would also like to thank my students, both undergraduate and graduate. You have all taken me under your wings, kept me young, kept me smiling, and most of all kept me teaching. I thank you for your friendships and the way you make me feel every time I scan my ID and begin what we know as "true pedagogy." Those experiences do not go unnoticed, but certainly, words cannot describe them no matter how "articulate" one can be. A thank you as well to those who said, "Writing about young women of color is a waste of time." I have "wasted" enough time and now the moment is finally here. To other writers, scholars and academics, like Paulo Freire, Patricia Hill Collins, bell hooks, and Alice Walker among others up and coming, I could not have had such a great frame of reference had it not been for your pivotal and groundbreaking works. I know I am forgetting many of you in my personal and professional worlds, but know that I thank you in my private moments and repeatedly as I teach my courses on Women of Color.

Last but certainly not least, a big thank you to my publishers, in particular Michel Lockhorst who has exemplified patience and support even though we are seas apart. Your support of my intellectual work, my erratic schedules and of me, as a writer has been invaluable and much appreciated. I could not have completed this without you presenting this opportunity to me, and without your help to get it finished and where I wanted it to be.

CHAPTER ONE

THE THIRD WAVE OF FEMINISM & WOMEN OF COLOR

The work of feminism and feminists is known not only as *the* "feminist movement," but has also been historically segregated into racial waves. The first wave quite simply dealt with white women from the United States and the United Kingdom noting their struggle as *women's suffrage*. Their fight was in the name of equality among white women who wanted the right to vote. Women of color were not included in this suffrage movement. Many of the "suffragettes" as they were once called not only fought for the right to vote, but were elite members of conservative Christian groups that fought for the prohibition of alcohol. Many have said that by 1920, or the writing of the 19th amendment, the first wave of feminism ended. The victory led white women towards a new form of empowerment, empowerment over white men, and possibly over fellow white women as well.

Forty years later, the second wave of feminism began to erupt. Now with the right to vote, white women were contesting "subtle" inequalities. While (mis) representation was a major issue of the second wave, along with career opportunities and choices, black and brown women were still trying to be recognized. The second wave, which lasted about twenty years, is one of the most interesting periods in feminist and/or women's history. Gaining the right to be college educated alongside white male counterparts had given many white women the opportunity to be competitive. However, as Betty Friedan stated so controversially (for her time) in the *Feminist Mystique* (1963), women were unsure, even with a college education, of what they would eventually become if not like their mothers and mothers before them (Freidan, 1963). In their argument, white women were sick and tired of being housewives, harboring proper bedside and tableside manners saleable and viable for well to do male prospects. They wanted to use their college education to become competitive with men and/or to work alongside them. Many of them rejected the tradition of having dinner prepared and served with a smile for when their husbands returned home from work. The complaint made its way not only towards the role of women in American society at the time, but it directed its attack on media. Magazines, books, television programs, and posters displayed images and textual evidence of the "ideal woman." She cooked, she cleaned, she smiled, she laughed and spoke when motioned to do so, she kept her husband satisfied on all counts and fronts, even if she was miserable, and she was white. Freidan called this dilemma "The Crisis of Woman's Identity" (Friedan, 123).

With programs like *Leave it To Beaver*, the lovely June Cleaver, so polished and clean on a regular basis, provided a key example as to what women should imitate in order to land the perfect husband. Her selfless identity is comprised of her love

1

for all things related to the home front, including her husband, and her two amazingly perfect sons. We never saw June outside of the home unless she was at a local social event, where many other white women just like her were present as well. They never confronted any social issues like rent, unemployment, long days and hard nights, or struggling to feed her sons. She accepted her skills as being solely hobby-infused; needlepoint, decorating the house, and baking, although she was college educated. This can be understood in part of Friedan's argument towards the media that strips women of their identities once she marries and becomes a homemaker. Needlepoint was not just a part time hobby, she used her projects in and around the house as proof of her "ideal woman" status. Decorating was not because she aspired to be an interior decorator, she was obsessed with her house looking presentable—presentable to her husband and her two sons, and competitive with the rest of the married women in her neighborhood. Wearing her pearls almost always, perhaps even when naked (if she ever got naked), June, quite simply is immaculate, just like her house and her family. As mentioned before, she too reads all of the very girly magazines that offered suggestions on womanhood, beauty, and more than likely, how to be a good wife (which means, pleasing your husband and your male children).

Recently, an article entitled *The Good Wife's Guide*, surfaced on the Internet, and made its way into many email inboxes. Although the article has been claimed a farce, the article still raised many eyebrows, and generated much discussion about an age-old problem in our contemporary understanding of roles for women. The article lists eighteen bullet-pointed key factors as to the role of a good wife. Although all the factors are interesting, the points are summed up in the last factor "A good wife always knows her place" (1955). The key to understanding the outrage over the article was commented on by psychiatrist, Dr. Gail Saltz as simply, "man may fantasize about a June Cleaver-like wife, because he wants more control in their marriage — or even have the upper hand. Wanting more control occurs when one partner feels insecure and unsure of his, or hers, own worth and power" (2006 MSNBC Interactive). While the article is the subject of criticism, and ultimately being claimed as never having been actually published in a 1955 edition of *Housekeeping Monthly*, women and fictional characters like June Cleaver fit all of the qualities listed, and created a format for such.

With all of this suffrage, where were women of color? When American white women received the right to vote in 1920, African Americans waited an additional forty-five years for the same privilege. While white American women attempted to break free from their housewife hell, black women were struggling to gain admittance to social events and education-based rights under the *Brown Paper Bag Test*, administered by fellow African Americans. When feminism is traditionally discussed, we do not hear about women of color and their dealings with suffrage. They are not classified as suffragettes or members of any groups with legitimate social problems. Feminism, for a long time was considered a white American women's movement. During the 1920s, when American women were given the right to vote, we are not told that three women, all African American, became the first black women to obtain doctoral degrees. It proved hard for many scholars to

include African American women into the history of a feminist dialogue. While women of color were indeed also struggling under male and racial domination, they were also achieving what seemed at the time, unattainable goals. In 1935, the National Council on Negro Women was founded by prominent black female figures such as Mary McLeod Bethune, and Fannie Lou Hamer. However, even with the creation of such organization that promoted the accurate representation of African American women, four years later *Gone with the Wind* (GWTW), made its debut. Although extremely racist, the film became a classic example of American dramatic love-in-the-time-of-war cinema, and winner of ten academy awards.

Hattie McDaniel who played Mammy in GWTW has been noted as a "happy slave" who not only appeared happy and quite content in her role of servitude to white southern female belles, but also saw herself as being above the slaves and servants who worked outside the plantation. Malcolm X, makes a clear indication of the struggle between the "field negro" and the "house negro" (1963), that plagued many people of color, and in this particular example, the female slave and/or servant. McDaniel clearly makes her mark on the world as a house negro, one that is dedicated to her "master" and is quite pleased with her position as a servant so close to the master. In addition to McDaniel, Prissy (played by Butterfly McQueen), also a house negro, has another dimension added to her character's qualities, quite frankly, she is stupid and childlike, and fears the ferocious hand of her distressed white female master (which she soon finds out stings when it is used). In an interesting scene from *Gone with the Wind*, Mammy is aiding the Mrs. with the tying of her corset. Trying to rationalize her waist going from 18–1/2 inches to 20 inches, Mammy tries to explain to her that obviously she has just had a baby, and thus would not be returning to 18–1/2 ever again. Scarlett so blatantly oblivious that perhaps there is beauty within Mammy as well, or that Mammy has some type of consciousness about her own heavy-weight figure, states, "There is something I can do about it...I'm just not going to get fat and old before my time" (Scarlett, 1963). Obviously, it is worth a mention that McDaniel and Mammy are both "fat" and "old" compared to Scarlett O'Hara. Life for the house Negro appeared much easier in films (as opposed to the field Negro) for black women. Beulah, and her two servants in *I'm No Angel* (1933) assist Mae West's character in a scene that could be mistaken for a multiracial circle of women, gathering to dress up and gossip. As they help her get dressed, West gives advice to the ladies on men. She even cares so much as to ask Libby (one of her maids) what kind of men she likes. Libby responded, "I'm just crazy about dark men!" All the women laugh at the response, and Mae West responds "Dark men? You wanna have a big time in Africa" (1933). The women in unison laugh at West's joke not considering the implication of the African male as dark-skinned and "Mandigo-like." Furthermore, black American men are not considered as viable candidates for Libby or as a reference for "attractive."

For white women and white female feminists in the 1960s, the struggle for accurate representation was based on their utilitarian ideals of wanting to expose their college educated minds outside of the household. The idea of receiving a monetary allowance from their husbands to feel "free" became tiring. Part of this

longing to be outside the home is what Betty Friedan classified as the "The Feminine Mystique" (1963). She defines the "mystique" as "the highest value and the only commitment for women is the fulfilment of their own femininity" (91). In opposition, not to the war as much, but mostly towards their disenfranchisement, African American women began forcing themselves into employment positions in various industries. African American women were not so much interested in the definition of their femininity, rather they were more concerned and obsessed with defining their citizenship and American identity or patriotism. The irony of the two groups of women is thought about when understanding that both black women and white women were trying to rid themselves of being "at home." While white women were trying to rid themselves from taking care of their homes as the "frustrated housewife," black women were trying to rid themselves from that same home, where she was the perfect mammy, and thus the frustrated and degraded woman who took care of the white women and her family, when she fell tired of her housewife duties. When faced with discrimination on the work front, black women would return to situations of sub-standard living, and eventually endure housing discrimination as well. The longing of wanting to work, led white women to seek employment in places that repeatedly discriminated African American women on counts of race and gender. African American women faced discrimination by white men and women, and harassment by black men alike (Kimble, 2001). The backlash of eventually hiring African American women would then lead to white employees leaving the job, and thus, setting the company at economic and financial risk (Kimble, 2001).

Many are steadfast in believing, and continue to practice in their classrooms of race and ethnicity studies, as well as classrooms of sociology, that Black Feminism began in the late 1960s as early 1970s Black Power community organizations began to surface. If this were true, many would forget Sojourner Truth's speech in 1851 "Aint I A Woman?" in which she states:

> That man over there says that women need to be helped into carriages, and lifted over ditches, and to have the best place everywhere. Nobody ever helps me into carriages, or over mud-puddles, or gives me any best place! And ain't I a woman? Look at me! Look at my arm! I have ploughed and planted, and gathered into barns, and no man could head me! And ain't I a woman? I could work as much and eat as much as a man – when I could get it – and bear the lash as well! And ain't I a woman? I have borne thirteen children, and seen most all sold off to slavery, and when I cried out with my mother's grief, none but Jesus heard me! And ain't I a woman? (Truth, 1851).

If black feminism erupted in the 1960s/1970s, we would find it difficult then to inculcate Harriet Jacobs' *Incidents in the Life of a Slave Girl* (1858), which explored and explained the sexual abuse that many a female slave endured during captivity. What gory details Jacobs may have left out, Toni Morrison does an excellent job depicting in *Beloved* (1987), when Sethe, knowing what life lay ahead of a black female slave, decapitates her own female child in an effort to save her from being sold into slavery as she was. Although many would like to think

Rosa Parks was the only female civil rights leader of the 1960s, many African American women worked right alongside their black male counterparts in the struggle for basic civil rights, and credible citizenship. Once the 1960s and 1970s arrived, black women far superseded the issues that white women faced in their quest for women's rights and/or liberation. So beautifully stated during her speech at the Radcliffe's Institute for Advance Study's Conference on Race and Gender, Dr. Darlene Clark Hine, History Professor at Northwestern University, and leading black feminist states,

> It was through the merger of interior and exterior locations that they struggle to integrate their pressing women's issues. Such as concern with finding fulfilling intimate relationships, forging unconventional families, increasing economic and educational opportunity, altering definitions of beauty, gaining healthcare access, controlling cultural production and representation. They forged these, pressed these women's issues into the liberation agenda into the national black women's community (Hine, 2006).

The idea of invisibility for the invisible black woman and other women of color in the discussion of women's search for liberation and/or basic human rights, should be called a crime against humanity. As previously mentioned, the struggle of women of color has been used as an afterthought in many a scholarly and educated layperson conversation. Unfortunately, with this tradition, young women of color are still being misguided. Many subscribe to a feminist ideology that historically isolated them or contributed to their subconscious/inherited invisibility. What kind of academic setting would that be if we were to trace the shaping of the black feminist ideology or the historical struggle that women of color both here in the United States, and internationally have experienced? What if a college class only traced the history of black women from slavery to the present? The class would be its own academic department. Perhaps the lengthy and complex history of the subjugation of women of color, which later led them to become members of the black feminist ideologies and practices (movements), is what keeps our histories abbreviated. The phases and stages of black feminism and its growth should be dissected to uncover the various facets of its history and productions of new knowledge and culture(s). The topics of such discourse should not only be dissected but should also be broken down in several different ways. However, the problem with what sometimes ends up happening is what I have laid out previously. There is the popularizing of some black women and the exoneration of other historical moments that lifted the movement off the ground. Before the division by race even takes place, many practices include the teaching of a "feminist" course that heavily depends on white feminists and the women's movement or goes over women's suffrage as the starting point. It has been noted by several scholars that historically, African American Studies was based on the review of black men and women's studies was based on the studies of white women and their issues. By the time the more "popular" form of black feminism came into the feared spotlight, people began to realize that the history of women of color does not solely lie in slavery alone.

In the 1990s, the third wave of feminism arrived onto the forefront of the longstanding concern surrounding women's issues. It was a direct response to the lacking concern on a variety of issues that the first and second waves blew off. Although there was massive activist work being done in the first and second waves, as I have described earlier, there was a lack of attention given to issues about race and class as they are linked to gender. It seemed women of color were engaging in battles still very much on their own and the divisiveness that racism, sexism and colorism causes, had women oftentimes, working against each other. The third wave was a direct response to these types of issues. As opposed to the historical construction of feminism, where the mobilization of white women was at the core of the issue, black feminism dealt with the core issues of black women's lives. As a result, the third wave encourages all women to work as co-agents of social change in reflection.

Women of all colors and creeds began joining the third wave camp as they watched, outraged, at the Clarence Thomas versus Anita Hill debacle. People watched as Anita Hill plead with the American public to hear her concern that the qualities they considered of a "good black man" was actually someone who helped to oppress women both racially and sexually. When refusal of his sexual advances ensued, Anita Hill, a law professor began to receive harassing email communication exhibiting sexual content including and not limited to pornographic materials. People began to call the case, a matter of hearsay or rather HERsay. The case had black women and men even more divided. The gendered public was angered by Hill in her attempt to discredit a black male in the eyes of the national public, and other women were aggravated at the attempt to silence a fellow woman. Interesting however is the amount of black men and women who rejected Hill as a member of the oppressed population. Feeling as though Hill was just another opportunist, they harboured animosity towards her for trying to "bring down another black man." The fact that the third wave mostly consists of younger women and men, under the age of thirty-five, is the pivotal point that even younger women were becoming engaged in fighting for their rights. However, the struggle still continues between the varying adoptions of the term *feminist*, and certainly among the waves, particularly second and third. Critiques regarding "real" feminism, and whether or not third-wavers were fighting for too many causes at once, are still topics for debate. Yet, while women are divided in thought and practice, and continue to battle a question like, who really engages in activist work in the name of "feminism," the struggle for women of color, old and young, continues. It is as though the two waves that continue to battle are simply missing the point, and are playing right into the hands of the dominating oppressor. As we all know, one of the key stereotypes of women is that we are known as being extremely catty with one another. It is usually men who fear when groups of women are in collection, and other women who reaffirm this fear by their complicity or complacency in the stereotype. A longstanding criticism of the third wave is the idea that this particular variety of feminism is selfish, and its goals mainly involve self-empowerment or improvement. What some fail to understand, and admit is that some women are indeed catty, but sometimes this self-empowerment and improvement can ultimately

benefit others. Women love to see other women who are bold, strong, and are vocal in their everyday lives. Who on this earth really enjoys supporting examples of weakness? However, racial concerns, no matter the coalition, still stand strong, are very much alive, and many of these issues under racialized tones are still waiting to be uprooted.

As I trace the three waves and their focal points, I must return to black feminism here. Having mentioned the different plights that the three waves focus on, it is important to note that black feminism still stands alone as its own movement where race, class and gender are at the core of the struggle. Women of color do not only fight sexism at the hands of white men alone, but as bell hooks and Patricia Hill Collins would argue, they also fight against the sexist oppression by black men. Combine this fight with the fight against societal oppressions such as Hine's categories of ideas about colorism, beauty, hair, workplace and housing discrimination, and healthcare among the top contenders. As many third wavers argue how great it is for younger feminists to attack the housewife stereotype, however, subscribing to feminism in this way, is only a small part of the problem, and does not come close to the surface of the issue for black women and other women of color.

During the 1970s, a vessel of black feminist scholarship began to gain popularity and recognition (at least in private among other black women). New terminologies were being coined and used for defining the varieties of social struggles that black women and other women of color were engaging in. A great example of colorism is depicted in Alice Walker's *The Color Purple* (1982), and in Toni Morrison's work, *The Bluest Eye* (1970), in addition to many more writers and academic scholars who also gave and continue to give relative variations of the term's definition(s). *Identity Politics*, coined by Kimberle Crenshaw, discusses the inextricable link of race, ethnicity, class, gender, religion, and sexual orientation is another terminology that can be applied to the mass of struggle for black feminist ideology and practice. Into the academic circles and within the confines of sociology courses, I have yet to hear the vocal or detailed use of Patricia Hill Collins' *Matrix of Domination* theory. Many professors and other academic scholars who believe they are discussing race, fail to use Collins' work as a pivotal indicator of black feminist ideology and practice. In college, women studies courses, much less women of color courses were not made available to me. We were to take an "ethnic studies" course, and that could be either Puerto Rican Studies or African American studies, both of which were an investigation of a whole unit of racialized struggle and its people. It was not until entering the doors of an Ivy League institution for my first master's degree that I began to hear the buzz about Collins. Everyone seemed to know of and about her, and some even knew her personally. I was jealous that they had been exposed to this and I was just jumping on the boat. I had always heard my mom talk about women of color struggling, and how we continue to endure the most of everyone's problems, but this was something I immediately had to share with her. Between those Ivy League walls, the black graduate students talked about Collins, hooks, Wallace, Crenshaw, and of course historical black female figureheads. However, no one was working

on black feminism, or women of color projects for their master's thesis. It was unbelievable. We talked about these strong black feminists as though we knew them, and as though we were in solidarity with them, but no one was teaching materials as the foreground of black women's issues. Later, as a member of the academic community, I again would hear no mention of these women, or active work in the black feminist vein, and became academically frustrated. I felt like the white girls at Ivy League schools knew more about black feminism than my own students who are females of color, and cannot define with accurate or new terminologies, the problems they face.

My students were taking women studies classes taught cross disciplinary in many other departments but still had not read any of the abovementioned scholars' work.. Who exactly was to blame? Faculty in the various departments? Administration, their requirements and mandatory decisions regarding what is and is not considered a classic and/or a requirement? Or, students who have the responsibility to self-educate when those in charge are not doing so? Perhaps, it is a combination of all facets of learning that is problematic. Our society is so heavily dependant on multimedia (minus books) that we are not exactly in the tradition of assigning students to do outside research, on their own time and terms. What is the likelihood that they will do it anyway or on their own? The risk of this is not insulting but tricky, challenging, and time consuming. This part of the parcel could be an example of the "matrix of domination" (Collins, 1990). The matrix of domination takes up space and consideration in what black women and other women of color have had to face when it comes to understanding our oppression.

> In addition to being structured along axes such as race, gender, and social class, the matrix of domination is structured on several levels. People experience and resist oppression on three levels: the level of personal biography; the group or community level of the cultural context created by race, class, and gender; and the systemic level of social institutions. Black feminist thought emphasizes all three levels as sites of domination and as potential sites of resistance (Collins, 223).

These struggles, and oppressive cycles, of when we are oppressed, or become the oppressor or simultaneously engage in the two, whether consciously or subconsciously, according to Brazilian educator Paulo Freire's *Pedagogy of the Oppressed* (1970), make up our consciousness. It clearly defines our place in the world, and that world while resembling other marginalized groups, holds its own special place in the systematic oppression that we continue to face on a daily basis. For me, it is how we structure our daily lives. Based on these elements and various social dynamics are the reasons we are still functioning and dysfunctional all at once.

As mentioned, black feminism is constant. It is not a mirror image of the white women's movement, nor a privilege obtained by the women's suffrage fortune or the privileges and societal memberships gained through their struggle. No doubt it paved the way for all women in many ways. However, the third wave of feminism is also paving the way for many women, both young and old. The attractive ideals

of hearing young women speak out on their matrices of domination or oppression is pivotal in the struggle for any kind of rights. True, there are many criticisms and issues gathered against the third wave. Many authors are releasing their feminist-based books that speak directly to young women. Yet, the audience seems predominantly white and female, as many of the problems discussed do not render true for or applicable to young women of color. Young white scholars are claiming not to know enough about women of color; thus, they extract us from the textual dialogue completely, or make brief mention that we too struggle in similar ways. Jessica Valenti's book *Full Frontal Feminism* (2007) is fantastic in many ways. It speaks directly to young women (although many do not agree with me on this point), and it uses non-academic jargon, which makes it easier to explain "superior" academic points and ideas. The issue that many take up with the text however, with all of its information and humorous dialogue, is that it does not go into much detail about the experiences of women of color who struggle with oppression. To blame her entirely would be faulty and misleading. It would be like someone being disgruntled over an author writing a memoir of his or her experience. Many would then critique the author for delving into topics that they have little knowledge of.

Valenti does do a brief mention that women of color should not have to live their daily lives separating oppression. We should not have to wonder whether or not we were discriminated against because of gender or because of race, which is unfair, and as she states, "there's no way to do that, to separate out your gender and race in your lived experience" (230). However, for many of us, who identify as women of color, wearing a badge of complexity and duality everyday becomes second nature to either (1) knowing how to separate the two, (2) living your life experiencing both types of oppression simultaneously if not daily as well. The inculcation of recognizing the various intersections of all types of oppression being slung at you at once is part of our practicing in the matrix of domination, or under the guise of the oppressor's bricolage. Valenti does explain that if women of color are not on the "fairer side" of the skin complexion scale, then they fall into stereotypical roles created by pop culture moguls, other than that we are invisible (Valenti, 2007). To some extent, she is correct in her assessment. Yet, in still, lighter skinned women of color also fall into stereotypical roles. As you will read in a later chapter, my example of Halle Berry being used as the prime example of the African American icon or woman of color beauty, to the point of where she can engage in an overly sexualized scene in *Monster's Ball*, is atrocious. She too is subjugated into the world of stereotypical "Black Beauty," and is what many people think, rewarded in the film for her acting skill set and her looks. She too however, is hyper-sexualized in this role, and used as a pawn in pop culture. At many points within pop culture, black women are not always divided in terms of skin color alone. Lighter skinned women of color are not always rewarded, for they too are isolated in many ways. The animosity between women of color, created by pop culture, has psychological effects on both groups of women. This also is not a recent issue, it goes as far back as the Hutus and Tutsi indicating their preference over African "beauties" and identity markers of beauty. Furthermore, there are

many examples that can be used to illustrate how Hollywood virtually sees all black women the same. Valenti is right in that many African American "overweight" women are cast as "sassy," but so are other women of color. In fact, many Latinas are known for their sassy roles, and we know that Latinas also range in shade and racial complexity as well (more recent example is the film *The Women—2008*). There will also be perspective to take into consideration, and this again falls into the box of understanding the matrix of domination. Depending on your lived experience is how you will come to know and understand the things that you do. Knowledge and/or epistemological approaches to the world are hermeneutical as there is no single truth. No one can tell me there is a better place to grow up outside of Hell's Kitchen, New York City, it is my lived experience that taught me so, regardless of how the rest of the world may view it. The same for many of the ways women of color are diverse, have their individual stories and are experiencing oppression no matter their shade(s) and/or hair texture.

When it comes to the various waves of feminism, and black feminism standing alone and intermixing into the third wave as well, many young women of color are tired of falling into categories (we get enough of that identity box-checking everyday). They know they are not part of the first wave tradition that did not include them and they know they are not part of the second wave, which maybe made mention of them, but in less than favourable frameworks. Many of us subscribe to the third wave, but we are not sure of the struggles that we face that unify and divide us, and more often times than not, we are divided and imbalanced in our collective. We still continue to struggle with questions of identity, race, gender, and social disenfranchisement. However, the third wave is a confine that encapsulates Black, White, Latina, Asian, South Asian, Caribbean, West Indian, and/or Biracial women together, but perhaps looking at struggle still quite differently. At least the intended motive is moving along the right track. Asking the question of "where do I fit in within the frame?" is common when trying to figure out what type of feminist you really are. If I am bi-racial, "mixed race/breed" or a "muggle" (Rowling, 2002) do I consider myself a third-waver, or black feminist, or a bi-racial feminist? Perhaps I am mobilizing to unify women in recognizing that oppression is the enemy, not a fellow woman. This is my definition of feminism. One of the things that you are allowed to do when you decide to fight against structures like the matrix of domination is to begin to think for yourself. Some days I am a black feminist, and then I am rejected by this circle and join the third wavers, and then realize I may have missed the age-boat at only thirty-one.

One of the exciting elements of the third wave movement is that many participants and subscribers are not man-hating. Men are heavily involved in the struggle, whether publicly or in private. It also makes being a tomboy quite acceptable in many social arenas (definitely a plus). For many old-school feminists, being a member of the third wave is almost like a slap in the face of struggle. This is not to say that women's struggles in the 1990s as opposed to the 1980s and now in 2008 are completely polar. For women of color, while we have the right to vote, read and learn, many of the previous struggles such as reproductive health, issues of racism, classism, housing and employment discrimination, and colorism are still

alive and well. For the younger generation though, there are hurdles to get over before they begin to encounter the several stages of the oppressor's tactics and roadblocks. Many second wave members have criticized third wavers for the simplest of acts, such as, ever believing that "dressing overly feminine," is anything other than playing into the hands of male oppressors. In fact, it is the complete reversal of this type of oppression. Part of being a feminist and believing in women's rights, is the right to wear what you please, being proud of it, non-competitive with other women, without the backlash of inappropriate men/women or the cattiness of other women. Some second-wavers believe that the traditional feminist must picket and march in public for the rights of women; anything under the covers or behind a computer is sheepish and cowardly. However, young women today are creating online magazines, websites, blogs, chat sites, and writing books at record rates on the topic of being young, supportive, and active in the production of new feminist knowledge. In particular, I had a student who believed that picketing, public protesting, and marching gets everyone nowhere fast. Instead, she wears feminist-indicator t-shirts, with great quirky and catchy sayings. People stare, stop to look, and they ask questions. I have told her countless of times, that generating discussion is imperative in the struggle for equality, and if her t-shirt closet is full of discussion, then she should continue to wear them even if they are pink.

For young women of color, and their uncertain subscription to the ideals of feminism, particularly for Latinas, as they are considered by the traditional roles and ideals of a Latino/a household. Among many of my Latina undergraduate students, they have had endless complaints about requirements from their homes and their male partners regarding their lack of cooking skills "like mama makes it," or how the home should look "like abuela's house," (grandmother's house) what they should be wearing and religiously-infused rules and regulations of the "mujer buena" (good woman). They grow tired of seeing their brothers run the streets all hours of the night, and with a variety of different women, as they sit locked up and away in their homes tending to their studies, household chores, or their brother's left-over assignment(s) of the house. Yet, in still, he is considered the man of the house under or in place of their father. They grow even more tired of being told that they have to get married before no man is left to desire them, or they become to old (old being twenty five years plus) to even be desired any longer. They grow restless hearing that education will make you smarter than your husband, so "don't get too smart, it'll make you fresh." The expectation of the Latino male and maybe his own suffrage with machismo is not so much the problem as the complicity and complacency that many Latinas engage in. Religion and tradition are used many times in how a Latina may or may not construct her life, and should she begin to live outside of this structure, she becomes a "freca" (fresh). In fact, many Latinas that I have grown up with, befriended, and have had as undergraduate students have explained their aggravation with having gotten pregnant as teens and being forced to marry. Many of them, in my and their opinion, married the wrong man for the right and/or wrong reason. Divorce never seems to be an option, which tends to lead into having a miserable life according to many of the students who

recount their stories. In many Caribbean and West Indian communities and cultures, women are secondary in the hierarchy of the family structure. Sure, they hold the family together when there is a crisis. Sure they are required to cook, clean and rear all of their children, but the requirements put on them as mandatory stipulations of being a "good woman," goes to lengths that one would not only classify as oppressive but suffocating as well.

To be a "new thinker" or a resistor against the matrix of domination, is to insult culture and tradition in many ways. For example, while I was in the Dominican Republic engaging in research one summer, my husband and I began talking to a woman who braided hair on the beach for a living. We began to discuss how difficult her life had become over the recent months with the economy being so low, and tourists not really coming to her part of the island as much as they used to. Our conversation led into the dialogue about gender, and hair. She claimed that I had "good hair" and I should not do anything to it. I grabbed my ends, and said, "surely you see the damage." We laughed. I mentioned that soon I would be chopping off my mid-back mop and going for a bob so I can deal easier now that the winter is coming and I would need as much sleep as I could afford in the morning back at home in the U.S. She looked stunned. "A woman does not cut her hair" she said alarmed. Of course, I asked why. She then told me that Dominican men (my husband included) do not like short hair on a woman and should I do that to myself, I would only be "asking for trouble." He would soon leave me. Now, this woman was not convinced that she was only telling an old wives tale. She was not agreeing with me that this was a superstition and an attempt to afford me less sleep in the morning. No. She told me that she was "warning" me for my own good because she knows. She lifted her hat, showed me her short hairstyle, and told me she was a single mother. I was not floored but I brushed it off. Were Latino males, to this woman, so affected by machismo, that her own husband left her because she cut her hair? I guess in this case, yes. My own Latina students have complained relentlessly to me that their boyfriends do not want to use condoms because Catholics do not believe in birth control, and "he might think I'm cheating." That the boyfriends or other men in their lives expected dinner when they arrived home from work, even if their girlfriends (my students) were in class for more than twelve hours that day or worked a full day at their menial-paying office job. They expected the newborn to be tended to if they cried at night, but the boys would be told to "man up" because "boys don't cry like girls do" and they expected sex regularly, otherwise they would go elsewhere for it. Sad? Maybe. What saddens me more than the pressure these girls are put under is the fact that they remain in these relationships and accept their fate, or write it off with a simple "I know he loves me though." Many of these same Latinas as well as my black female students, make the comparative example in that "I'm not one of those white girls Professor Bernard. I can't just wait it out forever until Mr. Right comes along, and when he does he wont have a big fat diamond ring for my finger, and a million dollar house to put me in." This also saddens me, in that my young female students of color see whiteness as a complete example of wealth and comfort and/or stability in life. It is not so much that they aspire to become white women who do

have these experiences socioeconomically and within their romantic endeavors, rather they are convinced these things are not, and will not be for them as well.

Thankful to many young feminist or pro-women writing like *Full Frontal Feminism* (2007), *We Don't Need Another Wave: Dispatches from the Next Generation of Feminists* (2006), and *Colonize This! Young Women of Color on Today's Feminism* (2002), and the abundance of websites and blogs dedicated to young women and their issues, some women will hopefully be spared from the gruesome details and requirements of tradition and cultural infractions of oppression.

Yet in still, for young women of color, there cannot only be the dependency on the new-day literature that has come out, or is about to come out. Young women of color have to be dedicated to understanding the work of black, Latina and biracial and/or bicultural feminists, and transnational feminism all over the world, not just our New York City frame of mind. Sure, commercials for birth control expose women on swings of a grassy park looking fanciful and free, and oftentimes women of color are even in the commercials as well. However, when birth control was first tested, it was done so on Puerto Rican women on the island, who were either made sterile or lost their lives due to the use of their bodies as guinea pigs. In many other countries (and some American states as well), birth control pills and medications, and abortions are not a privilege and a right, it is a sin. Many young women in other countries have their tubes tied without their knowledge and/or consent, and are left sterile for reasons unbeknownst to them until they are ready to have children and are left trying to figure out why they cannot get pregnant. These are the issues that many young women of color face, and why it is so important to do research, read, and learn about other women. For many young girls of color, abortions are used in lieu of birth control, and ultimately they find out that they may not to be able to carry a child once they are prepared to do so, because they have had so much reproductive surgery done. Due to religious beliefs and traditions, as I mentioned, some women do not even engage in the idea of an abortion for fear of higher power reprimanding, and so they have children at young ages.

Perhaps we are membranes from all of the waves, for if some had not forgotten us, we would never have mobilized as much as we did, nor would we have learned to fight so hard tooth and nail for what is ours too. Perhaps, we are to continue to struggle as long as we are making progress, and this, regardless of label or title, is a good thing.

GROWING UP FEMALE IN THE KITCHEN

A Narrative

What is a girl supposed to do naturally? The answer to that was surely not anything that I ever did growing up. As a toddler straight off pampers, I attempted to urinate standing up. I lathered shaving cream on my face followed by aftershave. I used male deodorant and cologne, I thought men's underwear was a clever design and looked tougher than days of the week frilly underwear, I liked tube socks, breasts seemed to get in the way, and big derrieres brought too much unwanted attention. High heels kill my toes and can eventually hurt one's back, I only knew of men smoking cigars and learned to love the smell too. I played cards by slamming the table and cursing (when my parents weren't looking or listening), and I played dominoes with boys only. I thought being a pregnant teenager was a sign of weakness and that it was a man's trap. I thought makeup hid who one really was and perhaps a bit of false advertisement should the makeup transform you completely. Shaving was a nuisance, unnecessary and deadly if done in a hurry. Manicures too time consuming and pedicures so oppressive to the *other* woman performing the duty, but at the end of the day, I am a girl, and these things would inevitably become part of who I am.

As I sat down to compose this chapter, I, at first, struggled to remember a time when I was reminded that I was a girl, or realized that there were gender differences in the rules of growing up. All of a sudden, the images flowed like water in my mind. Then, the images became tsunami-like waves, covering all else that I would possibly remember. Short flashes of elementary school, junior high school and high school, college, graduate school and so on began to flood me. Thinking back to these specific times, I realized that reminders everywhere about being a female were usually infused with race. The two were never separate, unless I was among my own brown-skinned population.

I grew up multicultural, and I do not mean multicultural by way of celebrating various holidays in school, eating "ethnic" foods on special days, or depending on any teacher to teach me how to "tolerate" people who were different. I grew up multicultural because my parents who are both British Guyanese, are from different backgrounds. My mother an Indo-Guyanese has Southeast Asian heritage by way of her grandparents. My dad, who is an Indo/Black Portuguese-Guyanese, has his heritage within the confines of Wales. They are two different shades of brown but come from two very different backgrounds. I was the first of my parents' three children to be born in the United States, born in Manhattan, raised and lived in Manhattan until I was almost twenty-one. In the 1970s, my parents were working multiple jobs each. I was but a few weeks old, and as two parents of color they

knew that they did not have "days off" from work that they could take. Therefore, while they stayed at work with shifted schedules, they found me a babysitter.

My Afro-Puerto Rican sitter took care of me for a few months until one day she received a phone call that her husband was ill, and she flew out to Puerto Rico the next day. She recommended her neighbor as her replacement until if and when she returned. Left without any choices or really the choice between socioeconomic struggle or unemployment, my parents took her recommendation while taking a chance. From six weeks old to today my Dominican babysitter replacement became my surrogate grandmother. Until I was old enough for kindergarten, I spent my days and afternoons with my abuela (grandmother) and her sister, my other abuela. It was through her that I learned Spanish, for she does not speak English. By the time I entered kindergarten, I was speaking, reading, writing, counting and playing in Spanish and English. My parents, not speaking Spanish, struggled with my new accent, and my request for things around the house in Spanish. I ate Dominican arroz con pollo, platanos mas duros, and mofongo, just as I easily ate chicken curry with dahl and roti. I listened to Merengue, Tipico, and Salsa as easily as I listened to Reggae and Soca. I watched Hindi and Bollywood movies just as easily as a Spanish-language novella or a cartoon in English. I was living in two worlds, and had no idea that this was called "bicultural." To me, it was and still is just *my* life.

Many of the children that my abuela took care of during the day and afternoon were boys. I was her first and took that title to mean royalty in her house. I ate first, I was asked first, I bathed first, I dressed first, and watched what I wanted on television…first. When the other kids came along, my abuela tried to even out the day between all the children…the boys. When I suddenly realized that they were getting more attention than I was, I started to become like them. I fought them, pushed and punched them back when they did the same to me, until my abuela sat me down one day. She told me in Spanish "Mi amor. Las hembras linda no se hacen eso." (My Love, pretty girls do not do those things"). So to get my way in her eye view, I was the perfect little girl. I cried when the boys pushed me, I went straight to her to complain when they pulled at my pigtails, and I moped around the house when they watched their choice of program on television. We argued over whether they could watch He-Man or I to watch the Smurfs. In my own home, all the children got their way, my brother and sister being older, never fought with me over anything. I was not used to dividing my interests this way and in particular with a group of boys. Eventually, I became unhappy with this situation. I remember someone once told me "get in where you fit in" so I started to watch Thundercats and He-Man as they did. They thought She-Ra was corny and even though I rather liked her, I thought she was corny too. She-Ra was just He-Man's sidekick, and his useless rib. When abuela was not looking, I cursed in Spanish like the boys did, played on the monkey bars and jungle gyms, I pushed them off the swings, wrestled with them, and arm wrestled for television privileges, I raced when eating and burped louder and longer than they did. The only thing I could not do and get away with like they did, was urinate standing up, but one day I thought, with enough practice, I will be doing that better than them too. By the time the new

girl came into my abuela's house, she was around our ages already, but her mom's shift changed at work, and so she asked if abuela would watch her for a few hours a day a few times a week. Carolina, a beautiful Dominican little girl, stole my abuela's heart for a few months and left me devastated while giving a new dimension to the word jealous. I was the only girl in that circle until she arrived, and I was not Dominican and knew my difference very early. The ladies loved me until she arrived—she was one-hundred percent Dominican, from a Campo in the Dominican Republic, and not a sweaty city kid like me—obviously their love for her reminded them of home, something I could not do, no matter how hard I tried. She became "la India" to many, and I became "la negrita." To my abuela, I was always her preciosa indisita, and I felt privileged. I resented the name "mi negra" as it was used to decide who got the most affection from the older Latinas in the neighborhood. La India (Carolina) got all the hugs from the neighbors. She got more than me during our trick-or-treating, not that my mom or my abuela allowed me to eat anything I got anyway, but the point was the tallying at the end of the night. They said I was prettier than she was, but I did not feel it among the elders. They only made that indication when I had my hair down—they told me that I had "el pelo bien lindo y suave." (Pretty and smooth hair). Carolina had "el pelo bien malo." (Very hard and/or bad hair). My abuela would always have me at her hip, and no one was allowed to insult or touch me when I was attached to that hip, and so if she thought I was "la bella" (the beautiful one), that was all that mattered and that translated as being prettier than Carolina, but inside, I wanted to tear her guts out.

Carolina wore dresses all the time, and would cry at the slightest sign of verbal or physical combat. Although my mom dressed me straight out of the Lord and Taylor department store, I was the Manhattanite who came from a good non-Dominican family, and Carolina reminded everyone of home. She stayed with abuela in the kitchen all day, not traipsing behind her as I did; she learned how to cook instead. I never took on those lessons, instead I walked behind my abuela like her shadow just wanting to be in her breathing space. She would open the fridge, and her third arm (mine) would reach for what she wanted. When we played games with teams, abuela's kids always chose me for the boy's team, and organized Carolina and other little girls from the neighborhood as the girl's team. I spent most of my time being reprimanded for playing too rough with the neighborhood girls, even though I was chosen to play for the boy's team of dodge ball. During an afternoon of dodge ball in the building's playground, I held back my dislike for Carolina until she screamed out at me, "that's why abuela doesn't like you, because you are a boy and prieta!" I hit that girl so hard in the face with that dodgeball that her face swelled up like an inflatable doll and she started bawling. My abuela told me that I was not a boy, and should stop trying to be one, and that I should not play that way, and if I continued to behave badly she would not love me any more. She was mad at me. I went home that night into the arms of my mother, and cried until I fell asleep. I could not understand why she could not understand that I loved her, and wanted her to love me too, a lot, more than she loved Carolina. At fourteen Carolina found herself a boyfriend, learned English and forgot she even met any of

us at abuelas. Although my abuela tried to reach her and give her motherly advice, Carolina refused and rejected her. At fifteen Carolina became a mother, and pushed her newborn down the streets of Hell's Kitchen embarrassed in front of the older generation but proud in front of her peers. We came to find out many years later that the father of that child had been a grown man who had left her the moment he found out she was pregnant—this was not shocking, as many of the brown girls in the neighborhood had the same personal narrative. I was glad. As selfish as that may sound, she was out of my hair, out of my abuela's house and I had my abuela all to myself again, until her real granddaughter was born.

Spending my young days with two sisters from the Dominican Republic, one very light and one cocoa-brown helped me develop some of the best multicultural lived experiences one could ever imagine. Once I learned that being bilingual was a credit, and a good attribute, I spoke Spanish with my abuela and her sister and I spoke English at home with ease and flexibility. I code-switched between languages, cultures and worlds on a daily basis.

For many of my classmates, this bilingual and bicultural person was confusing, and rather than embrace the two, school somewhat helped to mesh the two into one person. Teachers and classmates saw my bilingualism not as parts of my whole, but simply as another way to categorize me into boxes comfortable enough for them to accept in low dosages. There were no other students in school that came from Guyanese heritage, but there were plenty of Dominicans in school, so for many, I was "Spanish" because I spoke the language, and to them, I had "Indian" hair. These were small issues of race and gender that I faced, and looking back on them now, I understand them as political. I also found out that these "small" issues that are used to taunt schoolchildren are also issues that help to categorize adults that cannot fit into simple categories of race and gender.

AT HOME

My "real" home, complete with both parents and two siblings and later in my life, the addition of my maternal grandmother was a safe place. I have been the baby of the family for as long as I know, even in my adulthood. At home, although safe, I wanted to fit in there as well. When my parents had adult conversations with other adult family members, I used to switch up my school-English to sound Guyanese. The adults would hold their stomachs in stitches from the laughter asking, "is this girl for real? Are you sure she was born here," they would ask my mother. I was able to code-switch without notice, and without practice. However, while there were no students in school who had Guyanese parents, the need and desire for me to speak a different way never came about. If you had that Guyanese accent, everyone assumed you were Jamaican, and the conversation was left at that, similar to if you speak Spanish, then you are "Spanish." When my brother and sister would reminisce about their own childhoods growing up in Guyana, I would sit in their circle, listening, desiring, drooling, and desperately wanting to find something to add. When they would laugh at stories that started with "remember when…" I would feel the hot tears forming and feel so out of place. I used to beg my mother

to have another child, so that he (I assumed he would be a boy) and I could share the "remember when" later on in life, but my begging was to no avail. I used to think, I do not know any Guyanese people other than my family, and I was not born there so I cannot claim that I am Guyanese, and I cannot contribute to these conversations. My mother would remind me that I am the only one in the family that can speak fluent Spanish, and so I had my own "remember when" in another language, and as much as anyone pretended otherwise, she told me that everyone admired that and was fascinated by it. Eventually I became the translator for any of my family's Spanish-speaking friends who had trouble with their English. Random people on the street who approached my mom or dad for directions in Spanish, translated to my family as "wait a minute, my little daughter speaks Spanish." I suddenly felt as though my speaking Spanish was only good to help translate things to other people, not even in my age group, I began to pretend I did not know how to speak it.

While the only "American" in a Guyanese home, and the only English speaker in my abuela's home, I felt important. Everyone needed me. People would give my parents a hard time on the telephone because "they hear an accent" so I was used to dispel the stereotype that foreign accent equals less than capable, even if it is the "Queen's English." I would then get on the phone or speak to city agencies in person in English to dispel the stereotype that Spanish-speaking only, meant illiterate all together. All of my friends were in the same boat (no pun intended). I was never made to feel ashamed amongst my Hell's Kitchen friends because my family came from another country during the 1960s and because my "babysitter" was Dominican. All the kids that made up my friendship circle in Hell's Kitchen had the same immigration story in their own households, so it was not something we discussed, but rather we were proud that we were not the norm.

ELEMENTARY SCHOOL

I have the fondest memories of elementary school and the social skills I developed there. The school was located one block from my Hell's Kitchen apartment building, so the community was familiar and no one looked strange. My first grade teacher Mrs. Erlanger loved me. She made me feel almost as special as my mom did. Five out of the five-day school week, my mom dressed me in lovely little dresses, ribbons in my hair to match, clean dress socks (also matching) and often times Mary Jane shoes that would match my dress. At the beginning of class, after the principal's morning address over the PA system, Mrs. Erlanger would instruct the class "this is how a young lady should dress to come to school." She would then take me from class to class, her large hand holding mine and showing the other teachers what her "doll" had on that day. I loved Mrs. Erlanger. Although I developed several enemies because of her kind gesture, I loved her. She made me feel special, darling and pretty. I never really came to terms with how society would have wanted me to feel about Mrs. Erlanger being a white woman showing off a brown-skinned little girl. To this day, I accepted it as a kind gesture, and

thank Mrs. Erlanger for her encouraging high self-esteem at five years old, something only my mother can do so perfectly.

JUNIOR HIGH SCHOOL

By the time I got to Junior High School, I had locked away the dresses in my closet, and turned to my dependence on jeans and sneakers as my school uniform. Going to a predominantly white junior high school, every morning I left behind my safety net. My safety net consisted of several other young girls who were just like me, and I was just like them in many ways. We were each other's pastime. Attending Wagner Junior High School on the upper east side of Manhattan was a huge moment for me to learn about race and gender. Gym class is one of the moments where many young girls confront their gender roles and capabilities. Each moment in gym, I was confronted with my brown skin being maybe one of two in a sea of white girls. Their blond hair, light-colored eyes, perky breasts, shaved legs and armpits, and no underwear-wearing attributes, made me ask myself whether I was a girl or a "tomboy" and where did I fit in? They played volleyball, I watched. They played basketball, I watched. They played "gossip in the corner" and I watched. Whatever they did, and I was not chosen by the teacher to also do, I watched. In the locker rooms, I watched as they stripped completely naked to change back into their street clothes. I watched them take their combs and swiftly toss their blond hair forward and back. When I got back on my block, these issues were not being confronted. In the immediate circle of the Hell's Kitchen girls, my two best friends were black, and the other was half black and half Afro Puerto Rican. They were not being confronted with these issues as they attended Catholic junior high schools that were predominantly of color and also two blocks from our building.

Excelling in all of my traditionally academic classes, gym I struggled with. I began to fake stomach aches and back aches, until my teacher realized I was faking. He put me to task. We had something called relay day. Relay day was an obstacle course that was constructed by the gym instructors to test students' physical agility. I had been professionally dancing since elementary school, and so agility was just another one of those "simple" feats for me. I climbed the seven-foot rope, legs crossed at the bottom, hand over hand as I had been instructed. The second attempt up the rope was with a competitor. The blond haired blue eyed "monster" at the tail end of the rope next to mine. By the time she was able to mount the rope, I was already up and on my way back down. Halfway down the rope, I heard someone call me a monkey. I looked around to see a group of white boys and girls laughing at the bottom of my rope. "Look! It's a monkey!" I slid down the rest of the rope using my hands. The teacher did not tell the harassers to mute themselves nor did he look the least bit unnerved. Instead, he told me that I had not successfully completed the task because I slid instead of climbed down the rope. I looked at my hands and they were beet red from having been burned by the rope.

The next time we had gym, I wore my uniform under my street clothes, so all I had to do was strip from street to gym. The white girls laughed at me, and ridiculed that I must be hiding something in my underwear since I had to be already dressed from the street to gym. Looking at my pre-pubescent muscle definition from dancing full-time classmates called me a "boy," a "dude," and told me that if I was really a boy maybe they would start crushing on me. Repeating all of this back to my circle of Hell's Kitchen girls, they all tried to quench the fire by changing the subject. When I would not allow that, they then turned into monsters. They wanted to come to my school and fight the white girls. That is what we were, loud mouths, tough, muscular, and fierce, but we were all young girls. We crushed on boys just like the white girls, we were sprouting in unfamiliar places just like the white girls, but we were growing up very differently. Instead of spending free time in our feminine bedrooms like most of the white girls in my junior high school had, we adorned our stoop on fifty-third street between eighth and ninth avenues. We commented on everyone that passed by our stoop, we controlled the building's teens and teen culture. We fought, we cursed, we played hard and every sport seemed to be full-body contact like.

After months of suffering in gym, and feeling like a boy amongst the sea of white girly girls, I was chosen to attend the gymnastics sequence of gym class. To my surprise, this is where all or most of the school's brown/black girl population had been sequestered to. There were so many brown/black faces in the gymnastics gym. They were on poles, on horses, stretching and looking physically fit. However, for years, I could not shake the feeling that we were all in that gymnastics gym, because we were deemed "athletic monkeys." While the white girls were playing volleyball and using their hair for prepubescent shampoo commercial prototypes, the brown/black girls were in the dimly lit and small gymnastics gym, looking like primates in the jungle, swinging off bars without direction. Clearly, there was no escape.

My next-door neighbor at the time, a young Puerto Rican girl, who was about two years older than I was, befriended me. I had always admired her from afar, thinking, that she was so pretty, so tiny, and all the boys paid attention to her, and how lucky I am that she wants to be friends with me. Many months within our friendship I found out that her mother wanted her to be friends with me so that I could help her with her schoolwork. However, my new friend and I shared some of the greatest moments – we also went to the same junior high but we were grades apart. What I did notice was that in the cafeteria she sat with the white girls, as I struggled to find some place to sit. After becoming very close to a pair of white sisters, she eventually ignored my search for a seat in the cafeteria altogether. One day after school, she invited me to go with her to her new friends' house. To my surprise, these two white girls, who are sisters, lived on Eighth Avenue of the same street as we did. We lived in a building, they lived in a high-rise. The difference was striking. The building did not at all feel like "normal" people lived there. People did not stop and talk to each other in the lobby, people did not really appear interested in much of anything except where they were going to or coming from. We went up to their apartment and the younger sister who was closer to my age

decided to chat me up. She talked about her teen idols that were also plastered on her walls in her OWN bedroom. She talked about playing the flute in the school band (I was not in the band, I was taking piano lessons on the side outside of school with a famous Jazz musician from the "Inkspots,"). She talked about her diet (diet? What the hell is a diet?), she told me that she would give anything to have my figure but that I should take good care of it, because most "black girls fill out without even realizing it and become fat!). I thanked her for her advice (insert sarcasm here). She swung her hair and her bangs as she spoke, and told me that I should let my hair out sometimes because it is pretty and curly not nappy like "real black girls." She also told me to tighten up my jeans a little bit and show off my body and "please I know that you dance and everything, but you really need to cut back on getting so muscular." By the time this girl was done, my head was spinning. I could not wait another second to get to my friends from the stoop and tell them what had just gone on. Instead, when I did excuse myself from their apartment that from the outside was posh and on the inside was hideously filthy, and ran to my own building that was not immaculate but was safe, my friends who were all on the stoop turned and went indoors when they saw me. They had seen where I came from and were pissed that I was "with white girls all afternoon." I pleaded my case with them by asking, "if I do not hang with them how can I repeat what is going on with the other side of this block?" After what seemed like days of them giving me the silent treatment they gave in. They were furious with that little white girl, and any time she came to visit my building, they would tell her that I was not home and to get back to her diet!" However, they were not at school with me, where it was not just an afternoon of diet-talk and hair flipping, it was all day long and by the time I got home, I was too stressed out to talk to anyone about it.

Towards the end of the seventh grade, a new student entered our homeroom class. She was Puerto Rican from the island and spoke no English. Looking around the room, there were sprinkles of Spanish speakers but the majority were white girls and boys. What seemed to go hand in hand were AP classes and whiteness. The students who did speak Spanish without hesitation were in special education classes or "regular" track. The AP Spanish speakers did not allow anyone to hear them speak Spanish to each other, and did not define themselves as Latino/a or by nationhood. My teacher assigned the new girl as my "buddy" because I also spoke fluent Spanish (the Dominican dialect) and because "you'll understand what she needs as a girl." I wondered if she did not speak English how in the hell was she placed in AP History. Maybe it was the blonde hair and blue/green eyes that did it. Was she passing like Nella Larsen? Luckily for both of us, she and I became best friends. My beloved history teacher, Mr. Nelson gave me things to read on Che Guevara, Fidel Castro, the government, the Black Panther Party, and the Young Lords. He told me that I could handle it just as good as the boys and being that I was "not really black" but brown, this information would prove helpful to me many years later. Although a double-edged sword, his compliment and urgency with which he taught me was indeed helpful. All this info however was lost on "new girl."

While the white girls wanted the "new girl" as *their* friend instead of mine, they struggled because she did not speak English. She had blond hair and green eyes, and was seen as the gem to many of the white boys, and the nemesis to most of the white girls, and she was *my* friend. Shortly we created a circle that resembled the one on my block. Four girls, one brown and of Guyanese heritage (me), one light skinned, blond hair and blue/green eyes (the Puerto Rican in discussion), another light-skinned Latina (with curly brown hair) of Salvadorian heritage, and one white girl from the upper east side of Manhattan that struggled with her weight. We were the misfits. When our one white circle member was not around, the three of us sat together at lunch speaking in Spanish mostly, and doing what girls do, gossip, talk about boys, music and life. Although resembling sameness, they ridiculed my Dominican Spanish as "bad" and "broken" on many occasions. When another white girl attempted to penetrate our circle, the three of us except for "Miss Puerto Rico" (as we sometimes called her) were hesitant. Instantly, we did not like her or her attitude. We did not like the air of privilege she seemed to have, and we certainly did not appreciate her confidence in penetrating this circle. However, she took a liking to "Miss Puerto Rico" right from the beginning, we were not her focus.

For the eighth grade dance, our music teacher told the class that she would like a group of girls to choreograph a dance sequence and perform it at that year's eighth-grade dance. Immediately the new white girl that had abducted Miss Puerto Rico decided to nominate herself and Miss Puerto Rico as the performers. As our relationship became strained and we began to grow distant, Miss Puerto Rico told the new white girl that she and I had been friends for years, and that I was also a professional dancer and would really be helpful. Our music teacher told the new white girl that she was to choreograph the entire sequence, and put Miss Puerto Rico where she best fit, and for her to find me "something or the other" to do. By this point, I was no stranger to this experience. In my dance company, the National Dance Institute, I was never placed in the front line of performers, for any dance sequence. Although I hailed from a Hindu grandmother, and was no passerby to Kathak dance or Hindu culture, I was not ever chosen as lead for any "ethnic" piece. When the company choreographed the story of Rani and Rama, they chose a white boy and white girl to portray Rani and Rama and I was chosen to show the girls from India who had been flown in to perform with us around the rehearsal studio site. I was never chosen for a solo set, or was never recognized, unless I made a mistake during rehearsal. My sister once purchased for me a yellow and black leotard, after wearing it with pride only once, I was forever called the "BEE," by adult choreographers and teenage performers alike. During my sessions at tap, (tap dancing was a requirement of summer academy of dance) I was ridiculed for being of color and not knowing how to tap-dance. I imagine I was supposed to know how to "Sambo" myself throughout the studio, and it was not that I did not know how to, I just did not like it. I hated tap-dancing and found it incredibly annoying.

Returning to the school dance: although I was given "something or the other" to do at this eighth grade performance, the night of the dance would prove different.

Miss Puerto Rico, and Dancing White Girl, blocked me. I was to dance behind the two of them, doing all types of jerking moves that had been set out for me. I thought it would be a three-some, I did not realize I was the shadow. The song that we danced to, or rather that they danced to was Samantha Fox's *I Wanna Have Some Fun* (1989). After the dance, three young black girls approached me and let me know just how much of a "fool" they had made me out to be, and just how much of a bigger "fool" I looked with them. They told me that I looked like a goofball, and like a man dancing with two girls. They ridiculed me for even wanting to dance with the "two white girls" (it did not matter that one was Puerto Rican, she did not look it to them). At the dance, I stayed in the corner talking to no one, and trying to find my coat to go home. One boy, one of the very few black males, asked me to dance. Nervous, I declined, but gave in because he did not give up. As we danced, he said, "damn you sure do have some muscles, you're making me look bad." I did not know if he was complimenting me as so many of the other boys of color had used my figure to treat me as their equal, so I took his comment as negative and left him dancing as I again searched for my coat.

Boys were not crushing on me at my junior high school. They became friendly to me to get next to Miss Puerto Rico or because they could be boys around me— after all I had been transferred from home economics to shop. I wanted to return to my stoop immediately and forever stay there. The stoop family understood that I was tough, but I was also a girl, for they were just like me. The boys on the block also understood. We had all grown up together, and they understood that I could be rambunctious just like the next boy, but that I had stomach cramps from having my period. Schoolwork seemed to be the place where I put in much effort and it did not seem gendered at the time. I could do my homework, write my book reports, learn new vocabulary words, write short stories, and read novels without being ridiculed as a tomboy or a girl wanting to be a boy.

I figured out a way to be more of a girl without having to prove it to anyone. In my early elementary school years, I had already found my love of reading, and spent every weekend at the Donnell Public Library with my sister (my library buddy and my chaperone) checking out books. I read every *Sweet Valley High* book, and anything else that had to do with girlhood. I became obsessed, but physically it was never proven. I never wore makeup and developed a phobia about wearing dresses, because I had muscles but no feminine tone to my body. I also hated wearing dresses because on the stoop, anything could happen in a moment's notice, and how would that look if I was playing freeze tag or roller derby with my dress half over my head? Regardless of what my body looked like and how much teasing everyone did, I continued to dance. I watched Paula Abdul's *Cold Hearted Snake* (1989) video until I had the dance sequence memorized with my eyes closed. Janet Jackson's *Pleasure Principle* video also became second nature. These songs were written with the focal point being a man, but not in that lovey-dovey way. Abdul and Jackson were renaming these men for their behavior as "jerks." They were singing a call and response for other young women to be weary. Listening to these songs, I felt smarter than the rest of my population. I felt that they had told me about "nasty boys" and so I would not find myself hurt when I

grew up, because I already know they are "cold hearted snakes" and I am my own "pleasure principle."

Many a weekend I spent attaching my little hands to my older sister's, as she chaperoned me to museums, libraries, and parks. My mom inspected my darling outfits to match my sister's style and etiquette (one could not be sloppy while the other dressed up). Hand in hand, we rode the New York City buses from our Hell's Kitchen building to the Museum of Natural History (where she worked at the time), to the Whitney Museum, Guggenheim, or MOMA. Although I did not understand the art I was looking at, I was immersed in this grandiose space of "stuff." My favorite place was the New York Public Library's main branch on 42nd street and 5th Avenue in Manhattan; it would eventually end up being my first real job at fourteen years old. I loved the smell, the architecture, the floors, walls, books, carvings, huge open spaces and I especially loved the intensity of the faces I watched sitting at the various reading room tables. These folks looked like they were learning something new, breaking a mystery, or content in their solitude. I never really saw young people studying there. Although a reference library and not a circulation center, I begged my sister to take me there on random Sundays so that I could walk the halls of the library which in my mind felt very close to being in a church except without the creepy statues that seemed to watch me in my private moments. I floated from floor to floor touching the walls, the backs of chairs as though I was blind and trying to recognize what I had been touching in my blindness. In those moments gender did not matter, race did not matter and if I did, I was oblivious.

My mom also worked there during this time, and on days when school was cancelled, I spent the day with her when not with my abuela. The books on the shelves high and low served as my babysitter while my mom worked. Her co-worker, a brilliant gay black man who spoke over seventeen languages used to take me by the hand and show me around. He pointed out archives, rare books, books so rare and so expensive they were in cages wrapped in plastic and untouchable. He spoke to me in Spanish and in English testing my reflexivity in dual languages. I was in my glory. My love with books has since grown into a full-fledged thirty-one year long passionate affair. I remember one night coming home and watching the film *Amadeus*. Having learned about Mozart in my Junior High School's music class, I memorized the soundtrack in my head, and for some strange reason, every time I walk into that library I replay the soundtrack repeatedly in my mind, and suddenly I have come home—a place without gender barriers, racial classific-ations, socioeconomic brackets, and questionable identity. Just walking into the library, I felt smarter, and would stay there for hours upon hours taking in the weird smells that the patrons brought and the books kept between their pages. I often thought to myself it was no wonder why slaves were not allowed to read or even taught to read, look at what those pages old and new, torn and kept, smelly and tainted held...secrets to liberation of the mind. They held the answers that most of us search for in the physical world. For me, reading any and everything I could get my little hands on was like having the sheet music for Coltrane's version of *In a Sentimental Mood* tattooed across my back.

Once I started working at the library, I was able to escape the daily barrage of images antisocial quirks I had developed in the halls of the relentless high school I attended. While being a page at the library and dealing with issues with co-workers who treated me unequally and unfairly because I was younger than the entire staff, and because all the higher-ups knew my parents, I shut all the world out and focused on my reading. Through my reading I realized that I was not a young brown girl from Hell's Kitchen, and I was not like the girls on my stoop, they were just a safety, I was a nerd and I loved it but did not realize how much I loved that character until she developed into an educator twenty-something years later.

HIGH SCHOOL

By the time high school appeared in my life, my circle on the stoop had started to diminish. I just could not get into the groove of being a girly-girl. So many of my friends had excluded me from the circle's activity, although two of us were at one time ringleaders of that circle. My friends were dating and I was not. I had a job, they did not. I worked at the public library and then a record store after school, took college courses at John Jay College of Criminal Justice in an accelerated program that my high school offered and attended those classes at night. My "friends" were cops and detectives who were in awe with my academic skill. The "boys [and girls] in blue" replaced my childish stoop companions. I oohed and ahhed at the guns they were allowed to bring in school, and found their police and detective badges to be fascinating. "You mean, you can flash this thing and gain acceptance anywhere?" I had moved out mentally of where my stoop friends were going. They were still focused when it came to school but they were in relationships, and I was still waiting for someone who was not a grown man to notice that I existed. Having been in adult circles both at John Jay and at work, only the grown men noticed me (21 years old and up). They did not seem to mind my muscles. However, I was not allowed to have a boyfriend, so I did not respond much. My high school was predominantly black and Latino/a. Being a girl was taken to another level at this high school, because I am neither black nor Latina.

Norman Thomas on the east side of Manhattan hosted a day care on the first floor of the school and presented itself as a high school on all the other floors. I would only see young brown/black girls entering the day-care in the morning and exiting with child after classes were over. My major was secretarial studies, and I was depressed. I wanted to attend LaGuardia High School for Performing Arts, and auditioned for music (piano) and auditioned for dance, but did not quite "wow" my judges. I was accepted to the High School of performing arts in El Barrio, but because it was so far from home, my parents decided otherwise for me. So here I was, no more dancing, working at various retail stores, and learning stenography and typing. My parents were not thrilled with this school either, especially my mother, she worried about me night and day. My best friend, an Asian girl, was my splitting image. Our major difference was race and location. She is Asian and lived on the Lower East Side of Manhattan. When I first met her, I was hesitant to become friends with her, because she did not look like my Hell's Kitchen girls, and

the Asian girls at my Junior High School were very snobbish. To me, many of the Asian girls at Wagner were the same as the white girls, only Asian. On our Junior high school senior trip, I encountered a girl that was just like me. She cursed, she was tough, and stood up to anyone who confronted her, or me. Immediately we became best friends, and remained inseparable throughout high school. Many people thought the two of us were lesbians. We struggled through high school not having the bodies, not having any babies, and not having any high school boys taking a single look much less a double look at us.

My high school was a fashion show. I always wanted to wear a pair of door-knocker earrings, but the black girls at school and members of the Buttas Club[i] reminded me quite ferociously that I was not black and so, wearing these earrings and/or anything similar was simply being a "wannabe." They would say things like "Look at that pretty good Indian hair – girl you 'aint black please!" The Latinas at school ridiculed me for not having a boyfriend, but because I spoke their language, I was able to assimilate into their social circles. Many of the Latinas I had befriended, secretly called me a *tortillera*.[ii] The moment they would start talking either about their boyfriend or about anything stereotypically feminine, I would excuse myself from the conversation. I would rejoin the conversation should they start talking about Marc Anthony, the salsa singer. What the white girls did in my junior high school gym class, I had learned to be the makings of a girl. Therefore, I attempted the same once again in high school. My first year of high school, I decided that I would change in the locker room from street to gym clothes once at school instead of wearing my uniform from home. That proved to be a disaster.

I was ridiculed for not having painted toenails and not having shaved legs, and for wearing my gym shirt outside of my pants to hide my butt. Once inside the gym, I was ridiculed because of my love for converse sneakers, and wearing no socks or socks pushed down to the ankle. I was told "if you pull your socks to your knee, the boys will look at your legs more." Obviously, they did not know a thing about bobby socks. Nothing those white girls at Wagner did to prepare me for gym, was flying at this school. The girls of color at Thomas were definitely into something else and were doing it differently than I had ever seen. Girls in the locker room were tweezing their eyebrows, and I had a uni-brow. Tweezing hurts then and still hurts today. The first time I was waxed I was eighteen and entering a beauty pageant (more on this later). They applied make up and I was afraid of breaking out so I did not wear it, plus I did not want it on my clothes. They wore their hair out or in long ponytails, I wore my hair in a tight bun, just in case someone wanted to fight, they would not rip my hair out as was customary at this school. One of my gym teachers was a white lesbian that everyone called "Dude Looks Like A Lady!" She would barge into the locker room, and as if she were a man, all the girls would hide from her, or hold clothes up to their bodies when she approached. She was however, extremely nice to my best friend and I, and perhaps she thought we two were also lesbians, for we did not fit the common look. Every time I entered the locker room and the gym, I was teased, looked at funny, or hit with a ball. Instead of physically fighting back (this gets tiring), I wore my long shorts (to my knees), and decided to wear combat boots. I became resilient to the

rules of the dress-code by not following them, and my teacher did not seem to mind that my best friend and I sat on the bleachers eating sour ball gum and never actively participating. I had already learned that I was not to play volleyball or basketball and there was nothing much else to do in terms of physical activities. Every day our male gym teacher would ask to see my feet, and whether it was because I did not pull my socks up, or tuck in my shirt, or did not have on "appropriate shoes" he marked me unprepared. I was frustrated and did not know what to do. My term as a dancer had ended when I graduated my dance program, and I just wanted to get through the awful high school experience and go to college, where the adults at John Jay did not seem to mind what I had on.

I stopped attending gym in high school, and used the resolve of "what really is the point of gym anyway?" Any friends I made there became my annoyance if I were to see them in the hallway, as they would constantly ask "what happened to you today at gym?" As if they did not already know that they too had been part of my disappearing acts, I decided to just cut them off. I stopped going to gym because I was not "female enough" for anyone and not "masculine enough" to associate myself with the boys. That perspective and developed attitude of resistance landed me into failing gym twice, and spending my graduating summer taking two gym classes back to back, where I was forced to pull up my socks, tuck in my shirt, and "act right."

One of two special markers of gender and racial identity in high school that I remember very clearly was my typing teacher. The teacher was the type that you could turn to if you had a personal problem, a woman of color, she understood our struggles or so it seemed early on. One day in class as we typed our sample business letter, one girl mentioned her problem with her boyfriend. As she gave her narrative, all the girls stopped typing as I continued. Clacking away on the typewriter, I thought it would hide me from being called on to talk about the problem that I had no connection to. My teacher asked me to type slower so she could concentrate on the story. I thought to myself, "I will never get out of here alive. Now we're not allowed to do school work in school because this girl has an issue with her boyfriend." The problem being shared was my fellow classmate being mentally ready to have sex, but being still physically scared. Our teacher told her that if he was the right boy, and she feels right, then she should not be afraid. What?! I could not believe what I was hearing. My mother would have crucified her if she had found this out before reading this book. The conversation turned to the environment of the girl's situation and what type of "mood music" would help her when caught again in the same predicament. Double What! This was getting to be as good as my juicy teen novels; only the characters here were brown, black and broke, not white and rich. My teacher then made a joke, "as you long as you aren't listening to Jodeci's *Forever My Lady!* (1991)" then you're good to go." Everyone laughed except for me—I felt out of the loop. I was very much into R&B and knew the song she was referencing but it seemed funny that an adult would encourage teenage sex when the day-care at the school was already flooded. The excerpted lyrics to *Forever My Lady* are as follows,

Forever, forever, forever
So you're having my baby
And it means so much to me
There's nothing more precious
Than to raise a family
If there's any doubt in your mind
You can count on me
I'll never let you down
Lady believe in me

For years in my development as a young girl growing up in Hell's Kitchen, I remember wanting to be more like my older sister who always seemed to be put nicely together and the perfect image of a girl. After failing miserably, and only really picking up her similarities for music likes, I watched my brother closely and began to want to be just like him. He was stately too (they both still are), but had a flair to him that I knew I wanted to emulate no matter what. I tried on his clothes, used his cologne, practiced shaving imaginary hair on my face with a capped razor—and splashing aftershave on my face and I used men's deodorant (his). I sat in his room, and wanted to be in his shadow any time I would be allowed. Some twenty years later, it happened. I became my brother. I have his personality, his smile, his laugh, and his sense of humor, his wittiness and his bad temper and lack of patience. However, I still did not know where I stood in terms of how I should be as a female. When I was in junior high school, I wrote my brother a poem as I often did for my siblings. When I woke up the next morning, he left me a note that read "Babes, thanks for the lovely poem. You can wear my shirt and my belt to school today." It was as though the heavens had opened up and an angel left a gift that I had oh so wanted and for oh so long. I wore the shirt that morning to school, and all the kids wanted to know where I had bought it. He had made me an extra few holes in the belt so that it would fit me, and twenty years later, I still wear that belt from time to time.

Although moments like those were precious to me and rare, my brother moved out when I was very young. He left our home to go off on his own and seek out the truth to his identity. The struggle with becoming a typical girl intensified. I remember seeing the film Lean On Me and noticing the similarities between "East Side High" and my own high school. The similarities were striking. There were fistfights and hair-pullings every day. Fighting was common within the circle on the stoop in my neighborhood, but the fights at Norman Thomas were something of another kind. Kids brought weapons to school. Eventually, Norman Thomas instituted "captive lunch"[iii] for all the students, followed by metal detectors. Girls were hiding razors in their updos, and in their mouths. Guys were bringing knives in their pounds of baggy clothing and I disappeared from the atmosphere. The opening track of Lean On Me (1989), Guns N' Roses' Welcome to the Jungle (1987), struck me. I listened to the song repeatedly, and went out to buy the cassette. Suddenly, I found an album where all the songs were about aggression and none of the songs were talking about having a baby, or being in a relationship.

I found that I could relate to what Axl Rose was singing more than I could KC from Jodeci. However, this genre of music was deemed a "white thing." The one white boy in our school looked like he listened to this type of music too, but he was the only white boy, and for whatever reason he landed in Norman Thomas, I never took the time to find out. He just looked angry all the time, and certainly unapproachable. My best friend and I took in the metal music culture as if it had been ours all along. We bought every magazine, every cassette and then CD, and I had every poster, pillow or other fan paraphernalia possible, when it came to Guns N' Roses. Listening to the songs day in and day out I began to realize that the genre, the lyrics, and the sounds of the songs within my favorite metal bands had nothing had to do with being a woman. I could listen to these songs and never think of my lacking for being a girl, or not having a boyfriend, or any other issue that is deemed "feminine." It was ok to be a girl who was tough, and of color, and still be alive in this world. When people then began to make fun of me because I now entered the gymnasium with an *Appetite for Destruction* t-shirt and because they thought I was trying to act "white," I defended myself and the music by stating "Slash (guitarist) is bi-racial!" It did not matter; they did not care, and the conversation about race in my high school classes were not ready to talk about bi-racial identity. You were either black, Latino/a or "other," and no one really cared what "other" you were coming from.

The way that my teachers, fellow classmates and everyone around me (outside of my immediate family) treated me became instantly different. When I finally attended gym, I wore combat boots instead of sneakers, and I pulled up the socks to my knees just like the teacher wanted me to. My gym teacher did not bother to make fun of me any more. He paid me absolutely no verbal attention, but he watched me like a hawk. I wore my hair loose like Slash from Guns N' Roses. I was able to hide behind my curly mop, but not long enough to hide forever. I was no longer afraid of having it yanked out of my head from a random hallway fight. I was unafraid; I did not care, and hated everyone. The stereotype of all metal music being "devil music" had everyone talking to me from a distance. They watched me…again from a distance, and only commented on me trying to be "white" when they felt safe in a group. Race took another turn. The white boys did not seem to mind that I was not at all feminine—they talked to me for more than five minutes. They paid me lip service about music, bands, shows, and school. One friend that I became very close to (white male college student) became very involved in listening to my drama about school. He was shocked that I came to work every day and on time, but stopped attending classes. My last year in high school was the toughest and the easiest. By this point, I had attended several metal and grunge shows at Roseland (across the street from where I lived). I had completely immersed myself in this form of outlaw culture (hooks, 1994), and felt secure in who I was. The truth was, I lost the pressure to become more feminine like all the other girls of color.

Right before I graduated high school, I received a letter in my locker. It was from a Latino who I watched everyday. I admired him, I liked him, and more than anything, I spent months wanting to be in his circle, but knew I could never. I knew

that I would never be part of his circle because of the way the girls that were in his circle looked. They hung off of him, tugged at him, tossed their hair near him, batted their eyelashes in front of him, and he seemed to have them all dangling off his imaginary string of masculinity. I could not hang out after school, I had a job. I could not come to school early to hang outside of the school with him, I lived two bus rides away, and I was not allowed to have a boyfriend anyway. The letter declared an undying affection for me, and the realization that he wanted to get to know me. I showed the letter to my older friend (white male), and had him analyze it. He told me to be careful, and I hesitated to take his advice. The letter asked me to call him as soon as I was able to, because he wanted to talk to me. I showed one friend from the stoop circle that still talked to me, and asked her advice. She said that it was about time someone took an interest in me at that school so "full of cute boys." She urged me to make the phone call. When nervous, I usually pulled out my Guns N' Roses or Metallica CD for soundtrack-to-my-life music, but she was not into that "devil music" and did not allow me to play it. I went up to her apartment, and she brought the home telephone into her bedroom and closed the door. We called him and his cousin answered. We spoke in Spanish, and his cousin, who also attended our school, told me that it was about time that I called, and how long they had been waiting for me to call. His cousin then asked if I would help him with his global history homework tomorrow before class. This was shocking, neither the boy, nor his cousin ever spoke to me in class, or outside of class, and now they wanted help with their homework? True, I had a 98 average in the class, but no one ever spoke to me. I looked at my friend (who look puzzled at the conversation) and shrugged my shoulders. She urged me to keep asking him questions. When the boy came on the phone, he said in his beautiful Dominican Spanish "¿Quien Es?" I was so nervous I could hardly speak. I said my name and he asked "who?" I repeated myself and he said he did not know who I was. I told him about the letter in my locker, and he started laughing. I could hear the laughter in the background too, it was getting louder and louder. He told me that his cousin wanted help with his homework, and that they all knew I liked him so they thought they would prank him. The next day at school, the boy and his crew, including all the girls were hysterically laughing when I passed them by. My best friend told me not to pay attention but I could not resist. I stuck my middle finger up to them, and mouthed something filthy while beginning to wave a flipped finger from side to side. His girlfriend approached me later that afternoon and tried to tell me off. She told me that no boy would ever like me because I was "just like a boy," and unless he was gay, I was not going to get anywhere. She then began to explain to me, pointing at her pregnant stomach, "see this? Only girls can do this!" I laughed at her and reminded her that she would now have a lifetime reminder of her problem (referring to her teen pregnancy) and for that I was thankful it was her not me. Although my response was tough, and I laughed loudly, looking at her as if she was stupid, I felt horrible and embarrassed at some level.

Although I tried to hide behind hair, my heavy-metal t-shirts and combat boots, the fear of being found out as a physically developing brown girl was still very much prevalent. I punched in at the library one day for my shift, when a white male

co-worker was standing with a few other co-workers, both male and female. I entered the locker area to hang up my jacket, when he turned around and asked, "Have we started bra-stuffing?" The heat rose to my face, and I thought brown girls could not show their blushing, but I was wrong. I felt my face turn hot and my ears, I thought would burn off my head. I could only muster the nerve to respond, a few inappropriate profanities. He laughed and threw his blonde bangs out of his face. He then proceeded to comment, "I was wondering when you would let everyone know you are a chick! I mean black girls are not flat and they are certainly not rail-thin like you. I knew you had something under there. Now maybe we can look at you." I was so embarrassed and felt like crying, but I would not let this happen again. I instead told my supervisor, an older black woman who was the epitome of feminist nerd. I loved her and because she had no children, she took a sweet affection to me as well. The next week my tormentor was fired. One victory to go, about a million left to encounter.

The one "guy" that did pay attention to me in that intimate – boy likes girl, girl doesn't like boy back type of way was one of my teachers. An older white male. I thought he took special interest in me because he saw my struggle to fit in and my complexity of hating the school itself. I thought he cared because I was failing math and needed to graduate. I was wrong on all fronts. The man would slip me love letters during exams. In his letters, he declared his "love" for me and how he wanted us to have a "relationship." While I felt good that "a boy" was paying attention to me, I knew that he being in a position of power and two being much older than me and him being a white older man, it was all wrong and it grossed me out. He told me things such as "I love the way your green shirt caressed your café au lait body yesterday and your lips looked drinkable like fine wine." I stopped going to class. He then attempted to give the letters to my best friend who would pass them on to me the next morning or read it to me on the phone that night. After my guest appearances in class became chronic and my development of a tougher attitude towards him heightened and intensified, he ridiculed me for being "robotic" when talking to him and eventually became frustrated with my lack of response. I decided to give the letters to my mother. Apparently, she was not the only parent to be faced with this issue and this particular teacher. Students were told he was "fired" mid school year. Many years later, the urban legend around the school was that one of his students had actually given birth to his third child. My friend and I saw her years later pushing a stroller with a biracial child that was her own, his, hers, theirs. I like to believe that my less-than feminine approach to this dilemma protected me in this instance. It gave me the courage to give my mom his letters instead of being blinded by perverse flattery. At this rate, I would never get a "boyfriend" who understood that I am a girl, a woman, a lady, but that I did not aspire to be typical or average!

By the time I started college, my relationship with my friends on my stoop had completely disseminated into nothingness. None of us were speaking to each other, although I still lived in the same building as they did. For years, I mourned our break up. I had no cushion any longer. No other girlfriends to share what we had, and how we had shared it, and no friend could come to understand who I was they

way they did. Each time I climbed the steps to my building, I felt my throat hurting and burning, the way it does when you are about to cry. Then I became angry. I was determined to show them that I was okay on my own, and that as they had not needed me, I too did not need them. If I were to work my way up from the basement of the building to the sixth floor, I would remember each of the friends on each floor becoming pregnant at early ages. When my best friend realized she was pregnant, I was the first she came to. We exchanged advice, me at eighteen, she at sixteen. Her mother wanted her to have an abortion, but she wanted to keep it. What did I know at eighteen? I told her to do what she thought she could handle in the near future. Through her pregnancy, one of our other friends took on the role of sister/girlfriend/Godmother, and I was crushed. It had been said that she too was pregnant at one point, but sent back to her parents' native country to give birth and have the family over there raise the child, so that the family here would be without shame. This must have made them feel more of a connection, since I had no children, nor had ever been pregnant. They turned into super girls overnight. Sharing secrets about pregnancy, weight, maternity clothes, and the guys that were either worth it or not. I went to class, to my job and then back to class. After a few months of watching my friend get bigger and bigger, she completely stopped speaking to me and so did the other girl. Many years after I had moved out of the neighborhood without telling anyone, I bumped into my friend. She told me she had a girl, and that our other friend was chosen as Godmother. Our friendship at that moment had finally come to a close. It was said to me that they stopped speaking to me because I did not have any similar experience(s). What they should have blatantly told me was that I never became the girls they went on to become. To me, suddenly our circle instantly grew up. They had children early, they became young mothers, and I was becoming something else.

Many of my friends and best girlfriends from my neighborhood and from junior high school went on to have children. It was like an epidemic that many girls of color were facing. Having children turned them into mothers and super-women (Michelle Wallace's definition). They physically developed overnight. They had more attention from guys once they had their children. They had adult responsibilities, and somehow I went back to the junior high school moment of being a nerd. I went to school, then onto college, then onto an Ivy League institution for my first master's degree then on to my Ph.D., I have not seen one friend since that moment. For years I missed them. For years, I reminisced with new friends about my old friends, but somehow it was just not the same. For years I longed to be in their company, and since that longing, for many years I realize I had outgrown much of the things that I held dear, I only needed to learn how to let go. I had felt for many years that my love for and semi-addiction to teen novels in particular teen series novels, resulted in no longer having a desperate need to become a "feminine" girl because I had read so much about them in novels. I knew of their trials and tribulations, I knew of their stereotypical behavior, and while none of the real-life feminine females had befriended me in any stage of my schooling, I had my feminine sister, and I had my characters from my novels who always accepted the person I was because they could not see me.

CHAPTER TWO

GRADUATE SCHOOL

Being from Hell's Kitchen is how I usually identify myself. I always state that I was "born and raised in Hell's Kitchen." I love those memories. I fought with boys, fought with girls, played roller derby, full body contact freeze tag, and shied away from games like house, doctor, or hopscotch. To me, they were "weak." Only the girls who wore dresses played those games (I was most of the time in a dress!) Only the girls who allowed their pigtails to be yanked by boys played that game, and it was always the girls who were too feminine in the movies that were killed by the crazy maniac. Therefore, I had to be different. I could have become a really feminine female, had I learned how to do all of those things accurately, and I knew how those roles operated but did not want to show my "weakness."

By the time I moved to Corona, Queens in 1999 I was already attending graduate school at Columbia University. Gender, racial and class lines were always at the forefront of every class discussion. Although I was in a Black Studies department, I was torn between my tri-culturalism, the way I approached things as a strong woman and my longing for friendship among "girlfriends." Becoming close to women in graduate school is the epitome of Paulo Freire's theory of "false generosity" (Freire, 1970). I was befriended as a study buddy, but not as a true friend, and once again, I longed for my friends on my stoop. The women in my program with the exception of one were all coming from quasi-elite families. They drank merlot, they pimped their membership to famous and elite sororities, dropped names of famous people at "dinner with my family last night," and drove luxury cars given to them by their parents to "get around." The more I rolled my eyes at these types of situations, the more I wondered where I fit in. Again, I did not. I worked hard, I maintained my magna cum laude academic status, I had several work study jobs simultaneously and had nightmares about my Ivy League loan that my mother took out for me, and nine months later graduated with a master's degree in African American Studies. I became a pioneer of sorts and was proud of my accomplishments. Gender did not seem to matter with all of the accolades following close behind. The times I was reminded of gender trumping race was during our social "networking events" or "mixers." I will never understand how something can be called a "mixer" when it is a simple mix of all the same ingredients. Affluent, or bad imitations of affluence, largely borrowed vocabularies, ivy undergraduates and now ivy graduate students, all talking about the same thing, all at once, in the same place and in the same manner. What was that a mix of? During one "mixer" I brought a really close friend not in graduate school, and not an Ivy League graduate student, he is gay, affluent and white. I watched carefully as all the girls of color ogled him and his articulation of difference. They all asked him to dance, wanted to be close to him, and none of his differences seemed to matter. They danced by swaying side to side, in this monotone, stiff-as-board, fake-drunk type of motion. When he and I got onto the dance floor, we were all over the place, bumping, grinding, and carrying on quite lawlessly. I could feel the weight of everyone's eyes on me. Not on him, but on me. Clearly, I was no marker for Ivy Mixers! The women bounced from man of color to man of color, bubbly, toning down their vocabulary and expertise, to

engage in mindless conversation that would not compete with any of the masculine ideologies. I watched, as many of these men would engage in what bell hooks would call "Plantation Patriarchy" (hooks, 2001). Any of the men that approached me, boldly asked whether I was indeed a lesbian, as though they were attempting to prove the rumor true. I never figured out whether it was my company, my sense of intellectual security, or the way I challenged every idea brought to me by one of their strapping bodies.

Working on my doctorate was another issue to face when it came to race, gender and class. My program was filled with white women, both lesbian and straight, white men who were non-confrontational, and black men who found themselves as friends of mine. While most of my three years working on my doctorate have memorable vignettes, there is one in particular. During a class on the history of education, the professor asked whether or not anyone had any questions. A white female classmate raised her hand and stated, "Well this is not really a question, but I just wondered if you (to the professor) realized that you silence people! I mean here's poor little Regina who always looks like she wants to say something but never does. It's like you don't want her to speak!" As the blood boiled somewhere between my heart and my stomach, I struggled with my reaction of disbelief. The professor who also looked shocked asked me if I would like to respond and I immediately said "yes thank you." "Excuse me! I don't need you or anyone else to make a case for me. What I do is listen. I listen to you, I listen to him (the professor) and I listen to what everyone else is saying, and unlike some of you, when I have something worthwhile, intellectual and credible to offer, I will speak. Thank you for your concern, but I can handle my own!" I had analyzed the situation as one, where this particular white lesbian believed that the "poor little girl of color has no voice because we are all white in the room except for her." She infuriated me. The audacity she had to think that we were still living in a world where the white woman protects her mammy because she raises her child without dispute. How dare she? The professor looked proud as in defense of myself, he was obviously being defended as well. As she began to attempt her apology to me during class, I raised my brown hand and responded, "please!" She never spoke to me again, and every time after that incident, she never looked at me face to face. However, soon after that, many of the white women stopped looking at me. They did not acknowledge my presence whatsoever. She had stereotyped me as being one of the "inner city kids" that she worked with at her after-school program. She must have thought, based on her work-related population, "they are all brown, so this one, although she made it to a Ph.D. program must still be lacking somewhere in her life, and since I am white and privileged, I imagine I should help her break free from her oppression." Only in Spanish could I describe the rage she ensued in me, but in the world of my doctoral program, not one person in my circle spoke Spanish, so I would hold in what I really felt for years to come.

Thinking about all of these episodes, I could not decide which was worst: (1) Having elite black women think I was from the "ghetto" and joining a sorority or going to elite mixers would help break up that tough exterior a bit, or (2) Having white women, both lesbian and straight, believe that they owned my voice and

would help me break out of my shell that they believe, most people of color mask with rage and anger. This world was nothing like my stoop. Girls on this front were very self-absorbed, and route memorization of some of the most important academic texts of a scholar's time, proved intellectualism instead of good memory. Thank God, I lived off campus both times. To try and become a *real* graduate student and take off my "nerd coat" for once, I attended two "mixers" one at Columbia and one at the Graduate Center. Both caused me a terrible case of the yawning and anxiety. I had confused "mixer" to mean "party." When the music came on, everyone remained seated. They drank and drank and drank and while drunk remained positioned in their seats or standing on unsure feet. The conversation was about professors and their private lives (dirt on famous people). Wine and cheese circulated, no one smoked cigarettes, and the white boys threw their ties over their shoulders to eat. Black women wanting to be in the company of the white boys flipped their weaves from side to side and laughed at corporate America jokes. Having brought a small entourage of my own, I asked my friend, (male white and gay), if he was ready to leave, and he responded to my question by grabbing both of our jackets. Not having gone to graduate school himself, he declared to me in his car, "thank God you don't act like them even though you go to school with them." We made a u-turn from the "mixer" location and went to a real party.

The downfalls of all of this? Not many. I made in-the-meantime friends during graduate school, particularly at Columbia. I became close to my Dominican best friend there, again a male. I remain friends with two people from my doctoral education, with the addition of my two mentors (husband and wife). Through their friendship, I got through many of my classes and many of my experiences with racism and gender bias during graduate school.

GRADUATING WITH A PHD

In my doctoral program, we were required to take a statistical methods course. I could not fathom why qualitative researchers were required to take quantitative methods. My professor, a black female was my ultimate nightmare. From day one, this woman hated me, and my paranoia with people being against me confused my accurate judgment. People told me she liked me and wanted the best for me as a fellow woman of color, and so for some time I believed that her attitude towards me was an act of "tough love." Negative! Having read and adopted *Pedagogy of the Oppressed* (1970) as my guide to survival, I knew that something was wrong with my relationship with this professor and her skills or lack thereof as an educator. She taught her class for two hours by way of PowerPoint slides. I took notes from PowerPoint slides just to keep awake. During one class session, I got up to use the bathroom and she stopped her lecture to ask me the following "can't take it Regina? Going to smoke instead?" As the class, full of white people, snickered at her comment, I responded, "something like that!" I walked to the bathroom, looked at myself in the mirror and counted to ten. What would it take to hold back a Hell's Kitchen type slap across this professor's face? Would I have to recount Neil Diamond's *I Am I said* repeatedly in my head to give me the strength? All of this

would temporarily help; I still had four months to go. She let the class know that I had failed her exam because I "don't participate in class." She called on me during class for answers she knew I could not give. She asked during a session, "Regina, what do you believe the answer to be?" I responded in all my frustration, "I have absolutely no idea, and this you already know." The class erupted in laughter. I did not care. She looked more ridiculous picking on her own than me not knowing a simple answer to the "median score of whatever she asked."

Humiliated, frustrated and just simply angry, I arranged a meeting with my chair to let him know that I needed to drop this class, because she would ultimately hurt my GPA, and knew there was no way she was going to let me pass the class. He denied me the drop, stating that he (1) "did not want to get involved in between two black women as a white man in a leadership role" and (2) "she says she likes you but that you have to work harder." I could not believe this was happening to me. This was my tuition, paid in hard earned cash every semester depleting my savings account of years of working for corporate America and tips saved from serving hot coffee and pastries for hours on my feet. His refusal defeated me, and it took me years to figure out and really understand why he refused to intervene. I remained in her class and she somehow knew that I had had a meeting regarding her treatment. Days later, the professor emailed me a letter-length statement about my "inappropriate performance as a graduate student." In her email, she stated that my "behavior in her class was not that of a good graduate student" and that I "should certainly take her [my] words into account and do something about myself." I made an appointment to see her. Although I had an appointment with her, she took every white student waiting for her before she saw me, leaving me with a ten-minute meeting. I sat in the waiting area with the flu, practically fainting. When she motioned for me to come in she asked, "Are you sick?" I coughed my response and she waved her hand in a no-no fashion and said, "Don't get too close." During my meeting about statistics, she asked me if I had a good relationship with my parents, was I abused by a partner, was I a lesbian, and the list went on for minutes on end. Rage masked by exhaust and the flu, I began to cry. She had broken me down. I was in this woman's office for twenty minutes hysterically crying because I could not understand why she was putting me through this. She handed me a phone number of a shrink and told me that I should call this person, her friend, a shrink, to work out my issues. "You'll be better after you do Regina." I took the card, threw it in her garbage on the way out of the office, coughed in my hand, held her door handle with the same hand, and exited. She did hurt my GPA in the end. She knew of my goal of maintaining a 4.0 all throughout my doctoral work, and she brought it down significantly with a stroke of a letter. The following semester, and my last, she stopped to ask me how things are going, I responded, "oh so much better, I do not have quantitative methods and have seen hope again" and I walked away from her.

After much analysis of her manic behavior, I came to realize that she did not like the fact that another woman of color was in her class, who was also an educator, close to getting a Ph.D. and someone who obviously did not have an abundance of friends. My two other friends in the class were black male and failing

and she gave them hell as well. In fact, although the three of us were failing, she put us together for a final group project. Instead of allowing a passing student to join our group, she kept our group small at three, all of color, all perplexed by her PowerPoint-based pedagogy, and all failing her class. She commented during her lecture once to a white male student, "Oh my God, I'd never realized your eyes were so blue. Just like the ocean water." As he turned red from embarrassment, I turned red from rage. I looked around the room at the other people of color and watched embarrassment, anger, and confusion race across their faces as well. She had made her membership very clear. All the people of color in that class were doomed after that comment it seemed. What a confused woman she is both racially and perhaps with gender as well. I hope that the same card she had given me to use for help for my "issues" is one she has considered using.

WHY BLACK AND BROWN WAVES?

I wanted to write this book because of these experiences and others that are worth mentioning but within the context of other chapters. After having gone through these episodes in my own life, and becoming a college educator, I see other young women of color who go through similar experiences. While very different lives they are leading from my own as I was coming into my own adulthood, there is still a lack of voice. Only in the classroom that is based on "of color" studies, be it Black or Latino/a studies, do they feel empowered. Their perspectives as women and as women of color cannot and are not voiced in their other classes, whether core or elective requirements. More recently, right before I received the opportunity to write this book, I had been asked what class I would like to teach in the upcoming semester, and I responded "Women of Color in the Americas." What a perfect pair, writing a book and teaching a class on the subject would prove easy right? Wrong. For the past three months, I have encountered more intense emotions from young college women than I had ever seen in all of my six years of college teaching. I have watched these young girls of color, my girls of color, weep in class during one of their powerful monologue type of reactions to the reading. I have been kept silent by the enormity of "humor" in the voices and commentaries of young men, both of color and white, when analyzing the social experiences of women of color. I myself have shed many tears when re-thinking the dilemma I continue to face, and the foundation that only our mothers of color can lay for us to safely tread upon.

These young women are powerful, drained by the images they are subjected to and are prescribed, many of them have walked into my class looking for a new perspective, attempting to change themselves and develop a new form of strength, and some of them are still living double lives. By double lives, I mean perform in my class as a leading model of young, of color, female and incredibly strong; and while away from my eyeshot still flipping their hair, batting their eyelashes and hoping a man will open the door for them and pay for their first meal together when on a date. I do not feel as though these two lives are wrong, what I do feel is that they need investigating and need to be broken down so that many women do

not feel that their feminine qualities or that their femininity needs to be closeted. My only hope is that both lives are equally strong, and femininity becomes less confused with weakness as it had been confusing for me, and that they understand the interpretive consequences of those dual lives they lead.

THE PINK NIPPLE SYNDROME

AN ANALYSIS OF YOUNG ADULT NOVELS

Since the days of Judy Blume's *Forever* (1975), teen novels and young adult fiction has sexually exploded. *Forever*, God knows was better than *Little Women* (1868) in terms of "juicy" content votes. Blume's book was being passed around my elementary school and Junior High School like an airborne virus. By the time I got it, it was crumpled, wrinkled, yellowed and the pages were fringed. Half way through it, I understood why the book was in that condition when I received it. This definitely was not on my required reading or summer reading lists. Nor was it ever available in the public libraries (always checked out!). I had always been a fan of Blume, and when I read *Forever*, my membership detonated. I wanted to read more, and waited with baited breath for her follow up novels.

After reading the book and talking about it with a small circle of elementary/junior high school friends, I realized something very interesting and intense. My friends could be found in the school bathroom flattening their shirts against their puny torsos examining their breasts. Girls were wondering why their nipples were not pink but dark ("something must be wrong with yours!") No one was worried that exposing themselves to other girls in the bathroom would be something that equates to being a "lesbian," they were more concerned why they looked different than the characters in the books. The book also gave interesting standards as to what to look for when it comes to the ideal boy or relationship. In response to the love story demonstrated in *Forever*, one reviewer writes:

> Those who have already experienced their first love will inevitably compare. In my generation nice girls clung doggedly to their virginity and our reactions are apt to be tinged with regret, i.e., we missed out on something truly beautiful. Girls still looking forward to their first love will revel in anticipation, though in real life it is highly unlikely that many of them will have a similar experience (Nielsen, 1976).

I suspect the author to be referring to the actual romance in the relationship or the sexual experience for the first time that the protagonist Katherine engaged in, which was emblazoned with so much love and learning. In her generation, girls were obsessed with holding onto their virginity. What is missing from this commentary are the social dynamics that change the way we see these experiences from a variety of young girls. By the time I was in high school, many of my friends were already mothers, and if not mothers, at least pregnant. None of my high school classmates of color giggled about their first time, and for many, their pregnancy resulted in their first time, and for them, that first time was hardly a memorable

experience, given the result of a child and all that comes with being pregnant and at school simultaneously. In no way should it be assumed that race affects these types of decisions about one's sexuality or sexual experiences, however, it should be taken into serious account that environment plays an important role in these types of decisions. Although many of the girls that I went to high school with, read *Forever*, by the time they got their hands on it, they were beyond their first sexual experience, and were already giving advice to their friends on what to do when they feel contractions or cannot stop urinating during pregnancy.

Nielsen also suggests that if girls did not have access to Judy Blume's novel, then another recommendation would be *From Woman to Woman: A Gynecologist Answers Questions About You and Your Body* (Lanson, 1975). We are now in the year 2008, and many young girls are not perusing the shelves of their local library for books on sex, they have ample access to visuals instead.

However, I can speak on the experiences I had with young white girls in junior high school. They, unlike my high school classmates, giggled about their sexual experiences. They, in fact read the novels in discussion here, and passed it around from female friend to female friend. They did compare notes about boys who they had sex with and were present during gym class, they did compare breast size, and pubic hair, and they were obsessed with releasing their virgin-status to the boy who worked hard enough to get it. Being one of a handful of students of color at my junior high school, I wondered if boys were looking at me in the same way. Why would they? The boys in the books are white, and the boys at this school were white, and the other brown girl present during these conversations believed she was part of this circle regardless of race, and shared just as explicitly as they did, and with the same white boys that were in question. Sure, I found the white boys equally as attractive, but did they find me that way? As part of the heavily guarded family structure that I came from: (1) I was not going to have any sexual experiences with anyone at the age of sixteen, because I was afraid of what my friends from my neighborhood had shown me as proof of a "good time" (their bellies and graphic descriptions about childbirth, and what happens to a woman's vagina when giving birth); and (2) everyone knew everyone else's business. In my neighborhood, you know who had sexual experiences with who else, but no one ever spoke of it so flip-like. We gossiped, but that was the extent of it. Girls who had sex, went on to have more sex, and bring back war stories about how much it hurt them, and "I wonder what my mom is going to say when she starts noticing my belly."). All of this was like a real-life horror movie for me. I wanted to be able to contribute, but not in this way. The fear swallowed me on a daily basis, and what did not frighten me, made me anxious. Ever seen a brown girl turn red with embarrassment?

Although the books such as *Forever*, were fantastic, descriptive, addictive, and applicable so many years after it had been written, there was something not quite right about how brown girls were seeing themselves through the text back in the 1980s. Blume's characters were white girls with appropriate Ken-like of Barbie and Ken boyfriends. We were trying to see ourselves through a white girl's life experience(s). In no way do I fault white writers such as Blume who were and still

writing from personal experience. How can you write about dark nipples if you do not have them? The larger problem can be understood in four parts: (1) How are the books promoted and what is readily available for young women of color to access from public libraries or buy at local bookstores, (2) what types of faces are on the covers of teen magazines or these types of "juicy" novels, (3) what are the authors of color writing about and how do they apply, and (4) are we complacent in segregating reading(s) and/or literature into groups of either shared or separate struggles, and ultimately directing young women towards novels and magazines that may or may not present our experiences accurately.

A walk through Barnes and Noble, or Borders Books and Music stores presents a simple answer to part one of the larger problem and/or question. The magazine section at any of these two stores, are huge, and inviting with their color pictures, variety of readers standing before them, the celebrities plastered on each cover, or extremely handsome/beautiful models. However, on the teen magazine covers are images of the same type of girl; she is white, looks thin, has flat blond hair, piercing blue or green eyes, a heavy packing of make up on her face (but looks natural), and if not famous by my standard, is famous to someone somewhere who needs a heroine or a hero. You can find a gang of young girls of all races and ethnicities giggling as they unfold the pages of their favorite pop-star studded magazines. It is almost like porn for teens the way they peruse these pages back and forth, until the pages of the magazine become wrinkled and fringed from their sweaty little paws. Did I do the same? I guess I did. I pined over pictures of Prince, John Travolta (Grease Days), El DeBarge, Michael Jackson, and Slash from Guns N' Roses, until they too, had been replaced by something and/or someone else.

Moving away from the periodicals, one can head over to the teen novels section. Despite the huge variety and section dedicated to Manga, you will find a cluster of Asian and Asian-American teens, actually reading the graphic novels, still in their cluster. Large cardboard stands presenting new authors, the new installation of a particular series, and new releases. The books all look the same. A stack of books on the dark side (vampires, witches, witchcraft), at one end, and then the light-pink binding of novels that are geared to the young female reader. The covers of the majority of these books are impressive with their eye-catching fonts, and of course the cover girl. She is young, white, looks naughty or innocent, and has blond hair, an enviable teen body.

Obviously things have not changed all that much. The *Sweet Valley High* (SVH) series in the 1980s featured the same looking girls on Francine Pascal's covers as well. Every girl I knew, wanted to be either Jessica or Elizabeth, the lovely blond haired twins from the SVH series. The difference between other books and the SVH series, range. These girls had crushes, and dates, and cars, (same as others), but they were not having sex, and this proved much safer and calmer for populations that needed easing into the adult world of sexually-explicit reading materials during the 1980s. Yet, these girls were white, and their experiences still did not mirror anything I had ever experienced. Maureen Daly's *Seventeenth Summer* (1942), still receives rave reviews some sixty-six years after it was written. The book has often been compared to *Forever*, as a comparable love story,

the only difference between the stories is the explicit sex. *Seventeenth Summer* is often described as a pure, innocent, and a "true love story." The extent of the protagonist's "bad-girl" experience(s) is her drinking beer and feeling flabbergasted over holding a boy's hand, albeit in public. Indeed, the story is pure and sweet, and is a gentle introduction into the world of a teenager's first romance that lends itself against a summer backdrop. However, the idea of "pure" does not find itself among a popular audience of young girls in 2008. In no way have I read every single teen romance novel. However, where are the young girls of color and how do they play a part in these novels? Are their experiences not pure? Young people oftentimes emulate what they are exposed to, and if these texts stray away from being inclusive of a universal or at least semi-shared female experience(s), how is anyone to understand the experiences of all young girls? Alternatively, do we remain satisfied in segregating these experiences? If segregation is key to understanding varying experiences among young women, then the experiences of brown girls must be made readily available as well.

After offering insight on *Forever*, Neilsen also went on to comment on *Fast Sam, Cool Clyde and Stuff* (Myers, 1975):

> It is a rich, warm story about Black kids in which Myers makes the reader feel so close to the characters that ethnic group identification is secondary [...] One of the nicest things about the book is that it is so hopeful. The kids live near drugs and welfare checks but the reader finished the book buoyed up instead of depressed (Nielsen, 1976).

The context of *Fast Sam* are Black kids who *should* be depressed from living near drugs and welfare checks, but instead they are "hopeful." It could be a love story, as pure and innocent as *Forever* and *Seventeenth Summer*, unfortunately for the Black kids, the book's backdrop is 1970s Harlem, New York, surrounded by drugs, welfare, and young criminals. It is not interesting why the three books are used in comparison. *Seventeenth Summer* opens up with:

> I do not know just why I'm telling you all this. Maybe you'll think I'm being silly. But I'm not, really, because this is *important*. You see, it was different! It wasn't just because Jack and I either—it was something much more than that (Daly, 3).

Forever, opens up with:

> Sybil Davidson has a genius I.Q. and has been laid by at least six different guys. She told me herself, the last time she was visiting her cousin, Erica, who is my good friend. Erica says this is because of Sybil's fat problem, and her need to feel loved—the getting laid part, that is (Blume, 9).

Fast Sam, Cool Clyde and Stuff, opens up with:

> I remember when I thought modern science wasn't nothing but some jive stuff, and that was because the only thing it ever did for 116th Street was get everybody into jail. And on 116th Street we could get in jail being downright

primitive—we did not need new ways. I wasn't the only one in jail so do not think I'm just getting things off my chest either (Myers, 16).

The dialogue of purity and of first love is hardly apparent in all three texts. Both Daly and Blume's character entrances lead one to immediately wanting to know more about what happened to them. For example, why does Sybil Davidson have a fat problem? This wanting to know more is something both girls of color and white girls alike, want to hear about in these stories. However, with Myers's text, you are immediately put on your guard that there is a difference. You know that it is Harlem, you know it is taking place during the 1970s, and very clearly do you understand that the neighborhood is rough, as the narrator is in jail, and believes modern science to be "jive." It is disappointing almost that Nielsen (1975) would use this text in comparison to Blume's first love novel. Indeed there is first love in *Fast Sam*, but the backdrop is less than pure, and the experiences less than soft or warm, leaving you with no desire for any of the characters to enter your own personal black book. Young adult librarians suggest that if *The Coldest Winter Ever* (Souljah, 1999) or a similar text is not available to a teen of color, one should suggest *Upstate*, written by Kalisha Buckhanon (2005). The book is almost similar to *Forever*, in that there is a first love centered in the text. The difference, besides the main characters both being black, and this being set in Harlem, is that the love between the two takes place with the girl at home, and the boyfriend who is in prison. How in the world does this seem comparable? A first love between a young couple and the description of intensity that leads up to their first sexual experience together is being compared to a young woman of color who has to deal not only with first love issues, but with the first love being in prison.

In 1999, Sister Souljah wrote *The Coldest Winter Ever*. A novel that turned bestseller almost overnight. Fans of *No Disrespect* (1996), could be found at sidewalk street vendors huddled over their make-shift table, reading the back of the book before handing over their $7.00. The book was always sold out of the local Barnes & Noble, and usually in circulation at the New York Public Library branches that had an actual copy. The novel is set against a backdrop of housing projects in Brooklyn, and brings to fame Winter Santiaga, a teenager who is bi-racial, (half black and half Puerto Rican). Winter's father is a notorious drug dealer, but this does not scare the protagonist or the reader, in fact, it strengthens the exciting quality of the main character. Winter is able to have anything she wants, and anything that is current, which includes material items such as clothes, cars, and other material accessories, such as boys and later grown men as well. Her sisters are named, Lexus, Porsche and Mercedes. A major drug bust sends Winter's father into prison, her mother into a life of drug-abuse, and eventually Winter's world comes crashing down, and spirals completely out of control. No sign of a first love that is pure can be found in the book. Her entire world is disruptive. Although the text, all 337 pages of it finds its way towards a fantastically written moral ending, many young women did not get much out of the ending as they did to the series of exciting events which led essentially to this young girl of color and her demise.

Winter does have a "love" scene in her narrative. It is not central, nor is the book about a first love, or a "first time," but there is an intense sex-scene in the book. While there is one pivotal sex scene between Winter and another character, there are explicit sexual references throughout the text. This idea of *the* first time, love-centered, emotionally painful, yet pure and innocent does not exist with this character. In October of 2008, Souljah will release a sequel to *The Coldest Winter Ever*, named *Midnight: A Gangster Love Story* (2008).

Again, I have to reiterate, the quality of the text. *The Coldest Winter Ever* was one of the most interesting and well-written novels in this genre. I have since assigned the novel to my undergraduate students in Black Studies, several times. They absolutely love the text. My students that have read Souljah's book notified me with excitement that Jada Pinkett-Smith was working with Sister Souljah to produce a film version of the book. What many have gone away with based on what is written for the target audience of young women of color is the assumption that young women of color are not experiencing purity. They do not have first loves that give them butterflies, and their entire lives are led by this type of no holds barred attitude and experience(s). I understand that most people want to live an exciting lifestyle, and when it is not happening, we turn to magazines, books, shows, and other people's drama and live vicariously through those options. I also understand that most people want to relate to what they read and part of my argument in this chapter is that many of the teen books presented today in bookstores and wherever books are available, does not apply to young women of color. Does this make it easier then for young girls of color to gravitate towards books that have white female protagonists, who experience this type of purity when falling in love and having semi-adult experiences? It is also interesting to note, that these same books that are geared towards young women of color are not always in the "Teen" section at the bookstore, but rather are in the "African American Interests" section. On the other hand, if you know of the author, just check under their last name in the integrated literature section. Who really is better off? The fan of *Forever*, or the fan of *Coldest Winter Ever?*

Books like *The Coldest Winter Ever* have been classified under a new genre of novel-writing called "Street Lit," "ghetto," or "hip hop fiction." Hip Hop seems to always withstand the worst negative attribution. Megan Honig, a public librarian in New York City defines "Street Lit" as:

A genre that speaks to teens and adults in their twenties and thirties, particularly African American and Latina women in urban areas. Street lit has been criticized on political, moral, and literary grounds, but it is nevertheless immensely popular and has become a significant genre for many otherwise reluctant teen readers. Like it or not, the inclusion of street lit is becoming an increasingly relevant part of urban library teen services" (Honig, 207).

It goes without saying that getting young people to read is of great importance, but are all teens reading the same thing? Are the young girls and their experiences that are portrayed in "street literature" books universal? I have critiqued *Forever* and *Seventeenth Summer* as books that may misguide a young woman of color; leading

her to look for pink nipples. Yet, *Forever* has a rich quality of losing yourself in the race dialogue or thought process and allowing one's self to be led by imagination and fantasy, if not looking towards a hopeful future of love. In Blume's books, a female reader, regardless of race, will more than likely envision herself sharing in Katherine's experience or at least being hopeful that she too may have a first time as memorable as Katherine's. With texts that fall into the category of street lit, it is apparent that it is geared towards an older audience (at least older than 16).

After over fifteen visits to various Borders Books and Music, and Barnes and Noble stores, I could not find any of the street lit books in the Young Adult or Teen Sections. They were all either in the African American or mixed in the literature section. Although I see some teens perusing these two sections, they are mostly searching for required reading school texts. As I have stated earlier, books that depict the lives of young girls should reflect, a bit of who the reader is as well. The reader should feel a bit connected to one or all of the characters, and this could be the case for *Forever*, *Seventeenth Summer*, as well as *The Coldest Winter Ever*. However, street lit books are being almost shoved down the throats of young girls of color, because the assumption is that they do not like to read, and if they are reading, they should be given something relative to their lives. Is there a possibility that this plan or mode of operation could work in the reverse, in that young girls of color that read white-teen novels will want to live out the white teenage girl fantasy or lifestyle? Or, could it be feasible to think that young girls of color may want to live out the fantasy of becoming a "gangsta's girl" by reading examples in street literature? "The language of these books is rooted in and from hip hop culture. It is linked to experiences people understand, experienced or aspire to experience. These books are about identity development" (Burke, 2008).

Miranda Doyle, another young adult librarian decided to ask "what magic ingredient makes these [Street Literature] novels so popular?" (Doyle, 174). In order to answer the major requests of young African American girls who have read *The Coldest Winter Ever*, and are in search for similar readings, Doyle put together a checklist of what she calls "seven essential characteristics present in the most popular books, based on conversation with teens." (Doyle, 174). Allow me to list them for your review and offer a critique as well:

1. They feature an African American teenage girl in an urban inner-city environment. It's no surprise that patrons like to read about characters like themselves.

Is it fair to assume here that the surprise would only come from someone who is reading about characters who are in fact unlike them? For example, if an African American young adult were to pick up *The Coldest Winter Ever*, it would be befitting. If she picked up *Forever*, it may send off what kind of signal to a librarian who ordered *The Coldest Winter Ever*, for someone just like the patron she thinks she knows?

47

 2. Characters overcome one or more obstacles, whether it's poverty, drugs, rape, teen pregnancy, HIV, violence, incest, or some other trauma.

For characteristic No. 2, Doyle recommends *Push*, by Sapphire. I know many African American females who could not complete *Push*, because of the graphic detail in the text, and the overwhelming sadness that accompanied the main character's life. The only obstacle that the main character from *Push* (1997) overcomes, is that she learns to accept gays and lesbians, and she becomes literate well after she is supposed to.

 3. The teen girl character starts out selfish, vain, uneducated, or defeated by life, by the end of the novel, she has triumphed or last least gained maturity and insight. Recommended text for this characteristic is *Flyy Girl*.

There are a slew of teen novels written by white authors, about young white girls who are in the same predicament, except the uneducated qualification. Many of the young white girls that are central to white teen novels, are in fact educated at posh private schools, and more times than not, they are educated in Manhattan, the epicentre of "posh" for some. (*Gossip Girl*—the series is a great example of this).

 4. Vice is punished, virtue rewarded.

Many of these books offer the reader hundreds of pages of grit, grime and un-safe sex before getting to any discussion of virtue and rewards therein.

 5. Sex. The more libidinous the main character, the better.

This is exactly what much of street lit is partnered with. The other half of the partnership is either crime, drugs that pay in crime, or sex that is paid for in some type of financial benefit measurement. Yet, what Doyle fails to mention here, is that the population of girls that want these qualities and characteristics to be met in a single novel, are also not looking for sex with love, or safe sex, or sex for the first time. They are looking for what could be classified as textual porn.

 6. Characters live out teen's fantasy life, at least for a while.

These fantasies are classified by Doyle as references made to name-brand clothing and other materialistic items. Indeed many teens are obsessed with the latest fashion(s), but I do not think this is a direct request from only African American teens and their connection to street lit. If that was the case, the *Gossip Girl* series, later made into television show would not be as popular as it has become.

 7. They contain realistic, sometimes strong language-including up-to-date slang – and plenty of pop-culture references.

Again, Doyle is correct in her character assessment. Many of the novels in the street lit genre are jam-packed with words directly from slang dialects, but again, these words and phrases are not only successful in street lit books geared towards young girls of color. These popular words and phrases are also introduced and used in white teen novels as well. Another area of interest is the use of the word "Nigga" in many of the street lit books. Racial interest surely arises when white librarians are recommending books to young teens of color, where characters and narrators use the word "Nigga" extensively. After much debate over the term, and whether or not it is a term of endearment or a term that continues to hold historically negative connotations, it seems of no consequence that these books are written by African Americans and read by same, but offered by white librarians. For example, in *Gangster's Girl* (2004):

> I do not know what it was about this nigga, but just the sound of his voice made me quiver. Give me a thug over a square any day. […] Any other nigga would have been shot down at the snap of a finger. But this wasn't just any ol' nigga. He was so damn thugged out it was turning me on! (Chunichi, 19).

This kind of "slang" or use of "street" dialect is a key factor in the segregation of novels that young adults are reading. Yet, dozens of people, writers and readers alike defend the genre in that it promotes reading among African Americans, ages 15-50 (Veneable, 2004). Similar to Walter Mosley's perspective in that he can understand the arguments being made for and against street-literature, he also stresses the importance about the experience of reading. The larger question still lingers as to whether or not, young white women are reading any of the novels in the genre, and how they are affected; and whether or not young women of color are reading novels geared towards young white women, and are they affected. Certainly, reading helps to ensure literacy, and the desire to learn more, but how much are young women of color actually learning, if in fact, they are reading about themselves, and material related to their lives; if indeed that is the result of reading street-literature?

The idea of segregated literature comes in two parts: (1) teen novels or young adult novels geared towards young white women, and (2) Street Lit, "ghetto" or "urban" literature being directly geared for young women of color who are deemed as reluctant readers, is at the fault of many. Are white writers writing in a voice that particularly grasps the reluctant young white girl type of reader, or is she continuing to write the love story from a young white girl's perspective, be it a reluctant reader or not? It is not to denounce street lit books or their writers, it is to ask why are young women of color not being exposed to a variety of writings based on the same topic. Within the *VOYA* article that Doyle wrote, her biographical sketch indicates that she has been a young adult librarian in "one of the poorest neighborhoods in the city" (VOYA, 175). Why then is there no push to educate the young readers that come into her section at the library? Do they not deserve multiple perspectives when trying to read about themselves? If young women of color want to read about someone who resembles them, are they, as Doyle would suggest in characteristic No. 3 "selfish, vain, uneducated, or defeated

by life" (Doyle, 174). If they are, why are they not looking to break out of this and being given reading materials to help them better understand their situation, not find a cheering squad for a life of misery? Would I continue to assign *The Coldest Winter Ever* to my undergraduate students? Absolutely! However, I would couple this reading, as I always do, by assigning *Pedagogy of the Oppressed* (1970) in its entirety or by way of assigning *Getting Beyond the Facts: Teaching Social Studies/Social Sciences in the Twenty-First Century* (Kincheloe, 2001). Many of our young women of color, are not what some would say, desperately in need of direction, they are however, in need of multiple perspectives about life.

In defense of this genre, many educators and librarians are pleased that young people of color are reading something, anything, even if it is street lit, and have found fulfilment in their employment as librarians, by stocking their libraries with copies of books like, *Whore* (2006). While there is still much criticism, street lit novels are flying off the shelves by people much younger than the characters they are reading about, or the audience the book is written for.

> Censors from the right argue that these books are inappropriate for teens because of street language and depictions of sex, violence and the drug trade. Censors from the left feel the books should be excluded from libraries because of their misogynistic and homophobic content and because they portray African Americans in a bad light (Honig, 208).

Other perspectives may estimate that similar to librarians who are not of color, or who are not aware of "urban lifestyles," and who see the genre as problematic for young women of color, are ignorant to the positive effects of street-lit. Fact, many of the book covers in the genre host scantily clad, shades of brown, very long dark hair, and extremely large derrieres, for its female character. It seems that it may not be enough to have these images force-fed to young women of color via music videos, reality television shows, but now they can be found on what traditionally was reserved for porn magazines only (book covers). Is it far fetched to call the covers of street lit books, as black feminist Patricia Hill Collins would classify "Contemporary Pornography" (Collins, 136)?

> Contemporary pornography consists of a series of icons or representations that focus the viewer's attention on the relationship between the portrayed individual and the general qualities ascribed to that class of individuals (Collins, 136).

I recently visited Borders Books and Music in Queens, New York. I wanted to see their selection of Street Lit, and where and how it was shelved. To no surprise, it was not shelved in the "Teen" or "Young Adult" sections, but rather the "African American Interests" section, right next to an outward facing copy of Presidential Candidate Barack Obama's *The Audacity of Hope: Thoughts on Reclaiming the American Dream* (Vintage, 2008). I cringed as I witnessed two older white women perusing the books on the shelf before us. One of the women instantly conjured up a screw-face as though she had smelled a rotten egg, when she saw the cover of *Whore* (2006). She then used her finger to read the binding of more Street Lit titles,

still with her rotten-egg smelling expression. What was she looking for in this aisle? She then picked up *A Hustler's Wife* (Triple Crown Productions, 2004), and made eye contact with me. Rotten-egg smeller looked at me head to toe, and put the book back. She instead grabbed a copy of *The Audacity of Hope*, and moseyed out the aisle. At first and perhaps still, I cannot understand why she looked at me the way she did when she picked up Nikki Turner's book. Did I look like a *hustler's wife?* I was perplexed, but grabbed a copy of *A Gangster's Girl*, as recommended by young adult librarian Miranda Doyle, and purchased it. I wondered why the book was recommended to young adults or teens, particularly African American teens that were searching for a soothing remedy while waiting on Sister Souljah's sequel to *The Coldest Winter Ever*. After collecting a copy of *A Gangster's Girl*, I made my way over to the young adult section.

There were three rows of books, all for young adults or teens. Many of the books that were outwardly facing the buyer, as suspected, were novels either about the dark side (vampires, witchcraft), or romance, featuring blond haired white young models on the cover. A young white female teen walked into the section, and we made eye contact and smiled at one another. She picked up a copy of *Gossip Girls: The Carlyles #1* (2008). She flipped the book from front to back and read the blurb. I asked her if she thought the book would be any good, and her response was "Absolutely. If you like *Gossip Girls*, I think you would like this." I then asked her if she liked the show, and she answered, "OMG! Yes! Do you watch it?" I responded, "yes" and we smiled at each other. When she was done with her selection, she bid me farewell and headed over to the register. To my left of the Young Adult section, there was a group of young white girls sitting at one of the bookstore's café tables. They were huddled in deep conversation, with a slew of books strewn across their table, all novels (I did not expect to see schoolbooks, as most students during the summer are on a break from class). Although I could not hear what they were talking about, I heard lots of "he," "she" and "do you believe that?" "God, their lives are so interesting" I thought. My fantasy of wanting to sit at their table, was interrupted by a customer who asked me if I worked there (what was I wearing?), and after responding no, she said "oh boy. You sure look like you know about books." Where did that come from? Did I look "professoriate" on my day off? I realized my paranoia from the African American literature aisle, and my encounter with rotten-egg smeller was getting the best for me, and it was time for me to find my husband and for us to exit the store. This is just another reminder of the complexity of trying to separate the struggle between race and gender, but still left without the choice to do so, and in turn pick and choose what affects one the most.

Part of the argument with street-lit is whether or not they really aid in a young woman of color's identity as author of *B-More Careful*, Shannon Holmes claimed in an interview. There are many young women of color that do grow up in what can be called the "hood," but still do not aspire to be part of their communities in negative ways. Sure, many of the books that are geared for younger readers, come with a moral tone or moral ending, but many of the stories take extremely long before getting to this point. It is almost like watching someone prepare to shoot

heroine, and by the time you give them the effects of using the drug, they have spent a lot of time learning about the preparation, and that trumps what moral lesson you were going to offer.

Young women of color, as characters, are not central to the popular teen novels that exist, nor were they popular during the time that *Forever* and *Seventeenth Summer* were being written. Young women of color are not central characters, but they do show up occasionally in some of the teen novels that I have recently come across. In what ways are they present? Does it seem like a legitimate inclusion when in novels about young white girls, or does it seemed like a forced introduction? Are they categorized negatively or stereotypically? Do they have worse qualities than the novel's already-present, beautiful blond vixen?

Sara Shepard, successful young adult novelist, who wrote the series *Pretty Little Liars (PLL)*, introduced a young girl of color for the first time in the first book of the series, *Pretty Little Liars*. Her name is Maya St. Germaine, and from what I gather, she could potentially be attractive. It was the first time in a teen book I had ever seen a woman of color being described as having "tawny" skin color. I have heard of plenty of descriptions, but never tawny. Immediately I was interested in Maya, even though the book had me hooked from page one, even at the age of thirty. Maya befriends or rather is befriended by Emily:

> Emily had been a competitive swimmer since Tadpole League, and even though she looked great in a Speedo, she never wore anything tight or remotely cute like the rest of the girls in her seventh-grade class. That was because Emily's parents insisted that one built character from the inside out. (Although Emily was pretty certain that being forced to hide her IRISH GIRLS DO IT BETTER baby tee at the back of her underwear drawer wasn't exactly character enhancing" (Shepard, 2).

For various reasons, Maya and Emily begin to develop a friendship, one I was so keen on seeing grow in such positive ways, as I know many a young white girl was bound to read this book, as the series was becoming more and more popular at the bookstore. Emily, probably by no fault of her own, is a square, and more than likely befriends Maya, because she is not a square or at least does not appear so to the reader. A few pages into their introductions, or rather getting to know each other, Emily is invited into Maya's bedroom, where Maya offers Emily a hit of a marijuana joint. Later, Maya explains to Emily that she does not quite like boys the way that "regular" girls do. She admits she likes their (boys) company, but once alone, she does not want to be with them. It is now assumed and later confirmed that Maya is a lesbian, or at least bisexual. A bit later on in the book, Emily is confronted by her mother who is apprehensive about their friendship. Emily realizes that her mom is not worried that Maya is a lesbian and the "influence" that may cause (her mom is clueless as to their sexual experimentation), but the problem is "There are just so many cultural differences with her [...] I just do not trust those people. I know that sounds really narrow-minded, but I do not" (Shepard, 171). I applaud Shepard for writing this scene the way that she did. It was not sugarcoated, as some other teen books have done to completely avoid the

issue of race as though it does not exist. A few pages later Maya declares that she is also a cutter with no real explanation of why the illness had become so bad, her parents had to rush her to the emergency room. Immediately, Emily feels bad for Maya, and begins to contemplate her own life's drama of being rejected by a friend, and gives some detail as to the book's central issue of a harrowing secret. However, in her mind, Emily agrees with herself, that "she'd never wanted to hurt herself" (Shepard, 196). This overwhelming feeling of sorrow and intimacy (touching Maya's previous wounds), Maya makes the first sexual move. She leans into Emily for a kiss, in return Emily, although extremely self conscious, as Maya finds her way around Emily's body, she does not resist Maya's touch or kisses. All throughout the novel, Maya's identity is being slowly dislocated and uncovered, and her influence on Emily rings negative, as Emily breaks out of her shell, and begins to cut class, skip swim practice. The first book ends, without any more discoveries on their friendship that turned into a more intimate relationship.

I am so pleased at Shepard's introduction of a young female of color character. Maya's appearance in the story does not come late either. She is not an afterthought, and is not "thrown" into the story. Maya appears early enough for her to become fully integrated into the story, and Shepard's story-weaving is fantastic. However, Maya really leaves a bad taste in the reader's mouth. Although Emily's mother seems more disturbed by the fact that Maya is black or "tawny," she is not written in a way that race presents itself as the focal point and/or problem. Like Nielsen's comment regarding *Fast Sam*, race seems secondary, whether this is fortunate or unfortunate is dependent on the reader's background and racial expectations for the novel. What is troubling about Maya is the fact that the person she is, seems more than out of the ordinary in Emily's world. As mentioned, Emily is wholesome, she is Irish, is an athlete, and a complete square, a social ditz if you read enough about her. Almost immediately, we find out about Maya's troublesome world. At her life's baggage-claim, we pick up that she is a cutter[iv], cuts class, does not support Emily's achievements of becoming a professional swimmer, smokes pot, drinks Jack Daniels, and is trying to turn Emily out…sexually. Although I like to believe I am a "free thinker" to the extreme, and revel in the fact that Maya is a lesbian and of color, and makes an appearance in a story set in the scene of seventh graders, it is possible that her sexuality is also categorized as part of her negative attributes. Maya is always the one to approach Emily sexually, and although Emily does not seem to mind too much, she does still seem to be in the experimental stage only. In the second installation of *PLL, Flawless* (2008), Maya and Emily's love "affair" does not quite get off the ground still. Maya tries and Emily rejects her, to which Maya lets her know that she will wait however long it takes, until Emily is ready and will concede to being solely hers. After many blog searches on the Internet, young girls do not seem all too concerned about Maya being a lesbian, however, they are convinced and more concerned that she is the series' long awaited killer, (because she wants Emily to herself). It would be interesting if Maya were white and not black. Would she still have the same appeal, since her sexuality does not seem to caution the reader and bring conflict to the character's qualities? It is also interesting to note that she is the

only character who may be classified as "other," and all of her negative attributes qualify her clearly as the "killer" in question. However, it is still safe to ask whether or not her race and sexuality play a role in why Shepard created her this way?

PLL, is not the only text that uses a single person (race-based), as the "other" (in PLL's case the "other" is black) and demonizes them. In a street-lit collection of short stories entitled, *Girls From Da Hood 2* (Joy, 2008), one of the short stories involves the negative attributes of another female "other." In the story *WannaBe*, written by Joy, it outlines the relationship between Nikko and Harmony. Harmony is a girl who clearly is obsessed with thugs, and the lifestyle that comes with being such. Nikko is the son of a hustler/drug dealer, and has made a name for himself amidst the streets, as a legend in his own time. Hence, he too, sells drugs, and thus this makes him legend. The reader is taken on a urban street adventure, as Harmony trades in her "good-girl who comes from extremely wealthy parents," behavior and lifestyle, but ends up at the end of the story, using heaps of drugs, and basically prostituting herself for another hit when she can get it, or where she can find it. It is clear in the story that Nikko who is black turns her on to this lifestyle, and befriends her throughout the process. He is not written into the story as an evil drug pusher who gets this "poor young and unknowing" girl hooked onto drugs, or interested in prostitution. Rather, he just exposes her to the life he lives, and the one his father lived before him. The twist to the story is that Harmony is white. Joy writes so cleverly in a way that stereotypically one envisions Harmony, (as my students have been so quick to describe) as an "uppity black chick." The shocking moment when Harmony's race is revealed is thrilling. In my undergraduate class called the *Black Child*, my students were split in their feelings towards the story. Many of the young women of color were happy that "ole girl" turned out to be a white woman who had fallen among the lives of degenerates and misery. The other half of the women in my class were irate. They were furious that a black character was the cause of Harmony's eventual demise. They claimed that the author played right into the hands of a stereotype – white women wanting to be with black men to fulfill a fantasy, and hence ends up almost dead because of his "thug-life."

Both Maya from *PLL*, and Harmony from *Girls in Da Hood 2*, are written as the "other." They are intruders into a life already created for the characters that are central or that are a main focus in the story. They enter into worlds that are unknown, but fit right in, albeit negatively, and they both leave a stain on the reader, yet, had they not been present, the story would not fall into the same exciting path that it does. The only complication seems to be that the two women are given the role as "other," but both are incredibly negative. Maya is black and has negative attributes as well as encourages bad behavior, Harmony becomes "mixed up" with blacks and her experiences by mixing with this group are also negative. According to various young adult librarians all over the United States, many African American young readers, are not interested in reading books that are similar to the Cosby Show's plot, or story line, but the isolation one feels from being a representative of a particular group that is showcased as negative is immeasurable.

NON-FICTION TEEN READS

Nielsen suggested that young girls read *From Woman to Woman: A Gynecologist Answers Questions About You and Your Body* (Lanson, 1975), but today the book is clearly outdated, whether or not its ideas and goals perhaps still the same. Although the cliché may ask of us as readers to "never judge a book by its cover," the general population is judgmental, and will judge the cover first, and then flip to the back of the book for information before purchase, or a complete reading. Unless a direct recommendation from a shared interest reader, this action could be the defining reason behind actually purchasing the book with one's own money, or checking it out of the library free.

The cover of *Totally Me: The Teenage Girl's Survival Guide* (Collins and Rideout, 2000) hosts two painted girls from the shoulders down. It is clearly indicated that they are both white girls. The fact that the book sends off an immediate signal that white girls are on the cover, similar to most of the teen novels on the shelves next to these non-fiction selections, directs a particular audience to the book. However, by cover alone, it does not deplete the book of its good quality of helping young girls find out what is going on in their lives and their bodies. The book is a friend to turn to; similar to how *Forever* was and is still for many, regardless of race. An important point to note however is that *Totally Me* does not talk about race, racism, or cultural difference, or even skin color. Brown and black girls could have been disregarded in an attempt to reach the universal female teenage template—yet in still not all girls subscribe to this template. In the case of *Totally Me*, there is a mini chapter on kissing, which I thought was cute and quick to the point, but reading more carefully in my analysis, it is clear that neither brown nor black girls were considered in the chapter. Let me provide you with an example:

> Be on the lookout for potential hickey situations. Even the sweetest of kisses can end in purple bruises that are somehow seen as reflections on your character. Hickeys are very easy to come by and very hard to disguise (86–87).

Fortunately or unfortunately, we are not all the same color, and some of us do not get purple bruises, but various shades of red, burgundy, or maroon. Yes, skin color matters in how bruises appear on skin. This brings me back to the *Pink Nipple Syndrome*. We just do not have them and relate differently to this bodily experience!

Although the book has a great little section on sex, and the preparation thereof, it does not talk about interracial relationships or LGBTQ (Lesbian, Gay, Bisexual/Bi-Curious, Transgender, Questioning) experiences/relationships either. In *Girlology: A Girl's Guide to Stuff that Matters* (Holmes and Hutchinson, 2005) there is a slight introduction to homosexual relationships. I could not help but giggle as I read it, for I know that teens are much more advanced than what authors Melisa Holmes and Trish Hutchinson, two medical doctors, have put together. As they do a short introductory definition of "homosexuals" or men who are attracted to men, and "homosexual women" (lesbians), their notation about bi-sexuality is interesting:

> There are also some people who are sexually attracted to both males and females. They are called *bisexual*. If a male is attracted to females or a female is attracted to males, they are *homosexual*. Ninety percent of the people in the world are heterosexual (167).

The "ninety percent" reads as though it should have had a "but" before it. In fact, this excerpt is followed by:

> But love is love. We can't always help who we fall in love with. The world is filled with enough hatred and violence. We should never hate people for loving others—even if it means they are gay" (167).

Including this percentage of what "most" of the world is when it comes to sexual orientation, just further supports the idea of normalcy, and what is considered to be the majority. Startling to say the least. It almost reads as though the authors are asking their teen female readers (no doubt white), to have "tolerance" for people *even if* they are gay. Maya St. Germaine is looking better and better every minute that passes through the non-fiction analysis.

Appropriately moral, *Totally Me*, is structured from chapters 7-8 in the following order, getting the date, kissing, and chapter 10—sex. Somehow, in this day in age, I am not sure that is still the order, and where is the mention of pregnancy? According to the Center for Disease Control's (CDC), report in 2006,

> Hispanics" [I prefer to use Latinas], had twice the overall rate of the entire United States when it came to their percentage of teen pregnancy weighing in at 83 percent. Blacks had a slightly higher teen pregnancy rate than "Hispanics," and white girls came in last with the lowest rate. (CDC, 2006)

Where pregnancy may not matter as much as the life we are actually living, the authors do mention STDs, and make a poignant marker that, "what's particularly nasty is that you can have an STD and have no obvious symptoms" (Collins and Rideout, 103). Yeast infections are also listed under their possible STD list. True, the symptoms of a yeast infection can be the sign of an STD, and yes, it is quite offensive, but most yeast infections are not sexually transmitted diseases. Still a cause for concern, yeast infections should undoubtedly not be taken lightly. However, many people with diabetes who are not having sex are also prone to yeast infections, as well as pregnant women. (I particularly mention diabetes as the example here, because of the high rate of African American girls who have both juvenile and adult diabetes). Data obtained from the 2005 Center for Disease Control's *National Diabetes Fact Sheet* reported:

> 3.2 million, or 8.7% of all non-Hispanic blacks aged 20 years or older have diabetes. Non-Hispanic blacks are 1.8 times more likely to have diabetes as non-Hispanic whites (CDC, 2005).

Can diabetes also classify as "nasty?"

Although also written by three white women, the authors of *Deal With It: A Whole New Approach to Your Body, Brain and Life as a Gurl* (Drill, Mcdonald,

and Odes, 1999), do a better job at addressing the issues above, but still, nothing speaks directly to young women of color. *Deal With It*, is a guide for girls or *gurls* (as they prefer to use and spell the term), is a compilation of tidbits from their extremely successful website www.gurl.com. In each of the four parts, Body, Sexuality, Brain, and Life, they include postings from their online forum discussion, but they do not stop there. They also include a section called "resources" in each of these sections/chapters, so that girls can get more information if they so choose. Clearly, not only their opinion counts. *Deal With It*, hosts a great chapter on pregnancy, and how it happens, and what to do, and thoughts and opinions on the subject. They do their best to explain that no matter what choice you make in your sexual/love interests and experiences, "if you choose to date someone outside your cultural background, you may encounter opposition, whether it's because of resistance to change, cultural pride, or racism" (243). Sadly, though, the book gives a section, and I do mean one single column dedicated to women of color.

> The history of the women's rights movement in America has often been criticized as the history of white, middle class women's issue. In general, this is a criticism that rings true for many women of color—African American, Asian-American, Native American, and Latina women, whose gender issues are compounded by issue of ethnicity and race (272).

Great synopsis of embedding the lives of women of color as historical beings. Our history as women of color in America is extremely important, and should be noted as such, but we are also current. The section also talks a bit about the Civil Rights Movement. What about issues that affect girls of color who are living in today's world? In a beautifully written essay in *My Sister's Voices: Teenage Girls of Color Speak Out* (2002), Lianne Labossiere, a seventeen-year old, black Haitian-American young lady, writes, "To be utterly honest and blunt, I have trouble accepting Black as beautiful. I believe this a feeling many dark-skinned girls like myself have" (Labossiere, 23). Sounds like a *pink-nipple syndrome* to me.

These are the types of difficulties that young women of color were facing yesterday, last night, and are still facing today. It is more than an issue of having sex and who with. Before one can become involved in a healthy sexual or intimate relationship, there has to be some sort of standard set for one's self of how much self-love there is. In *My Sister's Voices*, many of the essays explore the issues that young women of color are currently facing. Shocking as it may seem, these girls do not seem all that cued-in on any of the events that are written about in street-lit, but many of the ones slightly touched upon in many of the teen novels geared for white girls, only these issues are real.

REMEDY

Overall, the majority of teen novels seem as though they are geared towards young white girls and/or women. They seem to have the same theme running through each and every single one of them, particularly if they are in the romance genre.

57

They consist of intimacy, relationships, sex, the good-girl vs. bad-girl complexities, and the general lifestyle(s) of a group of teenagers. For many urban teenagers they are not able to find a comparable experience in many of the teen novels that are available to them in popular bookstores. For many of them, either their communities do not have libraries, or their libraries are under-stocked and/or under-staffed. Many of the libraries are underfunded and are either closed early, or do not open on weekends, which is an imperative time-frame for teenagers without jobs. To this end, many urban teenagers depend on street vendors for their selection of novels. Further, many of these street vendors are predominantly African American and male, and do not sell "teen novels." They know there is no market for them at their table or among the adult customers that stop at their tables. Hence, the large sales of street-literature that is available to many of the customers that patron these "stores." At black-centered bookstores, they too do not carry many traditional "teen" novels. Their "Young Adult" sections also house many street-lit titles, or books geared for the African American young adult or teen, but there is little along the way of feminism or women of color studies and/or topics. Young girls of color are left to choose from either street-lit for adults, or African American historical books and a small selection of African American-based academic books.

It is not a call to white writers to begin introducing girls of color into their novels, nor is it a demand that we become present in their stories. It could very well bring a lot of pressure to writers to begin designing characters they (1) do not know enough about, (2) may represent in a bad light (un) intentionally, or (3) compromise the structure of the story by throwing in a "random" character that does nothing for the story, unlike Maya from *PLL*. Neither are we commanding street lit authors to begin writing about women of color in more positive lights, and with stronger character qualities or society-valued morals. If authors such as Chunichi did this, *A Gangster's Girl*, would not be a "gangster's girl." It would be similar to asking Hip Hop moguls and entertainers to refuse the marketing of the new Venus Hottentot or a "whore-like" female in their music videos. Like white writers who write teen novels based on the lives of young white girls, street-lit authors are writing about people of color that they know, live near, and have experienced their whole life, at least that is the defense for both: safe and inarguable. Their stories would also be in jeopardy for the same reasons I listed above with regards to white teen novel authorship and story-crafting.

Fiction writing is all about the fantasy, the imagination, the technique and skill to get your reader to buy the next book in the series. This is particularly true for young adult books. There has to be more than just a hook, the story has to be woven with care, it has to be deliciously detailed, or the reader will put it back on the shelf or return it to the store unread. Teen readers whether brown, black or white are also loyal to the books they buy and read as well as to the author that writes for them. Once you have written something your potential reader likes, and while it might not be deemed "bestseller" by *New York Times* standards, if they like what they have read, they will seek our your name, and read everything else you have written. To this end, Maya has to exist alongside the rest of the white girls or *PLL* would not be as interesting by teen standards. Like Maya, Harmony

has to exist as well. If Nikko had gotten a "regular" black woman hooked on drugs, the world would frown on him, and not celebrate him, as he helps Harmony back to normalcy and sobriety in the end. We cannot fault fiction writers for their own imaginations, whether they see young women of color as tramps or psychos. Our world is not constructed that way, particularly in the United States. The world overall has to become a different place for these types of characters to co-exist within the pages of these types of books and be introduced naturally whether they play negative or positive roles, and at times it does not matter. The exchange and the learning process is a worldwide initiative, and without sounding like a wet blanket, there is doubt that this change is coming in my lifetime. For as much as this is the case, it is a call however, for those who do write, to realize that we could potentially be turning away readers who could really learn something from reading our books and our opinions, whether they agree, or disagree. Whether readers relate or aspire to relate, we have to think about who it is that we are targeting and what other signals we could be sending off. If we are not targeting, say women of color, do not include a blurb about them/us, it does not feel adequate, and it feels like just as it is, a blurb. If, as writers, or academics, we are okay with that possibility happening, then that is our choice, and the reader must be ready to accept this as well. If we are conscious about these types of pitfalls, then as writers, academics, and readers, we have to also in the process of teaching others, teach ourselves to be more knowledgeable and inclusive of other people and their experiences. This is especially true for writers in the young adult non-fiction genre.

I will never forget the time I was teaching a graduate seminar on diversity, and I posed the following question to the class: "Where in our everyday lives do we see that someone missed the memo on diversity?" A white male, in his mid thirties, raised his hand and answered "with stockings/hosiery." Although the room was full of adults, many of them giggled and others rolled their eyes at him. To them, his comment seemed like a lame and off-the-wall response. I immediately was captured by the student's statement and wanted to hear more, so I asked him to elaborate. He responded, "Well they sell nude pantyhose right? Well, nude isn't everyone's nude right? I mean, if you were to wear nude pantyhose Professor Bernard, it wouldn't look nude on you even though you are what some would classify as light-skinned." Wow! A heterosexual white male in his mid-30s just uncovered what most do not think about. I for one detest pantyhose, find them oppressive, and rude, but immediately I jumped on his bandwagon. I liked where he was going with his thinking. Some called it obsessive, and hypersensitive, but I found it observant, and the fact that he is a white male, made all the difference. At least if he noticed it, I did not appear like the only overtly paranoid, overly sensitized and racialized professor or person in the room. I could admire his comment and revel in his strength to "come clean" and feel proud that that was a student in *MY* class. Other students went on to make similar comments about nude band-aids, how nude was not so nude when black women and/or darker-skinned Latinas used them, and the list went on for two hours. Our class had come up with such clever little ways to uncover the missing diversity memo from corporate American think tanks.

 With conversations like the one my graduate class and I had, surely people are thinking about what it means to be inclusive in a non-fiction type of way. Surely young girls of color are turning through the wrong pages looking for answers to life's larger social and emotional questions, but perhaps *The Coldest Winter Ever* being taken as practical reality might be sending the wrong message. I would still recommend each of the books that I have critiqued in this chapter. They were not wastes of my time or money, and each book I read taught me a lesson. If not noticing these strange little nuances in store products or the marketing thereof, many brown and black women, more than just a few, will certainly end up with the *Pink Nipple Syndrome*.

CHAPTER FOUR

BEAUTIFUL

Black and beautiful, you the one I'm choosin'

Hair long and black and curly like you're cuban

-Snoop Dogg: Beautiful (2002)

Saartjie (Sara) Baartman, also known as, the "Venus Hottentot," seems to have died in vain, and for naught. Did she know she would become a civil rights leader for many women of color? Probably not. Baartman brought to England by her slave masters with a promise of returning to Africa and an abundance of wealth in exchange for her travel, was unaware of what her exchange would be. Her buttocks and the shape of her vagina, indicated to Victorian men and women that a "freak" was in their midst. Her body was so "freakish," that even in her death (some time in her twenties), people believed that everyone should continue to learn of this "freak." Her Khoisan body was mutilated and dissected. Her genitals were cut off, and stored in a Parisian museum's jar for the world to see, and ogle over to their heart's content until 1974. Her body was not returned to her village until 2002, which was a process overseen by Nelson Mandela. I wonder how many a video honey or "video hoe" are aware of her story.

Three years after Baartman's remains were returned to Africa for a "proper" or traditional burial, rapper Tony Yayo released off his album entitled *Thoughts of a Predicate Felon*, the video to his single, *So Seductive* (2005). *So Seductive* featured a model, and "video-honey" nicknamed "Buffie the Body." Although darker skinned than what historians claimed Baartman was, the side profiles of Buffie the Body and Baartman are almost equal in resemblance. For many, Buffie is revered because she is not the "typical" light skinned black woman with long hair that graces the set of this particular video, unlike so many other rap and hip hop music videos. Equally, Buffie commits no crime against third-wave feminism. In this video, she does not strip out of her clothing, nor does she qualify as a "whore." It is Yayo who in his chorus tells listeners that the way she moves is what makes him "horny." Based on this single video appearance, Buffie's career immediately took off with print advertisements and more music video appearances and full-blown magazine spreads. Her website notes that www.buffiethebody.com receives thirty-one million hits a month (www.buffiethebody.com). Recently Buffie released an e-book that she declares is for her "sisters." The book she guarantees features an intimate journey into "urban modeling," health/nutrition tips, and advice on life. She has a variety of female fans, and tons of black female supporters who see her as a role model. Many have made the argument that Buffie sets the history or the

historical reference of Baartman on its tail, and now what used to be "freakish" is the precedent for "black contemporary beauty." It is worth a mention, that neither Buffie nor her body are usually featured in mainstream modeling campaigns or advertisements as the competition is among the "waif" and not the "voluptuous." However, does the "celebration" of Buffie and her body render so different from the "celebration" of Baartman?

For centuries, beauty has been the obvious physical indicator but also the clear social marker of what is man, woman and "other." Fortunately, for men of color, they were not held up to the white male's standard of masculine beauty, they were held up against competing and internal identities of masculinity more than ideas of beauty. Historically, the Victorian/European woman was held as the highest standard of beauty. Milky skin, light-colored eyes, blond hair, and a small waist suffocating underneath an unhealthy corset. One cannot dispute that many Victorian women were in fact quite beautiful. In oil/canvas paintings (pre-airbrush equipment) the appearance of "purity" and "innocence" is a factor that helped to push the ideals of beauty for everyone. Their religious-based prudish and sexually repressive characteristics added another dimension to their desirability. African women, such as Baartman were not revered because of their "purity and prudishness." In fact, they were held in curious scopes because of their eyes, lips, noses, mouths, derrieres, sagging and uncovered breasts, and hair that looked like "burnt cotton." How can the African woman's body compete with pride and purity? As slave masters began to understand their positions of power, dominance and sexual predatory instincts, "mulattos," "half-casts," the mixed-blood, (or as J.K. Rowling so appropriately called those who are half witch/wizard and half human "muggles") (Rowling, 2001), the prudish and the freak can both be found in one slave girl. Unfortunately, these desired slave girls were not given stools to sit on for their portrait to be painted. One could not be in the role of servitude as well as having general admittance into classifications such as beautiful. Many female slaves did not only appeal to their white master's as prey, but they also appealed to their black male slave counterparts as desirable sexual objects.

> [...] A large majority of black men took as their standard the dominator model set by white masters. When slavery ended these black men often used violence to dominate black women, which was a repetition of the strategies of control white slaves masters used (hooks, 4).

Perhaps it can be argued that many rap and hip hop artists are under the same "plantation patriarchy" that hooks describes in her book *We Real Cool: Black Men and Masculinity* (2004). In this, it is arguable that Buffie's body, and many other "urban models" like Buffie, are under the same construct(s) of black male patriarchy and psychologically-damaged understandings of masculinity. We indeed need to remember that abuse on a woman's body is not solely physical, and sometimes comes with high pay as well.

Latinas as well have suffered under the same scope of fascination with the derriere and the struggle to overcome the skin color complex. In her essay *Jennifer's Butt* (2004), scholar Frances Negron Muntañer (2003) explains that

Hollywood sees Jennifer Lopez as the racialized definition of Latina. She is neither "too light," nor "too dark" but the fact that she is indeed on the lighter side of Latinidad or Latina identity is a definite plus. So much is the plus that Lopez can be cast as a white woman, Latina, Chicana, or a girl from "around the way." Some would argue that this is just another addition to the superstar's versatility. Others would argue that Lopez's body is being used just as Baartman's was with an additional touch of the skin color complex issue along with an icing of "plantation patriarchy" by the men that desire her.

> Precisely because her back end became a required and often a central concern
> for journalists and other mass media observers, the disproportionate attention
> to her body began to overshadow any of Lopez's other possible achievements
> or abilities. Jennifer no long had the best, the biggest, or the baddest butt in
> the world; the butt had her (Muntañer, 244).

While I will go into Jennifer Lopez in later detail in subsequent chapters, it is important to note here that for women like Buffie and Jennifer Lopez, the possibilities are seemingly endless. However, the root of those possibilities mirror one another in that it is possible that neither woman at this point in their career would switch their lives for that of the "average" girl. Furthermore, it is beyond "average" that they aspire to be, while stripping themselves of any "average" characteristics.

The reason I began this chapter with a brief example of what the woman of color's body has been seen as and partially gone through in our history (in its physical transformation), is because many young women today confuse sexual appeal (for a heterosexual audience) for what are actual elements of beauty and vice versa. Young women of color are not exposing their innards first in order to be classified as "beautiful." They are exposing their outer body and out of body assets and attributes in order to be highly revered in our celebrity-crazed society. For many young women of color, music and its videos (particularly rap, hip hop, reggaeton and dancehall reggae) has been the outlet to which they compete to be "most beautiful" or more beautiful than their "average-girl" counterparts and/or competitors. With many women, competition within groups of their own or groups of others is key in recognition of beauty. The less your wear on your body, the more you wear on your face, and the way you carry yourself, conjures up markers that young women classify as qualifications of beauty. Keeping up with the current times of sex being the major sale in most every aspect, young women of color send their bodies into a whirlwind of changes, and almost never stop to gather up their individual pieces of such.

Fast forward to 1990s and enter into our present state of understanding the complexities of racialized beauty. No one is throwing coins at our bodies while we move around in cages back and forth, scared for our lives, similar to Baartman. No. Instead, they are throwing dollar bills, and many times still scared but for different reasons. The difference is, now black and brown women have the choice whether they want to perform in this way or not, and for what type of audience. When it comes to a potential audience that may gain from a woman "exposing" herself, an

interesting hermeneutical approach could be used: It cannot be helped if a convicted male rapist is imprisoned and using your "eye candy" spread in a hip hop magazine to get him through his lonely heterosexual nights. The sexual frustration that mounts in him as he is reminded that he cannot be free to ask for or take what will quench his desire, only mounts as he collects the photos of the eye candy spread and secures them under his prison cell's mattress. He cannot help that the lyrics he is listening to through his headphones are sexually aggressive and as he battles with not being able to break free of his desires, even in his state of "rehabilitation." Lil' Kim in her 2006 video for *How Many Licks*, also clarifies this example and interpretation by depicting men in prison who use magazine images of her (hardly dressed) to relieve themselves of the pressure of incarceration. Just as many of us understand and ultimately agree that a woman should be free to wear whatever she wants without being harassed or the popular "asking for trouble," while working off the "rape schedule" (Valenti, 2007) should we similarly understand that a rapist has an "illness" that often times goes untreated. In the music industry, more in particular, hip hop and rap music, women have set a precedent for being "hardcore." This image of the hardcore musician/entertainer does not give men the same response as someone who is soft, fluffy and sweet like cupcakes. She is a bitch, she is aggressive, and emasculating. Men would think twice before attacking this type of hardcore woman in a variety of ways, instead he would befriend her because she shares many of his qualities.

In 1996, female rapper, Lil' Kim, released her debut album, *Hardcore*. When I first popped the cassette into my player, I was completely unprepared for the content. Wow! Kim was vulgar, raunchy, unpredictable, lyrically slaughtering, absolutely emasculating and unapologetic for it. It was obviously, the type of album a "good-girl" listened through her headphones only. However, it gave girls, (mostly of color) a new sense of identity. Brown and black girls, particularly high school aged, were dubbing her cassette on blank TDKs, and distributing it to their friends. What seemed as empowerment through Kim's lyrics at the time, seems only to further degrade women of color in their current lives and lived experiences as young women of color in a society where only their sexuality is popular. If you are not having reckless sex, or engaging in promiscuous relations with "hotties" how can you identify with her lyrics? If you do not wear expensive name-brand clothes, where does one fit into her circle of references? Interestingly enough most fashionistas regard "expensive" or "mentionable" clothing by texture and style, not by the outward branding of the company's logo—think *Devil Wears Prada*). If you do not wear a weave, but rather struggle through the frustration of combing out your born-with curly locks and knots, how can you testify to the various trips to the beauty salon that she refers to? What if you are too young to "drop it like it's hot" or guzzle from overflowing pimp cups of Crystal at a club? We cannot all "smoke a blunt" and still obtain a college degree. We do not all refer to our black and brown male counterparts as our "nigga!"

Perhaps the goal of artists like Kim is not to inspire but to encourage aspirations. Obviously, she and others in the genre have paved the way for other explicit and unapologetic-type of female rappers and hip hop artists. The average young woman

of color is left confused. Does she wear a cross around her neck, sing with the gospel choir on Sunday mornings, and still aspire to be a "freak in the evening" like Adina Howard (1995)? The struggle to be both requires a lot of work, and the process itself oftentimes psychologically-emptying or draining. How does one actively preserve both identities, while still recognizing the struggle of being of color, young, wealthy or impoverished, fat, thick, or wafer-thin? The prerequisite is a life of constant dualities as well. It is still incomplete. As young women of color, we must be educated, but code-switch in order to talk to our friends or our white corporate employer. We must not get a weave, nor wear dreadlocks either because it can be viewed as a "cultural threat" at our Fortune 500 workplace. Our pants cannot be too tight, but cannot look prison-like baggy. We can dance, but we cannot "drop it like it's hot" in front of too many guys. We can buy any type of sneakers we want as long as no one sees us coming out of Conway or Kmart with a shoebox. We can be encouraged at all costs to buy Prada, Fendi, and Chanel even if we are completely ignored at the flagship stores on Fifth Avenue (by white, black and Latino/a employees). We can resort to purchasing knock-offs as long as someone with a real version is not standing nearby. Once we get enough money to buy just a coach belt we must also wear the Coach key ring around the belt and let it dangle in front of our crotch so everyone knows it is not a fake. We can purchase Timberland boots, even though it is 125 degrees outside and we are not hiking, or working construction. Note: the Timberland tag must also be visible at all times, just like the Coach key ring tag. Last but not least, we can walk around the streets of New York City like a moving billboard of advertisements for companies that sometimes own sweatshop factories and rape us of our own minimum-wage salaries. We can also sit next to two Latinas speaking Spanish, and if we cannot speak the language, we can become instantly infuriated and make comments like "Speak English! We're in America" but we can agree to accept Asian nail salon employees who sometimes never communicate with customers in English except to ask questions about preference in nail color. We can also repeat tracks from various songs, sung by women who look like us (black and brown basic appearance), but we do not have to accept that we have none of what they are singing about. We can sing about the luxury automobiles as we are ... walking. We can aspire to be "Mafioso" and walk around oblivious and denying any knowledge of the historical relationships between Italian and black New Yorkers. We can repeat for hours about the "Hot Boyz" (Missy Elliot, 1997) that have the platinum visa as we frequent the pawnshops and our lay-away purchases.

Am I criticizing hip hop and rap and its artists? Am I attempting to persuade females of color to dump their Ludacris tunes and replace it with a Sam Cooke or Maxwell track, just because it is my representative choice? Am I forcing anyone to understand that Maxwell's songs do not require him to "lick you up and down" (Silk, 1992) in order to recognize your beauty? Certainly not. Artists do not have a responsibility to their audience or listeners, or do they? They have a responsibility to the profession, to the artistry of creating music (beats and lyrics alike), and they have a reputation to maintain among their own celebrity peers. What young women of color need to begin understanding is that it is okay to enjoy celebrity-type of

fantasies whether in our ears or before our eyes, as long as there is no pressure to dutifully aspire materialism without substance. Women of color and their history, has waged a war against a historical timeline of stereotypes—one that traces the experience of slaves, mammies, to whores and now to "video-honeys."

True, rare to find a fan of an artist that ladles onto their albums lyrics about education and racial triumph. Not quite as catchy to sing a song where the chorus asks "will all the virgins please stand up!" Most female virgins do not always publicly disclose this information unless they are so confident in their decision to remain celibate that they are not afraid of being ridiculed as a prude or "dried up." A common joke of a remedy among women of color, and perhaps other women as well that are frustrated with life's circumstances has been "you need a man!" Is this same remedy applicable for a young woman of color who is fifteen? After listening to Ludacris's "What's Your Fantasy" (Ludacris, 2001), I felt confused and perverted. I felt like a prude, almost as if I had turned into an "old lady" well before my time. How could I not enjoy this amazing beat and call/response type of track? I so enjoyed it earlier that year. At the same time, I felt empowered after listening to Maxwell's song "Fortunate" (1998). Such a lady did his music make me feel, that when I saw Maxwell walking down Fifth Avenue in New York City, we exchanged a smile, and there I stood, dumfounded and star-struck and for once, speechless. I hardly think in our quick eye-exchange that he saw me naked, and dirty is the furthest feeling I walked away with. There are enough societal pressures for young women of color with factors like race, gender, socioeconomic disenfranchisement, social positionality, health, sexual preference and orientation always at work, without adding the pressure(s) of living up to another standard laid out for us by none other than entertainment. Music is supposed to inspire and change the way we feel, think and engage in our epistemological adventures, not force us into a world where again we are reminded that we do not measure up unless we can signify with a number of varying identity-driven boxes.

The abundance of beauty in Hollywood is made up of plastic, and the general public is aware of it. Women recognize "silicone" in bras whether it is the actual breast or the chicken cutlet inserts in the bra. We are enraged when we see them, look at our membership cards to the "itty bitty titty committee," and sigh. Some of us are thankful we did not waste our money on such a dangerous investment, as we know that gravity is the real bitch. Amidst what the world of celebrity lifestyles have deemed "beautiful," and as we push through the endless amounts of weaves, acrylic fingernails, contact lenses and plastic surgery, how emptied have we truly become? The general working population, cannot afford many of the requirements of being a "beautiful black and/or brown beauty." Yet, we see homes unkempt and in shambles as young women are encouraged to purchase "ice" and "get their lives in order." How? When most of us hear the word Hollywood, we immediately tend to think figures that represent whiteness. It takes a longer time to delve into the depth of racial Hollywood to point the finger at artists of color as well, that help to perpetuate this fantasy-like hypersensitivity desire for materialism. In many places in the world, a woman does not have to be totally impoverished to *not* be able to afford many of the things she has been told she needs to be competitively beautiful.

There are two extremes here: (1) Earthy-Crunchy, backpacker-type like Erykah Badu (who I like) (2) rich and "beautiful" like Lil' Kim (who I also like), but where is the middle-ground young woman of color and her representation?

Female artists are not entirely the only ones that we can critique for setting standards on black and brown beauty. Male artists set the caliber of beauty acceptance for straight girls and lesbians of color as well, and set these prescriptions (Freire, 1970) to new heights. The skin color and hair wars are continuous. They continue to permeate throughout our lives as we watch music videos that cast specific girls repeatedly; where the hair gets longer, the skin gets lighter and the derriere gets bigger every time we watch a new visual installment. They continue to permeate our pages as we read magazines, where we sometimes do not even see ourselves represented among the hundreds of glossy colored pages. We purchase music-based magazines, open up the centerfold eye candy, and heave. She is beautiful, she is a man's choice for the month, she is airbrushed, and we have seen more of her than we needed to secure in our heads that indeed she is beautiful, albeit we do not come close to her. If she is short, petite women feel pulsed, but if she is thick, and we are only still at short, we have lost. The heterosexual man that finds himself agreeing with the magazine's editor in that this centerfold *is* "eye candy" he is now in search on the streets for the same or similar. Then we have to deal with men who find that "black women have too much attitude," or why "someone's been sleeping in my [his] bed" (Dru Hill, 1996). I cannot begin to imagine why. What music, television, and other print media have done to young women of color is to keep us negatively competitive. We walk down the street, and stare at other women's body parts just as heterosexual men do. I had a young female student say to me "I look at women's asses as much as my boyfriend does." What followed her comment was an explanation of how his (her boyfriend) obsession with "big asses" had her in constant turmoil with regards to her own physique. How she looked was never good enough, and for years, after I stopped professionally dancing, I too acquired the same complex that my student was now suffering from.

If sickened by the obsession with how one's derriere looks, a young woman can now purchase underwear, jeans and other types of pants that are complete with "ass padding." For forty dollars, women can now purchase padded underwear from a company called *Booty Pop Panties*. At one underwear for forty dollars how many can anyone afford to keep up the appearance every day of the week? If you cannot afford the various underwear you will need for the week you can always purchase silicone pads to put *in* the underwear itself, and all of this at only thirty-six dollars before shipping to your home. Once you take them off, does it remove the self-esteem issue of having a less than pouty booty prior to having them on? Does the woman who purchased and wore this underwear feel any less of a farce upon removal of such item? For some women of color, a "pouty" or extra large derriere (or "junk in her trunk") is an attribute to be proud of, and not one to lament over. Hip Hop magazines love overly huge derrières, especially the type that can take up all the space on a centerfold or induce an expensive shot in a hip hop music video. For others, who are less than "fortunate" they can resume to purchasing their

derrière in stores nearby or far away. This still requires a specific socioeconomic bracket and membership, as the purchase of these items requires a computer, with Internet capabilities, and a credit card. For many, it is considered less than desirable for a woman of color to have a small or "flat" derrière. Young women of color have to constantly remind themselves how to resist this contemporary variety of popular culture images that help to slain identity, culture, and keep everyone confused, clueless and undoubtedly "necrophilic" (Freire, 1970).

Young women of color and their beauty issues are not obsolete from other women's issues about beauty, but they do differ in many ways. Madam C.J. Walker, born in 1919 in Louisiana became famous for her entrepreneurship dedicated to the hair care of black women. Walker, as well as a pre-civil-rights, and civil rights leader, became most known for her transformation of black hair care to which white women also benefited from. She invented methods to smooth and style African American hair by using hot combs, curlers, and pomades instead of the ever-damaging flat iron, which can run to as much as $300.00 today. Through her work in inventing products to save African American hair from being lost and damaged, Walker has been called the first African American woman to be a self-made millionaire. Since Walker, a mass amount of African American companies, and products have hit the market and appeal to all women of color. One very interesting and helpful website called treasured locks (www.treasuredlocks.com) gives women with "ethnic" hair an overview and factual approach at understanding hair types and textures from a variety of women of color and their perspective(s). It also goes into detail about using relaxers to straighten hair, or pomades and other types of products that can be used to make African American hair more "soft" or "flexible." Yet, there is an abundance of websites that offer contrasting perspectives, such as accusing women of color of wanting to look "white" by way of using these types of products. Again, another way to confuse the population, and keep us "necrophilic" or in a state of numbness (Freire, 1970) when it comes to beauty, ideals and standards. Should we or should we not straighten our hair? Should we or should we not use a relaxer? To use or not use the flat iron, hot comb, hot oil treatment, a weave, or extensions. The problem here that *Treasured Locks* attempts to address is the diversity in hair types and textures. The website makes claim that since most women of color are "mixed" our hair types can range from extremely course and dry to that of what white girls have (but it does not give detailed description on what they claim white girls have). Unfortunately, what is not often mentioned is the fact that white women also have variety when it comes to hair type and texture, and sometimes their hair can be as coarse or "kinkier" than women of color. However, it becomes a problem when others do not understand the diversity in our hair, which leads us to further damaging our appearance. It takes a lot more legwork and research for women of color to understand their hair and ways to take care of it.

A small social experiment that I have done for years, and have encouraged many of my students to engage in, has been to visit the variety of major drug store chains and neighbourhood pharmacies to begin searching for products that all women can use, as opposed to just women who do not classify as being of color, or as having

"ethnic" hair. The same results are drawn from this experiment repeatedly. Products specifically geared towards women of color, whether young or old has been stocked in the same aisle as "regular" products, but there is a single column dedicated to "ethnic" needs (hair and skin). In this single column of products, you can find, bleaching cream (for skin), pomades and greases, specific oils and conditioners, and/or hair growth serums (usually only a couple of bottles or containers of each). There are hair colors or semi to permanent dyes with black and brown women on the box's cover, and a variety of hair relaxers. We are again confused by our ideas of integration (shopping and buying products from the "regular" section) or segregation (shopping and buying products from the one single column of products "dedicated" to "ethnic" needs). Not all hope has been lost. For years, women of color have not had to stick to these major drugstores or beauty-laden pharmacies for products to help beautify. We can now walk into stores in predominantly black and Latino/a neighborhoods throughout New York City and its five boroughs that specifically sell "beauty supplies." On sale usually, one can encounter tubs and vats of hair gel, or deep conditioners, and pay less than what we would at stores who do not give a damn whether we have alopecia or not. We do not have to walk past hundreds of colorful products that we cannot or should not use if we do not want to. We can walk straight through five or six aisles with endless shelves and pick up the products and other "things" that we want. However, the stores are not as attractive. Tucked away on less-than-desirable blocks, or big and bold on the street corner, the stores usually have a factory-like appearance on the inside. The problem here with these stores is not the lack of experts who will either run to your assistance or treat you as invisible. The problem is whether or not you *should* even be in the store, and whether or not the store's "expert" feels s/he can help *you*.

My sister and I who do not have coarse hair (but it is very curly), have frequented several beauty supply stores and have been given a slew of dirty looks by shop owners. I have been told that I have "good hair" so I really do not need anything from that particular store, but "regular" products would and could work just the same. "Experts" do not run up to help us; instead, we are the ones I refer to as members of the invisible group. There is a lot of promotion of getting people to try and understand the variety of hair within the circle of women of color (for example the *Treasured Locks* website), yet many of us are not treated equally. We have been turned away by many salons who simply state "we're full" or "we don't have any more room today," or by stylists who roll their eyes when we walk in. This happens at both white salons and black salons alike. I never have a problem however, if I decide I want to get my own hair braided. At least seven to ten African women on the corner of Harlem's 125th street train station will stop and approach me asking if I care for "hair braiding today." In fact, they have been eager to escort my sister and I into their tiny shops, sit us down and set us up at a stylist's chair, as we nervously eyeball her stylist's table, full of various aspirin bottles (for customers not the stylists themselves). Our hairs are braided within the hour, we tip well and exchange several "thank yous" and "you're welcome" and we move on out of the shop. We walk into a Latina salon (typically Dominican)

and are immediately noticed. It has been said, we "look Dominican" (whatever that means, because variety there is no anomaly) so service is rendered immediately or delayed when there is a rush. We are not really asked what we would like, the assumption is that we want our hair blown out straight, so we get a wash, get rolled up in domestic hair rollers and told to sit while being tenderly placed under a huge alien-type hair dryer for an hour or more. The culture of the salon is another book indeed, but the work that goes on there is worth a mention here.

Many of the salons of color serve as a communal for women, where stories of "disgusting" husbands, boyfriends and baby-daddy dramas are shared. The joys and struggle of being a woman are told, and the "he said/she said" narratives are explained in great and graphic detail. Stylists know their customers well, and customers know of and about each other in many ways, as they exchange urban stories and alcoholic cocktails. It is a small family, and this is obvious. What turns sour is the familial type of bond that is created to the point where the salon is just another clique, where the "popular" women of color frequent, and get preferential treatment. This can be used in comparison to my sister and I being treated differently in many of the beauty supply stores we have frequented. A stylist took so much time in talking to all of her customers, that she completely forgot I was sitting in her chair. It was as though I did not matter. She did spins and circles around me flipping my wet hair from side to side, complaining about my split ends while chatting with a regular customer. I figured that it was the way of the salon, and not a big deal. She then began talking about white girls' hair and how they all wanted black styles, and then looked at me and stated, "no offense girl." Sure I was not immediately offended, as the clique looked on, but I knew she was referring to my hair as being that of a "wannabe white girl who hangs with girls from the hood." All I had asked for was "a wash and blow," same as I would at a white salon that charges $160.00 for nothing stellar. What I began to feel and understand was a new-day brown-paper bag test; "Too light" and too much "good hair" to be black, and "too dark" with "ethnic hair" to be white. Who then would save me from hair damage? How can I be sure that product speaks to me and I can use it? Again, being of color, takes a lot of legwork and research, more than anyone else. If not everyone understands the diversity of our hair, and magazines continue to celebrate the longhaired (weave) beauty, then young women of color are called to responsibility to recognize their own diversity. Homework should be done and one must continue to force one's self into cliques in order to get the care and attention, that one needs. It is not mandatory to actually *become* part of the hair salon clique, however, demand that service is provided to you in the same fashion and form as everyone else or walk out, take your hair, and money elsewhere.

More serious than perhaps the treatment of customers in particular stores and supply shops, is a case of discrimination against women of color because of their hair in "professional" settings. The *Treasured Locks* featured a forum post regarding an African American female in the United States Air Force that was discriminated against for wearing her hair in braids and being classified as having "dreadlocks." Clearly, another example of the popular style of classifying one style as every style without recognition of diversity. In 2007, "Kim," an Air Force active

member was required to either cut off her hair or face dishonorable discharge. Her mother asked the owners and online forum community members of *Treasured Locks* to launch some awareness among the hundreds of women of color who frequent the site and elsewhere on the Internet. The dispute was over a hair type and style that appeared to be between the margins of braids and dreads. Although Kim kept her hair and style neatly tucked away under her Air Force headgear, the government institution still frowned on it.

According to *AFI 36-2903, Dress and Personal Appearance of Air Force Personnel*, it is stated that dreadlocks are not allowed. The *Treasured Locks* blog continues to ask women of color to support each other and "Kim" and by putting pressure on the military to discontinue what they consider as a discriminating practice (Treasured Locks Blog, 2008). The flipside of this argument is the act of wearing hair in stylish dreadlocks or dreadlocks not naturally born into such. Another battle between people of color may come from cultural misunderstandings or misrepresentations of cultural practices. Many West Indian communities resent what they deem as "processed" dreadlocks (getting them taken care of salon-style). The *Discrimination in the Military* piece written by Treasured Locks states, "There is no good reason to ban neatly groomed, locked hair and doing so creates undue hardship on women who refuse to put chemicals in their hair and do not want to chop it off" (Treasured Locks, 2008). Biblical and religious doctrines and documents, make references that dreadlocks are indeed steeped in religion (Christian Bible, Hindu Scriptures, and Rastafarianism) and thus keeping them "neat" by way of treatments or salon work is a misrepresentation or misuse of such cultural and/or religious practice. Many American white youths have also adopted the "style" of hair as a rebellion to conforming to societal standards and pressures of looking a particular way. Apparently having a "choice" is no real "choice" for young women of color. However, the military is a tricky and interesting organization. While *Treasured Locks* claims that there may be no good reason to ban the particular type of hairstyle, the military (all branches) pride themselves on uniformity. Outside of race, gender and physique, every member resembles the other in some way, specifically when in uniform. It would be difficult for the military to consider when it is acceptable to have dreadlocks for some, and others not. We have to consider, if "Kim" is allowed, what about women who choose to dread their hair outside of the reasons of maintenance and the use of harsh chemicals? What if it is solely about choice and or cultural practice? With organizations such as the military, it almost seems to be an oxymoron to ask those in military-based positions of power, to understand culture, cultural differences, and cultural practices while running a uniformed society of men and women who already differ by race. Others would argue as well that sexual orientation in the military is a much bigger fight than hair and/or hairstyles. I can only ask whose oppression is worse and is that even worth finding out? Imagine the case scenario if "Kim" was an open lesbian, black, and wore her hair in dreadlocks? The fight might take on several different forms of discrimination. What does hair represent to the military that perhaps we are missing in trying to understand why it is banned?

Makeup or "masking" as I tend to call it, is another issue when it comes to women of color and issues surrounding beauty. Thankfully, I do not wear make up, except on special occasions like my wedding day, but I am very much into the D.I.Y. (Do It Yourself) movement that has been surfacing up again and gaining lots of interest among young women. In fact on my wedding day, the price (for their service) of several interviewed make up artists were absolutely absurd. One even stated that my husband would "absolutely love the false eyelashes" she wanted to apply. When I refused the suggestion, she shook her head at me very concerned. I know had my husband lifted my veil and saw prehistoric looking eyelashes, he would have jumped in fright. I was just nervous that they would fall off in the middle of something public and festive. I asked for whatever she considered "basic." She had no idea what I meant, because I do not ever really wear make up, unless lip balm that costs one dollar and nineteen cents at the pharmacy counts.

My sister and mother as well, are very DIY-type of girls, very hands on, and much of what can be done on their own is done as such. Being a member of several online chat and community forums that are dedicated to all things DIY, I began to search for videos on "women of color" and "beauty." Wading through the pornographic Internet waters, and being blinded by images of breasts, derrieres, hairy and hair-free vaginas, and explicitly abusive language, I finally found something of interest. On the *Expert Village* website (www.expertvillage.com), one can find a variety of videos on any interest in particular, "women's issues." Usually, I depend on my sister (my only source for contemporary beauty tips), and when she is not available, I cringe at the thought of having to visit a salon or cosmetic store for several reasons: (1) The salon's clique as described above, (2) the beauty supply store shuffle (also described above) and (3) the pushing of products that are extremely expensive and do not necessarily apply to me, only the saleswoman's commission. On expert village, I found several videos on "how to" for women of color. Many of the videos that I saw, I also recommended to my female students who have encountered any of the three categories of discontent above, or any new variation of that type of experience, and asked of them their opinion. Interestingly enough they were supportive of the videos, because they felt they learned new beauty tips. For many young women of color, it is impossible to afford fifty-dollars on a single eye shadow or lip-liner. The cost far outweighs the desire to be "beautiful" in that moment. After typing in "African American Skin" in the expert village's search box, 199 videos were listed. Some of the areas and its videos available for viewing are on the topic of makeup application and choices, as well as hair issues. The variety of information that was left to be read ate one of my entire afternoons and I was completely overwhelmed and anxious by all these "tips." Most of the methods I had hoped to try even though I do not typically classify as having "African American hair" and the "regular" products seem to dry out or help to either weaken or clump up my hair.

Why is the process to becoming beautiful so tedious and such hard work? Do we not as women resemble "sugar and spice and all things nice" already from the outset? Who are we presenting ourselves to be in this day (made up/make up) that

we are not when at home (not made up with makeup)? We put ourselves through so much extra struggle throughout our gendered lives, and sometimes we become complicit in this type of oppression, and complacent in our reactive behavior. We have so many issues when it comes to beauty, that by the time we doll ourselves up, we are still seen just as "exotic" as we did without all the additional work. What is our aim? Is the aim not to be beautiful or more beautiful than the next girl, or is the aim to stay away, far away, from being ugly? Without casting huge generalizations, many women wear make up simply to enhance their existing beautiful attributes, but other women fear leaving their home without covering their faces in pounds of foundation. Like the *Booty Pop Panties*, have the flaws vanished permanently (without make up and without padded panties)? Even makeup is competitive among women. Specific brands for specific types of women, and only when most of us see advertisements with or commercials for companies using famous celebrity-branded products, do we feel secure enough in buying them. Still, we are never encouraged to buy makeup that is affordable. It simply is "not good for your skin." At a cosmetic counter at a very expensive department store, I was talked into a buying an eighty-five dollar bottle of face tonic, works great, and lasts very long, but the price I was too embarrassed to return the item, after hearing it. My purpose at the counter was to buy a gift for someone who *actually* does wear makeup, instead I walked away being prescribed something to "take care of that already beautiful skin you have. You don't want to get wrinkles yet and your skin is so lovely." Unfortunately, months of use of the tonic created dark marks on my face and left me feeling even more self conscious than before.

In keeping with the idea of what inspires or what popular culture offers us in terms of the prerequisites of being an "attractive" or "beautiful" woman of color, I again began my DIY search. Music videos, magazines, and even the sex-ridden columns and pages of *Cosmopolitan* magazine seem to offer up superficial examples. For young women of color, the pressure to be beautiful and add "sexy" or "appealing" is enormous. We do not fit the stereotype of the "all American beauty" historical or contemporary, and we cannot all give the same as what Halle Berry or Buffie the Booty's may offer a television screen or magazine spread. We resort to coming up with ideas of our own. A wikihow.com article lists nine steps or ways to be a "sexy woman." Race not influenced and non-consequential to this endeavor, or so it seems at first glance. The steps listed are:

- **Get Clean**. The article recommends that you bathe daily, because feeling and looking clean is crucial.
- **Practice Good Dental Hygiene**. Brushing, flossing, using mouthwash.
- **Get Groomed**. Toenails and fingernails should be cleaned and underneath the nails as well. The article also recommends using a beige nail polish as opposed to a fancy-colored one in order to hide discoloration. (Beige does not always look great against every skin color).
- **Style Your Hair**. Along with the recommended trips to the salon or doing something different and not dramatic, the article makes reference to studies that show "most men are attracted to long hair." Obviously, this cannot be applied to

everyone and it is also quite obvious now that the article is written for a particular type of woman (heterosexuals with long hair).

- **Create Winning Skin**. Not all skin is the same, but the article does not make reference to the variance. This tip also recommends using a self-tanner lotion, two shades darker "if you have pale skin." Darker skin should use a bronzer "for a more natural sun kissed glow." How dark is the article suggesting? Maybe darker-skinned white women?
- **Show Your Style**. This point reinforces the idea that finding clothes that are flattering is easy if you just look. Curves are good, but make sure you hide fat rolls.
- **Take Up Dancing**. Interestingly enough, the recommended forms of dance for being "sexy" besides their suggestion of ballroom and ballet are hip hop, salsa and belly dancing. Since when is a ballerina not sexy?
- **Wear Make Up**. I grow tired of this requirement in order to secure a spot on the "sexy woman list." However, this point perhaps reinforces that the article is not inclusive of all women who aspire to be sexy. It suggests the use of bold red lipsticks, or "clear lip glosses" and "subtle pink lipstick."
- **Get In Shape**. Obviously no arguments there in terms of being healthy, albeit, I can go as far as making an argument here that the article is not inclusive of women who aspire to be sexy but also have special needs.

Once you wade through the porn (unless you find that to be sexy) again, the examples on the Internet similar to this article are infinite. Beauty is equated with sex and being sexy. It is not an examination of a woman's innards, and oftentimes it is not an examination of women of color either. Most of us can get angry, and begin to start Internet petitions, but it does not always go far. However, how do we feel when the models used look like us? Are we still angry, or do we support her efforts, and deem her as a "role model" as so many have done for Jennifer Lopez and Buffie the Body. I heave heavily at the overabundance of misrepresentations, the harmful images and ideas/advice given to young women of color in regards to their being happy with themselves and who they are. Their bodies and what they have and will encounter because of their race and gender, are lessons that cannot exactly be taught in any book, but rather should be taken into a level of importance in understanding the future of the body. Not one of these articles in the variety of popular magazines that suggest they are "for all women" talk about being young, of color and feminist or understanding their place in the world as women of color (not even black and/or brown magazines). Now wireless service providers like Verizon and Alltell offer wallpapers than can be downloaded directly onto a cell phone of young women of color that are deemed by their companies as "sexy" with "voluptuous curves" and "beautiful assets" (2008). I am reminded in this moment of the books at the popular Barnes and Noble in my area, where among the young adult section and shelves, the novels and series books are geared towards white girls, but the non-fiction books offer tips on how to be sexy and smart (all results from being solely confident). Is confidence enough for young women of color?

There are several issues about self-image and ideas regarding beauty that young women of color face that do not ever get the attention it deserves. Naomi Wolf's

national bestseller, *The Beauty Myth* (1991), lists in its index a one-page reference (one line) to black people (not even black women). We are reduced to a historical and simple reference. In her argument, Wolf makes the assessment between black men and white women, she writes,

> A black employee can now charge, sympathetically, that he doesn't *want* to look more white, and should not have to look more white in order to keep his job. We have not yet begun the push toward civil rights for women that will entitle a woman to say that she'd rather look like herself than some 'beautiful' young stranger (55).

For Wolf, the argument here can be understood as a semi-extraction of the woman of color from this conversation. What about black and brown women who are in the same position oftentimes as the black man but also suffers against the pressure of having to look like a "beautiful young stranger?" (Wolf, 55). The black and brown woman faces both dilemmas and has to push harder to make her mark in the world as someone who is beautiful, young, but still herself. It is unfortunate in many ways that Wolf does not include women of color into this context for the suffering is obviously similar and in this case much more oppressive.

Clearly there is a myth about black and brown beauty as well, like many women, there are so many instances in which we knowingly and unknowingly help to perpetuate the *urban* truths to this myth. Issues that need more addressing such as: although white(s) or people with lighter skin also get skin keloids; African American and/or darker skin is prone to keloiding when cut and the scars sometimes impossible to get rid of. When we get pimples or zits, we do not turn red and blotchy, we oftentimes swell and when tempted to face-pick, we leave large welts on our face which turn dark to black. "Keloids occur in individuals with a familial disposition among the blacks, Hispanics and Orientals, they enlarge and extend beyond the margins of the original wound and rarely regress" (Meenakshi and Ramakrishnan, 2005). HIV/AIDS ransacking young female bodies of color, lupus, sickle cell anemia, high blood pressure, diabetes, asthma, obesity and other health issues that consume black and brown communities are strictly related to health magazines or self-issued and inspired Internet research; but not normally do they take up space in any article that talks about young women of color and their struggle with beauty. To this end, it is a common practice to exclude girls of color from the anorexia and bulimia conversations. The invisibility in this conversation is false and extremely dangerous. Not uncovering and disclosing the many young women that suffer from such a horrible disease, kills them off faster than we can imagine. Unfortunately, when anorexia plagues young women of color, many write it off as a phase, or an attempt at being white:

> Anorexia is overwhelmingly absent from black society because the ideal body type white girls seek is not an ideal for black girls. The cult of thinness is not a cult black girls tend to believe in; the disappearing waif is not a figure that holds any power over them. The anorexia findings, and the difference in ideals they point to, illustrate that there is no one story of girlhood, because there is no one set of ideals called the feminine (White, 174).

It would almost appear as though being overweight to the point of obese is not of clear-cut concern among women of color. While we understand that having a particular type of derriere that is appealing and enviable, it is important to understand that there are still pressures to be thin in communities of color just as there are in white communities. What this type of analysis does in fact is continues to silence women of color from confronting their issues with body image and/or eating disorders, since it can be said these illnesses are "white girl diseases."

Beauty comes in different forms however. Obviously, it is not only in how one appears, in body. What you wear also plays a role, and how you wear it also is a key factor. Women check out each other's shoes, but not just the shoes, but how the woman is wearing them. Is her dress hideously ugly, but is she wearing the hell out of it? Who did her makeup? Her hair is a mess! What is with the acne at this age, as though there is an age-limit? The list goes on and on. Unfortunately, this is one of the ways in which all women resemble each other in their competitiveness for "top beauty." Again referring to the historical and oppressive divide between the Hutu and the Tutsi women, the divide that the oppressor has placed between women of color still exists. The good-hair versus bad-hair fight has been a long withstanding one and the pressure of examining beauty is full-fledged and still at large.

Dress Code and clothing is another factor in how the oppression of young women of color, particularly black and brown, struggle against stereotypes and society's prescription of norms. In particular, low-income communities of young women of color are forced into prescriptions of what "designers" pump out of their factories as the ideal "outfit" for them. Without recourse, resources and socioeconomic access, many girls in these particular communities depend on these stores just as much as they depend on music videos to indicate ideas to emulate or fashions to aspire to have. Once the celebrities have grazed our television screens with their highly expensive wardrobes, young women are left hungry for more. While they may not be able to purchase the exact outfit that their favorite entertainer appeared in, they are drawn closer to the designer when s/he puts out their own line of clothing. Jennifer Lopez's line JLO, which includes not only clothing and accessories but fragrances as well, offers buyers a 3.4oz of her fragrance *Glow*, sold at Macy's department store for fifty-eight dollars. Britney Spears' fragrance *Fantasy*, runs at fifty-five dollars for a 3.3oz. Jessica Simpson also offers clothing, accessories, and fragrances, as well as a line of hair wigs all in the seventy to hundred dollars plus range(s). In 1989, Debbie Gibson (now known as Deborah Gibson) released her fragrance *Electric Youth* distributed through Revlon, which has now faded in popularity and priced at sixteen ninety-nine. Hip Hop entertainer, Nelly released his line *Apple Bottoms* in 2003 in which he launched a model search, complete with celebrity judges, looking for the best representation of an "apple bottom" for his Apple Bottom company. Taken from the company's website,

> He describes the intent behind the design by saying, 'A woman should not try to fit the clothes; the clothes should fit the woman!' His creative team of designers created the perfect fit for different silhouettes that accentuate the

curves of all women. Nelly is personally involved in the process to ensure that the designs enhance the beauty of the woman who wears them (www.lifestyle/applebottoms.com).

As with most cases, women are not making their own choices about the enhancement of their own beauty, but rather this decision is based on what a male decides best suits them. After all, is it not the appeal to a heterosexual man that is the purpose of how we put it all together on the outside, and how we will then put the pieces back together on the inside?

In various lower-income neighborhoods within New York City's five boroughs, there are a variety of stores such as *Pretty Girl, Mandees, Coqueta of New York* (coqueta: the Spanish term used to refer to a female flirt) and a slew of similar stores. These stores and many like them all host the same type of outfit, revealing and non-normal fitting, whether slim or not. To say that the clothing is geared to a particular type of girl of color would be to look at the situation only through half a lens. The idea behind this is the inspiration of such. Again, we cannot blame entertainers alone for creating an atmosphere where young women aspire to look just like them. That again is only half the battle.

The larger problem here is why these stores are only available in low-income neighborhoods that are heavily populated by black women and Latinas. The stores on a Saturday afternoon looks like the moment before, during and after a stampede. Girls of all sizes are all looking at the same outfit, and in my mind, I struggle to think how any one of them would fit into a particular pair of pants. The clothes are made using cheap material, are not one-of-a-kind, and are on cheap plastic hangers, huge garbage bins (disguised as clothing bins), on the floor, or spread out onto a large table used at most places for a picnic or BBQ. Fitting rooms are covered by semi-standing wooden doors, or plastic shower curtains, and women wait on lines to try on these outfits including lingerie and hosiery (more of a sanitary alarm here than anything). Young girls of color giggle over the selection of thongs, g-strings, push-up or gel-filled bras, see through teddies and nightgowns that are short and tight (clearly not for just sleeping through the night). Most times, there are not many items in the entire store that cost more than twenty dollars. At this price, it creates the stampede-like atmosphere with ease. Girls and grown women push each other as they ransack the bins and tables, and male employees walk through the aisles looking at the women while looking for shoplifters. In many of the stores, a male employee sits atop an extremely tall ladder outside of the store so he can oversee where everyone has their hands. Yet, women continue to patronize these stores because a department store is nowhere in sight (in some of these neighbourhoods), and why buy a pair of jeans for seventy-eight dollars (Apple Bottoms) when you can purchase a pair for five dollars? In short, much of the items look very nightclub appropriate. However, these young women of color are not waiting for nightclub nights, they are purchasing these outfits followed by wearing them to school the next day.

A young girl of color who lived in my neighborhood at one point (between the age of ten and twelve), transformed overnight it seemed. One day she visited with her neighbor's daughter, and they played with stray kittens found in their backyards,

the next day, she was patrolling the block in a midriff top and skin-tight "skinny" jeans (although she is not so skinny). I watched as this young girl's wardrobe became increasingly adult and revealing as the months were passing by. When asked where she got the money to purchase her "nice" clothes, she responded to her same-aged friend, "If he [her boyfriend] wants me to look good he has to buy it right?" They laughed, and I felt my nausea rising to my mouth. Being a Latina, this young lady was very immersed in her culture. She knew Spanish well enough to curse at the young boys who taunted her by calling her "slut" or "chiflera," and she knew how to dance very seductively as cars passed by blaring tipico or reggaeton tracks. She oftentimes danced for passing cars (with young boys in them). Watching her carefully, I watched as her body developed and sprouted into a forced-ripe woman before my eyes, years had not passed only months. She approached her front yard several times with shopping bags from any of the stores mentioned above. Oftentimes one would catch a glimpse of her with her hip cocked to the side approaching grown men on the street (whom she knew from the neighborhood) and engaging in adult conversations. Eventually she moved. A neighbor repeated that she moved because she had had sex with a boy and her mother was not happy that the boy still lived so close. Where did they move? Perhaps, out of the neighborhood that promotes the kind of activity she was engaging in? No. She moved up the street from her previous home, maybe two or three houses up from where she was originally. The boy seemed to be the biggest threat, not herself, and not the environment that was swallowing her innocence two gulps at a time.

Some would argue and say clothes do not make the woman, but we really do begin to confront these issues that prove that, and other types of talk like this as false. These girls are clearly unprepared for job interviews in corporate American positions. Philippe Bourgois has a great example of this in *In Search of Respect: Selling Crack in El Barrio* (1994). A leading character in his extremely successful ethnography on Puerto Ricans in El Barrio amidst the crack epidemic was the pinnacle of unprepared for the "real world." Candy had two bouts with the dress code of the world outside of her "ghetto" environment. Candy appeared in court with her hair dyed blonde and a "bright red jumpsuit" to which the judge ridiculed and made her feel less than put together, as she would be seen in the eyes of her peers in El Barrio. The second instance of her humiliation, indicates that Candy was showing off her new "yellow jumpsuit" to her boyfriend and his mother, on her way to class. Her boyfriend at the time explains to Bourgois that he refused to "dress up" for interviews himself because he overheard people talking about Candy appearing "tacky" (Bourgois, 1994). Candy cannot be entirely blamed for her choice in outfit. What was her example of "appropriate" dress before she purchased her jumpsuits? People in the neighborhood set the example, and the stores that are available in the neighborhood, similar to other neighborhoods like it, place great emphasis on sexy/sex, as well as the examples and pressures provided through their television sets. The emphasis on a woman of color to be sexy in these neighborhoods is more important than preparing them for gainful employment and a life outside of their cycles of oppression.

With situations like these, it seems people would like others to think that there is no hope for young women of color. In white or well-to-do neighborhoods these stores do not exist, people generally do not dress this way, and if indeed the outfits are purchased, it is not worn in the same way. Because of the voluptuousness (not "fat" nor obese) that is so highly revered among women of color/men of color, clothing obviously will fit differently, tighter and more closely fitting. While wealthier white females are wearing Abercrombie and Fitch across their derrieres, and also engage in becoming self-employed walking advertisements for various companies, the world frowns on women of color who do the same. For women of color, when clothing fits tightly or close to the body, in particular items with Lycra or spandex, they are immediately sexualized. Add heels to that outfit, and it could very well be a "street walker" that we might be talking about. The cultural imbalances are far worse than young white girls who under their stereotype, hike up their catholic school skirts and flash men on *Girls Gone Wild* videos, or something similarly useless and nonsensical. There are social dynamics at work here more than there are with young white girls. By having these types of wardrobe possibilities, the factors involving the beauty of a young woman changes drastically. She automatically does not have to be known to have sex to be deemed a "whore." Comedian Chris Rock, during a set of his standup made reference to women who fight back against being called a "ho" because of how they dress. Although many of my male students find him hysterically funny, and there is some embarrassing truth to his comedy, it does effective work in making us understand how women of color are viewed. Rock goes on to claim that we do not approach someone in a police officer uniform and expect s/he to be anything other than a police officer, and so is the same for a woman dressed as a "whore." She is to be seen as the "whore" she is dressed up to appear as. The stores that host these various types of clothing help to perpetuate this cycle of stereotyping, and with young girls' lack of access and recourse, oftentimes it cannot be avoided. Also worth mentioning is the diversity of the slut or whore. Emily White, author of *Fast Girls: Teenage Tribes and The Myth of the Slut* (2002) explains that white girls who suffer at the negative connotations with being called a "slut" eventually feel a sense of isolation. For women of color (Black, Puerto Rican, and sometimes Mexican girls), when called "whores" or "skanks" find solidarity with one another (White, 2002).

With all of these pressures that young women of color face, and no doubt other young women as well (just with different factors), it is some wonder that young girls keep up with the times as opposed to just chucking it all alongside hopelessness and despair. The feminist revolution holds steadfast to continuing to break the cycle of oppression against women of color and their struggle to live healthy lives, one without societal pressures like:

The pressure to have sex, not have sex, keep the baby, have an abortion.
Speak well but not "too white."
Wear make up but not so much that you end up looking like a drag queen.
Eat well, but do not get fat.

Lose weight, but do not get too skinny.

Attract boys even when you are attracted to other girls.

Listen to hip hop and rap, sing the lyrics and emulate the artist, but do not aspire to be a video honey or "poisonous" ho.

Dye your hair if you so choose, but not blond because you might look like you are trying to be a white girl.

Look appropriate in "professional" settings, but stay "black" and don your afro or dreadlocks proudly.

Smoking cigarettes is for white girls and boys, lighting a blunt is an urban community dealmaker.

Do not drink and drive, but a little Crystal every now and again like a celebrity, is a sign of wealth and shot-calling.

Can't afford what the entertainer has, steal it, but don't get caught.

Forgot your name, get it tattooed…on your neck.

All these conflicting images make a person nauseous. Within the tornado of images, societal pressures, peer requirements, family structures and responsibilities, ad hominem ridiculing and behavior is what begins to deteriorate the young woman of color, to the point at which she is exhausted, lost and confused.

At best, we, as women of color should really be trying to take care of each other if we see we are not taking care of ourselves as individuals. There are so many supportive Internet (especially and in particular blogs) resources that support young women of color, their issues, their concerns and triumphs; I also worry about girls without this type of access as well. The dependence on television and print media can be replaced with a bit more solidarity in our real lives and in our real homes. A first plan of action might be investigating, understanding and breaking through and past the psychologically damaging effects of intra-racism. Part of this struggle is understanding that women of color and beauty not only needs to be understood by those who are outside the circle of women of color, but by our own community as well. For example, we need to accept that all Asian women do not always classify as white, and they too struggle with issues of beauty. In fact, many of their oppressors also oppress young Latinas and black women as well. Asians and South Asians fall into the trap of what music lyrics and magazines promote for them to try and embrace as "beautiful" as well, but more of an "exotic" beauty. Certainly, we know this to be true as in the x-rated version of 50Cent's P.I.M.P. video features a topless Asian model that unfortunately for her, we notice her strange looking breasts before we recognize that she is Asian. We need to understand and accept that Latinas come in all different shapes and sizes; some are sick and tired of being compared to Jennifer Lopez and Salma Hayek. It is not that hard to find beautiful, sexy, hardcore, or soft in her core, women of color, both young and older, both lesbian and straight, married and unmarried. Women of color come in so many various shades, shapes and sizes that it is hard to classify us into a single category, such as "black" or "Latina." It is our diversity that should be adding to our definitions of beauty, not adding to our psychological trauma. If we say we are women of color, please accept us as such. There is more than just black and brown that makes us up, and more to what society's pressures

try to define us by. If we say we are pro-black, believe us by the work we do, not how we wear our hair or by what types of messages we have on our t-shirts. If we speak well, use the "Queen's English" when in regular colloquial settings, do not attempt to call us "sell outs" or "white girl" we are proud of our degrees in higher education, as everyone should be. We set the whole race forward in our progressive actions; they should not always be classified as individual achievements. If we decide we want to classify ourselves as "woman of color" do not attempt to think we are somehow self-hating or refusing to identify with the boxes provided for us. Please refrain from identifying every Spanish speaker as "Spanish." Native Spanish speaking women also have dualities in their oppressive struggles, expressions and living identities. If our parents are Guyanese, but we were born in the U.S. and thus identify ourselves by stating we are American born, but of Guyanese decent, please take the time to understand the significance. Do not ask us where Guyana is and whether or not they speak English there. Get a map, a cartographer or a clue.

Young women of color have far a harder time succeeding and accessing the tools to mentally equip themselves against these conflicting messages and damaging stereotypes. Oftentimes, we are more than triple threats. The psychologically altering effects of racism and intra-racism, color coding or colorism helps to continue our oppression, and makes it harder for younger girls to get by. Definitions of beauty have been historically laid out for us, but it does not mean we have to continue our subscriptions to them. Every time I have a headache, I do not always reach for aspirin. I work through my headache. Every time a guy makes an offensive comment as I walk past him on the street, I do not turn around and confront him, even if that causes another remark from him, such as the popular "you're a dyke anyway bitch!" Remember it is not he who defines your beauty, and stopping to engage him, gives him fuel that should not be so cheaply exchanged with anyone.

TELEVISION, MUSIC, AND THE AMERICAN IDOL HYSTERIA

Like many others in the United States (that have access), I have become reality television addicted. Television today is definitely not a thing of the past. I rush home to catch shows that would never have aired when I was growing up. My 1980s television-watching schedule every day after school, if permitted, followed something like this:

5:00 p.m. – Diff'rent Strokes
5:30 p.m. – Facts of Life
6:00 p.m. – What's Happenning!!
6:30 p.m. – Three's Company
7:00 p.m. – Jeopardy

Now I find myself paying close attention to a different line up. Each day is another television program that I have labeled as my "favorite show." Missing episodes is also a thing of the past. Whatever I miss I can catch online through the show's website or another website that offers full episodes. Either way, I am fully connected and kept in the loop as much as I allow myself to be. The over-thirty something in me has become addicted to teen-oriented soap operas just as I am addicted to teen novels. I find I am constantly flipping between The Learning Channel, Style Network, Martha Stewart Living and Do It Yourself Shows (DIY) and the Noggin (A Canadian Broadcasting Channel simply referred to as the "N.") However, I am very much inclined to watch shows that bring me back to high school moments of questionable gender, racial and class themes. Safer now because I no longer am a high school student or a college student, I can watch these shows from a distance without the pressure of trying to figure out how to emulate what I see. However, I can turn on my academic bricolage with purpose.

For many young women of color, in particular, some of my own college students, there is a dependence on these shows to help them get through their questions and struggles with gender identity, just as I had done with the ever-corny *Beverly Hills, 90210*, which to no surprise recently made a comeback. Although they try to fight it verbally, many of my female students have told me that they wish they had an opportunity to be on *The Bachelor* or *Who Wants to Marry a Millionaire*. My students, although painfully, become addicted and agitated by MTV's *Super Sweet Sixteen* because "I ain't never had no sweet sixteen birthday party like that, in fact, I aint never had no birthday party at all!"

What various television programs have done for many young women of color, is given them a visual reference for their self-esteem issues, without recourse. My students often tell me to "stay away from television" because my hypersensitive

racialized sonar is at full blast any time I am distracted by the glowing hue of the television in my background. I am immediately drawn into a misrepresented world of race, gender, sexuality and all things that remind me of my junior high and high school moments of girlhood. Halle Berry's performance in *Monster's Ball*, does not inspire me to want to be an actress, rather I am confronted with my own characteristics of "prudish" behavior. I walk down the streets of New York City on a daily basis, still taking in the sights as though I was not born and raised in this concrete jungle. However, I have not heard of many times of women of color being "discovered" just walking down the street. Even though I have been approached on the street by young men (both white and black) who have asked, "are you interested in modeling? You should call me." Our bodies of color have been so long subjected to being oversexualized, that I did more than hesitate to call the number on the sleazy business card. I dumped them.

Breaking out of the cyclical oppression of everyone wanting to be part of a larger social atmosphere, many young women find a private obsession with social acceptance through the programs they watch. Could I, if discovered suddenly on the gritty concrete streets of New York City, play opposite Thornton in *Monster's Ball*? No, certainly not. It has nothing to do with *his* race it has to do with mine. As a young woman of color, I realize how many cultural bodies similar to mine are (mis)represented on television, both historically and in our present day.

To my heart's content, *Beverly Hills, 90210* (BH) has returned to television after being off-air for close to ten years. Unlike the original BH the new return includes a black character, and to no surprise it is a male. What kind of message permeates through the television waves when a very popular show is off-air for an extended period of time and returns to television with a new generation, and still hosts no diversity? I do not want to fail in mentioning that there is no Latino/a character either. Perhaps the goal is to strengthen acceptance of on-screen and young interracial relationships? If so, this is not completely faulted. However, the idea of a young girl of color and a white male, may seem as though it is difficult to cast unless overtly sexual in nature, and certainly not meaningful. Alongside BH, comes *Gossip Girl*. Having been a fan of the book series, and unfortunately not being able to keep up with all of the books so rapidly published, the show hosted on the same network as BH offers a visual to the text. As "juicy" as these teenage lives are, again, they too are predominantly young and white. I have no real qualms with the socioeconomic bracket of the characters. They are wealthy and this factor is accepted without hesitation. In fact, one is drawn closely to their high socioeconomic-based lives as though there is some type of connection, and is immediately immersed into the program. However, I hesitate to believe that the women of color that are cast for these various shows could be more than a token. Interestingly enough, I have hardly ever seen young women of color in the halls at school (on the show), or even on the street (on the show). How is this possible when the show *(Gossip Girls)* is hosted by New York City as the backdrop? No matter how wealthy the environment, you will run into someone of color, and women outnumber men in this city two to one, so where are we, or is the ultimate message that we are non-existing in these worlds? Similarly, people complained

about *Seinfeld* and *Friends* for their lack of on-screen diversity, both shows also using New York City as their backdrop albeit a humorous script.

The longevity of the stories, the roles, and the excitement behind the shows has almost subliminally forced viewers into giving up the struggle for accurate representation. It is almost believable that young women of color only want to be something else or anything other than young women of color. They do not really have great or leading roles in shows, and its almost believable that they are not wealthy only aspire to be of such. They are not elegant, only "hood-like." They do not have social graces, they only use slang versions of English full of ex-rated dialogue. They have reckless sex, get pregnant, and choose abortion as their preferred method of birth control, and when they want to have some fun, they do not attend soirees, they gallivant along the streets of the "ghetto." Truthfully, along with reading materials, young women of color are experiencing invisibility within relative television programs as an outlet of entertainment. For many young women of color, watching television programs becomes an activity with racial connotations, whether "cryptic" or "overt" (Kincheloe and Steinberg, 1994). Images of oppression, stereotyping and bias run rampant on various channels throughout the day and evening. Animation or cartoon programs, seems so innocent to the unknowing parent, but can also be cause for concern. The idea that television is simply filler in the lives of women can be seen as both true and false.

Obviously, the struggle for accurate representation or inclusion, does not begin at the high school/college experience, it begins much earlier than many of us would like to accept. In his essay, *Are Disney Movies Good For Your Kids* (2004), Henry A. Giroux provides a deep analysis into the work of specific films, characters and cultural production of childhood and/or childhood fantasies. His analysis of films like the *Lion King* (1994), *Beauty and the Beast* (1991), *The Little Mermaid* (1989), *Aladdin* (1992), explore the relationship of both gender and race individually. What is important to note here is how television makes even more of an impact when it affects both social dynamics at once. The gender argument that Giroux constructs is based on female characters in the above mentioned films basically giving up their female identity to the idea of securing a man or male counterpart in order to be happy or "free." Agreeably one of the defining moments of gender (mis) representation is seen in the *Little Mermaid*. Ariel (The Little Mermaid) is told by the sea witch (Ursula) that giving up her voice in order to gain legs and be with her desired male human fantasy is acceptable, because men do not really like women who "blabber" and girls who gossip "are a bore [...] True gentleman avoid it when they can" (1994). However, there are two more registers in operation here besides Ariel exchanging her talent or gift in order to "get her man," and does so for a man, who will not learn how to live underwater instead of having to live on land to be with him. So desperate she is, Ariel turns to Ursula the "sea witch" or the cecaelia for advice. Ursula is not only dark (voiceover is by white actress Pat Carroll), and hideously ugly, but in her musical monologue she explains to Ariel that she helps "poor unfortunate souls," also described by Ursula as "pathetic" women who long to be thinner (Ursula is quite heavy), and men who want to get the girls (1994). The negotiation between the sea of girls (Ursula's customers) then continues as

Ursula gives an explanation that the prince must kiss Ariel on this particular day, with the sunset being here and there. Similar to how women plan their sexual activities based on the moon and their menstrual cycle. Women here are not only subjected to Ursula's banter about what constitutes a male companion's search for women, it is worth noting that Ursula serves as the magician under the sea who engages in "bad" magic, and Ariel's father can conduct "good" magic. As with many of Disney's movies, the desired mermaid (the main girl) and the desired man (prince), are both white.

Poor *Mulan* (1998), she is not safe either from being depicted as a stereotypical helpless female, only she is Asian. Her bout to prove herself as a fearless fighter (regardless of the obvious that she is a woman), in the Chinese Army includes musical numbers and an adaptation of the real Hua Mulan's life. Although struggling to be accepted into the army, Mulan does experience stereotypical female tendencies, such as (1) falling down during training and hurting her derriere (the ever famous derriere makes it appearance yet again), (2) Is clumsy, (3) and possibly marriageable. Before Mulan decides she wants to fight in the all-male army, her female counterparts (mother and others) decide to prepare Mulan by singing to her:

> Wait and see, when we're through, boys will gladly go to war for you. With good fortune, and a great hairdo, you'll bring honor to us all. Men want girls, with good taste, obedience, who work fast paced" (Mulan, 1998).

Rejected by a potential suitor, Mulan launches into her solo of *Reflection* (1998) where she states in depressive tones, she may never pass for a perfect bride or daughter. Furthermore, being herself would ultimately break her family's heart. After being discovered as a woman, Li Shang (the film's fictional male army leader) saves *her* life only after she saves his, and later they fall in love after saving the empire. Her work seems for naught, as the love interest and story takes over the crux of the film; hence, the sequel *Mulan II* (2004), the story of their engagement and marriage.

Many of Disney's white princesses do not engage in hardships except being selected by a prince that they too are interested in, and the solidifying or unifying identity for all of the female characters is the "man/lover" as the end result of all struggle. Even with *Pocahontas* (1995), there is no detailed mention of her first husband (Native American). The movie is based around her being whisked away by Englishman, John Smith. Perhaps to give her more of an "All American" appeal, it would have been curious to promote the fact that Pocahontas indeed had two lovers in her lifetime (that we know of). The racial component of these characters and characters of some similarity is that they are not predominantly of color. Is the message for younger women of color to aspire to be a white princess who is out to get the best looking man while trading in her qualities as a woman and her attributes that would gain her some of her own popularity? Possibly.

Unfortunately, the trouble arises when we try to understand the effects of these types of messages into the homes and eventually the lives of young women, in particular girls of color. How many girls can remember being Cinderella for

Halloween? German brothers Grimm certainly did not have the woman of color in mind when writing their version of *Cinderella*, and finally did she appear in 2007, played by singer/actress Brandy Norwood as Cinderella and singer/actress Whitney Houston as her fairy-tale Godmother. Although the "black version" won several awards, the story is not the same, and by the time this came out, we were well aware that Brandy is not *Cinderella*, but "Black Cinderella" just not the same as the original. Intertwining these stories of romance with magic, Disney does a good job of attempting to distract the viewer and/or "poor unfortunate soul" (*Little Mermaid*, 1994) from recognizing misrepresentation or questionable racist connotations or infractions.

What do these television programs indicate? Do they ask that you pay close attention to who you are not instead of why you should be glad of that which you are? In some ways, yes they do. Elements and themes of race and gender play heavy roles within the concepts of these depictions. The everlasting questions: "why does the black character get killed off first or early on in the show" and "why does the woman always fall when running from her attacker?" still resonate as it did after Blaxploitation films became "classics" not the norm. Many people of color are still furious that Denzel Washington won his Oscar for his role in *Training Day* (2001) and Halle Berry in her grossly sexual scene with Billy Bob Thornton in *Monster's Ball* (2001). For some, it was perhaps much easier to stomach Denzel as a gun-toting, tongue lashing, six-pack ripped, drug dealing, gang banging, sexy crooked cop, than it would have been to recognize his skill as an actor and the image he portrayed as the iconic *Malcolm X* (1992).

While beautiful and talented in her role as Dorothy Dandridge (1999), Berry's perfect derriere and intense sex scene in *Monster's Ball* was what both black and white America wanted and did not want to see. No one wants to think about the tragic mulatto jazz singer who could not cope with her stardom so she offs herself. More than her well-acted role as Dorothy Dandridge, she wins her Oscar for playing a low-income, cheap and dirty looking woman (the "whore") whose son is obese and depressing and whose husband is on death row awaiting his execution. In her role as Leticia Musgrove, Berry becomes sexually involved with a racist prison guard (Thornton), who is her husband's executioner. How in the world that movie was even nominated for an Oscar is beyond my understanding of the film academy and its structure, so I offer no informed critique of the industry of Hollywood filmmaking. However, Berry not winning her Oscar for *Dorothy Dandridge* can be understood as an example of Patricia Hill Collins' argument regarding the black woman's body and her life as a cyclical sex object:

> Black women were used as sex objects for the pleasure of White men. This objectification of African-American women parallels the portrayal of women in pornography as sex objects whose sexuality is available for men. Exploiting Black women as breeders objectified them as less than human because only animals can be bred against their will (Collins, 135).

In her role however, Berry is not taken against her will, but consents to having this animalistic, "king of the jungle" type of sexual relations with Thornton, through

perhaps desperation and depression, but there is no negative struggle between the two, only aggression. It is clearly consensual. How her body is used in the scene gives Collins' argument much more of an impact. Thornton is the sexual dominator in the scene, as Berry begs him to answer the question of "can you make me feel good?" Was her role an example of the Venus Hottentot? Perhaps that would be a stretch, but not a long one. Critics have almost forced us to try to accept Berry's role in *Monsters Ball*, as her talent as an actress, shows the world her versatility and skill (Asika, 2002). Other critics, ask us to practically erase the damaging image in our mind of Berry and Thornton as the beast with two backs, and ask us why is anyone proud of her winning the Oscar for that role—critics ask whether or not many other actresses have won such prestigious awards for a nude sex scene. (Asika, 2002). Unfortunately, to many, the art of film is quickly replaced here by what novice critics would see as pornography any which way you try to paint the picture. "In contemporary pornography, women are objectified through being portrayed as pieces of meat, as sexual animals awaiting conquest" (Collins 135).

Indeed, Berry's character is in a subordinate position to her "lover." It is served clearly that Thornton's character is a prison guard, who has performed the execution of his black, female lover's husband. As mentioned, Berry's character questions of him (Thornton), in this rabid and drunken voice, "can you make me feel good?" In her questioning of him he begins to almost sexually assault her, and what perhaps looked like an on-screen "sex" or "love" scene, has now transitioned into her certainly awaiting for her desires, her pain, her passion and her body, to be completely conquered by this man who is in a position of power over her.

Berry's Oscar acceptance moment is almost comical. Something out of a weird Alice in Wonderland, just-want-to-laugh-because-I-don't-know-what-else-to-do kind of moment. As Berry's name is announced as the winner, the heads of several, extremely famous, and brilliant white actresses (many who have not done nude scenes) rise to their feet to applaud Berry. She looks absolutely beautiful, just as she always does with clothing on. Some of the expressions on her colleague's faces appear sympathetic or empathetic, as a hysterically bubbling Berry makes her way to the stage. As Berry reaches the stage, not finding her center long enough to compose herself, she is microphoned and still cannot gain her composure. Flash image of her then-husband Eric Benet, or rather, "the joy of my life" (as Berry notes him), who rises to his feet and gives his wife another round of applause. Weeks later, we find out he is a sexaholic and cheats on his beautiful, Oscar-winning wife. She continues her speech by stating that the moment is larger than she is, and her winning the Oscar is in the name of Dorothy Dandridge, Diahann Carroll, Lena Horne (both fair-skinned black women). She makes mention that it is also for the women that "stand beside her," Jada Pinkett-Smith, Angela Bassett and Vivica Fox. The women whom she shares her shining moment with, far surpass Berry's own young work as a young actress. Bassett as Tina Turner, and Jada Pinkett and Vivica Fox in *Set It Off* (1996), alongside the amazing Queen Latifah.

Berry's speech then takes a pivotal and sociopolitical turn almost instantly, as she cries into the microphone and states that this moment is for future women of color, or rather her direct quote, "nameless face" "that now has the chance, because

the door has finally been open." I hesitate to think Berry sacrificed her nakedness so that future young women of color may emulate with ease in hopes of the same reward. Followed by this, came her thank you, in particular her thanks to Oprah Winfrey "for being the best role model any girl could have." Clearly, I could potentially sound like a "hater," but this could not be furthest from the truth. I loved Berry in *BAPS* (1997), although the general public hated her in that role. I wanted to take care of her in *Jungle Fever* (1991), as she withered away from the crack epidemic that so convincingly affected her, and I wanted to buy every single Dorothy Dandridge record ever made because of her portrayal. I disagree with her winning the highest acting award for *Monster's Ball*, and I cringed when during her speech, the audience laughed because of her line up of thank yous (including one to her lawyer, and agents). Apparently, a seasoned actress does not thank these people at such at prestigious moment, but it showed Berry's innocence. Although Denzel Washington, and Sidney Poitier also won Oscars that night, and Will Smith received a nomination, Berry's role as Leticia Musgrove was clearly an indicator of what so many women of color fight against—their (mis)representation as being solely sexual, with a million dollar "ass shot." No one, I doubt, remembered her acting skills in that film (except for "can you make me feel good"), nor did they recognize how far she had come as an actress by that point. She is remembered in *Monster's Ball*, as the Venus Hottentot of her time.

Halle Berry is not alone. What she really did is make a name for bi-racial actresses, not women of color overall. Hollywood will not see Berry and Whoopi Goldberg in the same light. Replace Berry with Whoopi Goldberg as Leticia Musgrove, and I do not believe she would have won the Oscar, although Goldberg is much more stellar an actress than Berry. Choosing Berry as the Oscar Nominee, more so in that particular role, it becomes divisive among women of color. The color wars begin to explode all over the Internet, with confirmations that of course a light-skinned black woman would win. Hollywood reinforces the standard of beauty...Black beauty. The standard is not Black or African American, it is biracial, and as much as some people would like to apply that one drop rule to anyone who is brown, the fact remains that Berry is biracial and is stunningly beautiful by many a standard. Hollywood is known for setting standards of beauty, and this movie was not short of that. Where there is black or brown, and perhaps no beauty, the media turns to what other characteristics can be deemed as worthy television time. They look to body image, and stereotypes. If you have both, your ticket is Chocolate-Factory golden.

To date, we have come to see more and more examples of body image or stereotypical women of color in media. Films like *Real Women Have Curves* (RWHC) (2002), with debuting actress America Ferrera, who went from being a feminist in (RWHC), to a quasi-Latina in *Sisterhood of the Traveling Pants* (2005), to a school-marm, nerd and hideously ugly in *Ugly Betty* (2006). Other films like *Chasing Papi* (2003), starring Roslyn Sanchez and Sofia Vergara, and *Maid in Manhattan* (2002), with all time favorite, Jennifer Lopez. These three films all feature beautiful, fair-skinned Latinas who for the most part all are perfectly curvaceous, and like Berry stunningly gorgeous. One should not assume that a

light-skinned Latina should always be cast into a Latina role, but for darker-skinned women, it is much harder to "avoid." Rather their lives are explicitly cast for them in Hollywood or on television. Television is a dangerous tool, no longer can we call it an "idiot box" but rather we can consider it in terms of the idiots, as we seem them through a box.

Let us trace a contemporary timeline of black women on the big screen. Pam Grier, also known as the legendary "Foxy Brown" (1974). Although both Pam Grier and her on-screen characters are beautiful, and what most would state as the original example of "Black Beauty" (see Halle Berry discourse earlier), Grier and Brown are asexual. It has been said by many that the character possesses more "lesbian/butch" qualities, as was the stereotype of many women in the Black Power Movement. However, her heterosexuality is reaffirmed in the film as there are several references made by Grier's character to "faggots." To keep her "clean" from being typecast as a leader in black lesbian identity, directors heterosexualize her as much as possible on screen, but do not heterosexually oversexualize her. In *Foxy Brown* (1974), Brown blames the murder of her boyfriend on "The Man" (white man and woman). As the film progresses into her relentless search for her man's killer, we watch Brown affirm the stereotype of black woman as tough but nurturing (definitely not pure and innocent). She has special fighting skills, and is obviously much tougher than her white and female counterparts and enemies. Her afro (hair argument arises again) offers a "secret" place for hiding weapons. While her white female counterpart stupidly threatens Brown with a larger, horror-movie-like butcher knife, Brown reaches for her gun, which is neatly tucked away in her afro, and is able to shoot her attacker. The complexity of the Blaxploitation film genre is interesting. On the one hand there is the argument that black women are placed into roles that represent her both as mammy, and superhero, but asexual. As Gwendolyn D. Pough states in her book *Check It While I Wreck It: Black Womanhood, Hip Hop Culture, and the Public Sphere* (2004).

> The Black women that these heroines represent are not hiding behind a culture of dissemblance or policing their bodies, but they are not having a whole lot of sex either. They use their sexy bodies to seduce and trap bad guys, and they have sex with specific purposes in mind. For the most part sexuality is just another tool for revenge (56).

Pough also raises an excellent point regarding the complexity of the black woman within the Blaxploitation genre. By having the lead female black character, most times singlehandedly defending her community against drugs, pimps, prostitutes and other degradations of a neighborhood, she is mammy-fied. However, by being sexy, and only using her sex-appeal and/or image to defend herself and her community, she is asexual, and thus to some, it appears that black women do not have sex for pleasure, unlike their white female counterparts (Pough, 2004). She is however, desired by all (black men and white men), but her community comes first, and perhaps she has sex that we do not know about (her fun and fantasy is not more important that her community service work). She indeed is so militant in her fight for the black community she is ultimately sexless. Within this image, the

black woman's identity is complex if not confusing. The complexity of this argument is as such: black male characters had black girlfriends but were also overturning historical barriers and stereotypes, and having reckless sex with white women.

In *Superfly* (1972), light-skinned hunk Ron O'Neal does an amazing job as leading man "Priest" (better known as *Superfly*). In the film, he has a black girlfriend that is loyal and stands besides all the choices he makes as cocaine-dealer wanting to break free from the "life" by making one last big deal. However, in the film's original trailer, the narrator notes that he is the type of man where women "come to him." With his light-skinned looks, neatly pressed hair, and his overly macho appeal it is a no wonder that he is able to "bag" all the "bitches" that he lays his eyes on. One very famous scene in the film, among the many, is Superfly in the bathtub, entangled with his main girlfriend (a black woman). The complexity of the black female body in this argument is whether or not she really is asexual or sexless. When in the lead, and burdened by saving her community, she cannot and will not have sex; she is too militant and focused on the goal at hand. When not in the lead, and is serving as someone's "girlfriend" whether main girl or random encounter she is oversexed and treated poorly by her male counterpart. There is no medium for the black woman's body in the genre, as a leading lady, superhero type, she cannot compete with white women who are all too desired by black men, but is kept safe from being a "whore." Does she enjoy being the "whore" when not in a position of leadership? When is she both? Superhero whore?

In *The Mack* (1973), another Blaxploitation film, "China Doll," (female character) chooses to be "The Mack's" girlfriend. Complete with toy dog companion in hand, China Doll selects the man she wants to be with in front of her current boyfriend ("Mr. Pretty Tony"), clearly an example of her sex appeal resulting in the emasculation of *any* man. "Pretty Tony" is appalled at her behavior and demands of her "Hey bitch, come here!" As a verbal fight ensues, China Doll is voiceless and silenced by the black male testosterone that fills the room. "The Mack" declares, "your bitch just chose me." Later in the film, "Pretty Tony" shares his philosophy on women, or rather "bitches." He states while other "niggas" are interested in the "honey" he only wants the "money," and this is why he keeps his "bitches and hoes" broke, otherwise these women "wake up one morning with money, and they're subject to go crazy" (*The Mack*, 1973). The film, like many others in the genre uses the term "Bitch" and "Ho" relentlessly to define black women, and their bodies (many are prostitutes in the film if not superhero). A year later, *Willie Dynamite* (1974) also finds himself in combat with a black woman who calls herself "The Ralph Nader for Hookers." Similar to a slave master's ideology and practice over the black woman's body, during the "meeting of the pimps" scene in *Willie Dynamite*, high on cocaine, a pimp declares: "I don't know what they want from me man. I feed 'em, and I clothe 'em, and I rejuvenate 'em." Another pimp declares, "it's inflation baby," while another prophesizes that the real problem is "dem pussies you runnin' jack." Hey they get any older, and you goin' be taking down [their] social security" (*Willie Dynamite*, 1974). Willie goes on to refer to his "bitches" as "tough, aggressive, mean-looking animals." "Bitch" is not only reserved

for black pimps and wanna-be pimps to address black women, it is also used by white women to address black women, as seen in *Foxy Brown* (1974). In the exchange for the black community being "represented" on the Hollywood screen, it had to pay the price by subjugating black female identity. Although many believed that the films were in response to black oppression and black empowerment/ militancy, black women received heavy stereotypes that continues to oppress her and her body well after thirty years of her mis-representation. Her invisibility as having any duality (sexual and strong) is still presented today.

We leave the 1970s and Blaxploitation behind, and enter women of color on "regular" television (sitcoms). A variety of shows made its ways into the homes of many Americans. A few more notable and popular shows included, *Good Times*, *What's Happening!!*, *The Jeffersons*, and *Sanford and Son*. In each of these shows, there was one black female character that stood for as Gwendolyn D. Pough would suggest, "a mammy." *Good Times* (debuting in 1974), gave the lead female role to Esther Rolle as "Florida Evans." Florida was the family's matriarch, and could oftentimes be found in the traditional role of the superhero black mother. She cooked, cleaned endlessly, took care of her children and the children of her neighbors and friends, and was a doting housewife, but sexless or asexual (and did not work outside the home much). More concerned about keeping up with financial difficulties that plagued her family in their "ghetto" neighborhood and public housing apartment, Florida never made time for intimacy with her husband; it was as though she did not even appeal to him in that way, and out sprung her three children by way of a stork's gift. Rolle's character was a product of various truths and stereotypes that plagued the black community of that time. She was a high school dropout and originally worked as a housekeeper before deciding to become a housewife. Prior to the debut of *Good Times*, was *Sanford and Son*, debuting on CBS in 1971. The story of a junkyard owner Fred Sanford (Red Foxx) and his son Lamont Sanford (Demond Wilson) and the absence of an immediate mother and wife figure in both of their lives. Elizabeth, mother and wife to the two male Sanfords had died sometime in Lamont's early life. In "Elizabeth's" absence, another female makes a large appearance on the show, LaWanda Page as "Aunt Esther" (Elizabeth's sister). Esther takes on the role of the black church lady and/or woman, who is also sexless/asexual and a prude, who disproves of Fred having ever married her "pure" sister. Fred's relationship with Esther is volatile; with his countless references to Esther being ugly, gorilla looking and/or having a Godzilla-like face to which she could be heard responding to him as being either a "snaggle tooth," or a "jackass" or in a lucky moment, the combination of the two. Esther's husband is characterized as a "useless alcoholic" and a "pipsqueak" type of bum, who she more than takes every opportunity to emasculate in front of a large audience, both televised on on-set.

In 1975, *The Jeffersons*, took America by storm. Here was this half-pint of a man, black, successful business owner, complete with a maid (also black but female). Although the show had a large fan base and support, *The Jeffersons* held many of the same qualities and characteristics of the shows before it. Many of the female characters on the show had spunk, charisma, and were not sexless, but the

fact that the household was clearly run by this ill-mannered and bad-tempered man remained. One Louise Jefferson (played by Isabel Sanford) or "Weezie" (as she was "lovingly" called by her husband George Jefferson), was no match for her husband. A plus however, was certainly, that although she befriended the likes of "Edith Bunker" (white female neighbor who is more than just simple) she was not as foolish or clueless as Bunker's character. However, Weezie too suffers from not receiving the well-deserved attention from her husband. In the episode *Every Night Fever*, Bentley, the Jefferson's white male neighbour, recognizes Louise's new purple dress immediately, and makes note that "Mr. J." would certainly like it as well. Louise unfortunately, has to point out to Mr. Jefferson whether or not he actually recognizes something different about her; to which he responds that indeed it appears that her diet is working. Having been stuck all day at home, Louise is restless and lets George know there is no home-cooked meal because she was hoping they could have "a night on the town." Grudgingly, and at the threat of Louise breaking his legs, he concedes to going to a disco with Louise. Although she initiates this night out, she is first to become tired and decides to sit a few songs out to which George finds himself sandwiched between several women on the dance floor as Louise watches from a table. Louise also befriends "Helen" the black female neighbor who is married to "Tom" (a white man). It is they who seem to have a less volatile relationship, as they always do things together, and more oftentimes than not, travel as a pair. In fact, it is Helen who gets Tom to do most of what they do together; she is the "man" in the family as she bosses Tom around by snapping her fingers or shouting at him "let's go." He never refuses her, and thus Helen is happily married, it seems. As the episode progresses, Louise decides to take a role in a community center's play that she earlier turns down because she preferred to "spend time with her husband." Having taken the role under the direction of the white male playwright and/or director, George finds himself in an awkward position in defense of his "manhood" (albeit we think he is defending his wife and/or marriage). Only when George decides he will give up disco dancing at night, does Louise give up her role in the play, and immediately decides to fix her husband dinner instead of going out to rehearse. Florence, the Jefferson's maid is also a loose-lip, fast-talking, sassy black woman. The complexity of her role is an interesting one. She does have relationships or rather several dates with men, but is still typecast as a maid (as her use of English is clearly slang or "broken" as opposed to Mrs. Jefferson's use of the language which is quite proper). In her broken-down use of English, her sass and quick wit, she is identified as the black maid for a black couple, who is clearly not refined and is loose on all fronts.

What's Happening!!, debuted in 1976, and for many represented the "average" urban black family. Similar to *Sanford and Son*, *What's Happening!!*, also had the absence of a dual-parent household, this time "Mabel" played by Mabel King, singlehandedly raised her son and daughter while working over-full time shifts as a maid/housekeeper. Mabel, the character, again serves as matriarch, (both father and mother) to her children, is very overweight, and is sexless, with the occasional moments of falling weak for her ex-husband who is a player or ladies man. So hell-bent on raising her children, and keeping her household together so that her

children have a better future than her own, she has no time for dating or issuing replacements for the children's absentee father. "Shirley," also a major character on the show, played by Shirley Hemphill, is also asexual. In one episode, her occupation as a waitress has the three teenage males (Rerun, Duane and Roger) on the show feeling sorry for her and lamenting that she may spend all her Saturday nights at home and all alone. The boys indeed decide they will set her up on a date. Complete with a hair-pick in her afro, and her round figure, Shirley is smitten by the date and is "one in love person" (*What's Happening!!*, 1976). The audience as well, is taken by how much of a "smooth brotha" this man is. Upon their first meeting, he takes her hand (making her more of a lady), and kisses it, claiming that the pleasure of them meeting is all his. However, her dreams of marrying a man that is not turned off by her job and her figure, is shot when she finds out that "Ed Roberts" is married already. Shirley does not really have many opportunities with men prior to or post this experience, and all examples pretty much fail in comparison.

The 1980s arrive, and a new stage is set for black women, having replaced much of the shows from the 1970s, and Blaxploitation films long leaving the socially acceptable circles. *The Cosby Show*, consisting of Bill Cosby and Phylicia Rashad as husband and wife, are the parents of five children. The show set aside the backdrop of Brooklyn Heights, New York, debuted in 1984. Claire Huxtable played by Phylicia Rashad is an amazing feminist (perhaps a raceless feminist). As a full time lawyer, and mother, Claire is able to semi-run her household with the amazing support of her husband Cliff (played by Bill Cosby). She is a heroine, but also is sexual. There are several instances and nuances throughout various episodes where Claire hints to Cliff that there may be sex involved during their evening together, at home alone without the children, or in their bedroom when the children are asleep. To look at the show closely, it is Cliff who really spends more time raising the five children, as he not only works on-call at the hospital as an OBGYN, but also has part of his practice at his Brooklyn Heights home office. The household is not only supported by both parents, but by both sets of grandparents who make regular appearances as well. The family also puts on regular dramatic and musical performances in the household, and is supported by constant visits at home by "famous" people. The show received lots of support in that this is exactly what the black family and/or household needed during the 1980s, also the era of the crack epidemic.

However, the show also received a lot of negative criticism for its unrealistic interpretation of the American black family struggling at the hands of American poverty. Some of the characteristics that were up for a lashing of negative criticism had to do with: (1) The careers of the parents; Cliff is a OBGYN and Claire is an attorney, (2) They do not promote the idea that they are wealthy but there is not a single episode where the family seems to struggle financially, (3) Of the five children, not one of them seems to have any social/emotional problems, except for maybe Theo's dyslexia problem that is recognized in college, or his being caught with marijuana that "wasn't his" (4) their home was extremely classy, a brownstone all their own, complete with neatly shared bedrooms, a huge professional kitchen,

separate family dining room, and expensive African American art all throughout the house. There are moments in question as to the authenticity of black life in the 1980s, particularly in New York, (1) Denise's (Lisa Bonet's character) friend being a pregnant teen, (2) Vanessa (Tempestt Bledsoe's character) receiving a D on her exam, and lying to her parents to stay out late with a boyfriend, (3) none of the girls having sex even though there are four female children, none seem to have sex that is not planned, nor does it happen before marriage, and none of the girls appear feminist, although their mother can be a model for such.

From the 1990s to the present, there have been a handful of films that discover the duality of the black woman. *What's Love Got To Do With It* (1993), although a biographical film on the life of Tina Turner, Angela Bassett does a glorious job in her lead role as Turner. With the support of the story's truth of Turner being the product of an extremely tumultuous and abusive relationship with Ike Turner, Bassett turns the audience into a fan club for women who have been abused but still maintain their sex appeal. Certainly in this role, her duality is existent. She is strong, super-hero like (living to tell the story after the abuse), and oozes sex on screen with her buffed body and amazing acting skills. In 1996, *Set It Off*, offers viewers a look at several strong black women, many who have the duality of super-hero strong and sexy or having sex appeal. The film, set against the main plot of black women suffocating from their low-income and/or dead opportunities, they decide to rob a bank. While it fits the stereotype of the low-income African American who so desperate for money turns to crime, we cannot say (especially if we are low-income wage earners or middle-class) that we too have never considered the possibilities of what may be easier than our desk jobs and dashed hopes at equal and fair treatment. However, all the women are strong, and possess qualities of sex appeal. Jada Pinkett's character, as the tiny but fearless semi-ring leader of the bank robbery has an on-screen love/sex scene with equally attractive Blair Underwood that changed the way we look at African American love scenes in Hollywood. We also for the first time see an African American female and famous actress in the role of a lesbian who loves women but also is quite fearless herself (Queen Latifah's character).

The downfall of the film comes with the low-income socioeconomic background that is written into each character's lives, where they are desperate for money and also find themselves escaping their poverty by way of big dreams, blunts, and malt liquor. Whether negative or positive, these characteristics have plagued black male actors for years, and the flip of watching black women in this role is offensive, refreshing, complex but readily accepted into the minds of many.

In 1997, we also saw Nia Long represent not solely as a sexually frustrated black woman, but a woman who reeks sex appeal on her own terms, as well as a successful woman (again on her own terms) in *Love Jones*. In as much as Long's character (Nina Mosley) refuses to classify her relationship with Lorenz Tate's character (Darius Lovehall) as anything but a "love thing" she is smitten but holds on to her feminine powers and femininity until she decides its time to share them with a man. Additionally, we take from famous African American female author, Terry McMillan, *How Stella Got Her Groove Back* in 1998. In this film, we again

witness another performance by Angela Bassett as a woman who, recently divorced, and raising her young son alone, also immerses herself into a world of corporate America. This is, of course, until she is fired, and at first reluctant, decides to take a vacation to Jamaica, where she exploits the likes of a much younger man (a Jamaican native), who makes her feel like a woman. Being in a position of power by way of (1) being an American female as opposed to a struggling Jamaican male, and (2) being financially more successful than her twenty-year old lover, Stella in her mid-forties has the duality that many are in search for. She is able to maintain her household, raise her son alone, go on vacation, regain her sense of sex appeal, and turn out a "young brotha."

In 1994, Spike Lee's *Crooklyn* was released and made it to my list of favorite films of all time in a matter of an hour. The film so related to my own experiences as a child being raised in Hell's Kitchen (*Crooklyn* is set in Brooklyn) represents the innocence of a young woman of color at the development of her female identity with regards to race and gender. Unlike so many of Spike Lee's films with controversy and questionable roles for women of color (*School Daze, Jungle Fever, Mo' Betta Blues*, and *Do the Right Thing*), *Crooklyn* makes us fall in love with the female characters of color. The household shares the leadership of both mother and father. The mother played by Alfre Woodard, is a public school teacher and father played by Delroy Lindo is a struggling jazz musician. Together they take care of their household consisting of one daughter "Ladybug" and five sons. They raise their family together as they face financial difficulties, but mainly we watch as "Troy" (Zelda Harris) develops from tomboy to head of her household (albeit she has older and younger brothers, and a strong father as a role model). As she wades through all of the stereotypes plaguing the black community, we watch this child in the 1970s become head of her household when her mother sadly dies from cancer leaving the family distraught and the audience broken. However, since she is a child character, she remains sexless thankfully, but she is not asexual, so even at such a young age, we see her duality.

With all of the references of films that support the lives and roles black women, it seems increasingly hard to hold on to positive identities of women of color on the big or smaller screens. With films like *Boyz in the Hood* (1991), and *Baby Boy* (2001), set against scenes and backdrops of drugs, overuse and abuse of alcohol, low-income or unemployment, whores, and hoes, thugs, super-inflated versions of black masculinity, and black women who gossip about each other and everyone else, the film is less appetizing. In addition, the film, sadly, results in many others attempting to represent the entire black community by way of similar characters. As women of color, we lose our footing on positive identities on-screen repeatedly. With the likes of Disney attacking images of women, people of color, and presumably both at once from the time our articulation of sense begins developing, to Hollywood representing black women in a less than flattering way, what is next? In 2008, most, if not all women of color are still awaiting accurate representation.

Turning the color scale to another dial, we find the similar dilemma of the Latina on the big and small screen. At the risk of sounding almost dismissive, Dolores Del Rio (Mexican) never really made a huge dent on the mark of what

most people (non academics/scholars) consider a "popular" Latina actress because of her roles in many silent films. I use "most people" to refer to what is taught in courses in "Hispanic" or "Latino/a" studies (in my current academic experience). However, she too suffered at the stereotype of being a sexpot both in her silent and vocal roles. In *America on Film: Representing Race, Class, Gender and Sexuality* (2003), Del Rio is understood that because her roles were usually chaste and upper-class, the women she portrayed found themselves "in the arms of white leading men" (Benshoff and Griffin, 140).

Rita Moreno, or her birth certificate, is named, Rosita Dolores Alverío. Born in Puerto Rico, she was the first Latina to win an Emmy, Grammy, Tony and Oscar award(s). In 1954, at age twenty-three, Moreno was featured on the cover of *Life* magazine under a caption that read "Rita Moreno: An Actresses' Catalog of Sex and Innocence." Obviously with such a prestige of being "sexy" as opposed to her black female counterpart as "sexless" or "asexual," Moreno would be pressured to live up to this stereotype. Part of the Latina imagery and sex appeal exudes the stereotype of being "exotic," "spicy" and/or "saucy." Indeed, many of her roles were. More in particular, at the age of thirty, Moreno was cast in the extremely successful musicial *West Side Story* (1961), as Anita (Puerto Rican girlfriend to gang leader Bernardo). In a pivotal scene in *West Side Story*, we watch all the "Puerto Ricans" dance and sing to *America*, in which they display to their audience how racist America is if you are a Puerto Rican male, and how much choice and opportunity presents itself if Puerto Rican and female. Obviously the musical makes light of the situation, Puerto Ricans really did face on the mainland, during and after the great migration of the 1940s, but less amusing when we find out that Moreno is one of the only "real" Latinas in the film. Main characters, Bernardo is played by George Chakiris (Greek), and Maria played by Natalie Wood (of Russian descent). Did I wish Tony sang "Regina" instead of Maria? Yes. Recognizing that "Maria" was "of color" on screen, it gave many young women of color a sense of identification, but what a light skinned woman of color she was, which changes things. Suddenly, if you "say it loud" it does not sound like music is playing as Tony (played by Richard Breymer) would like us to believe. We much more can identify with Anita, eventhough she is the sister of a gang leader, we feel more comfortable in this type of on-screen black/brown, although we understand the ramifications of solidarity. Interestingly enough, one wonders why Moreno is not cast as Maria since she is the real Latina in the film (and could possibly look innocent just as Wood did). We wonder why Wood is chosen to play Maria, almost church or saint like in name, character and in virtue, and albiet the pure and innocent virgin who pines away for this white male lover she so desperately awaits.

What is both shared and different in many ways between the African American female and the Latina experience is that many Latinas were forced to change their real names to screennames in order to secure roles that were "white" or "whiter" than them. With many African Americans, passing is less talked about when it comes to on-screen roles for black women. Many Latinas including Raquel Welch (biracial), Rita Hayworth (biracial) were able to change their names, since they already "looked white" in order to get their roles. What Hollywood has done to

both black and brown actors/actresses is either prepare them for white roles or simply exclude them all together, unless the film is surrounded around topics and issues of Blackness and/or Latinidad. Jennifer Lopez could be a great example of the "semi-white" Latina, the "whitening" of a Latina, or a Latina who can be cast as a Latina.

Ultimately, what has happened with the Latina is similar to the oppression that the African American woman's body faces. She is "exoticized" and "over-sexualized" at all costs. Brown and black women fall into the borders and margins of both stereotypes and breaking free from such proves difficult for many including the young women of color who look to these figures as role models. In 1999, Jennifer Lopez's video, for the debut single, "If You Had My Love" was released. The video was set against the idea of a voyeur logging onto her website to watch her "perform." The young voyeur who is actively perusing her and her website, is able to virtually head into various parts of her home, where he finds Lopez straddling a sofa in a bikini-top and baggy lounge pants. The young man is not the only one watching Lopez's body and/or performance, he is accompanied by shots of other young men *and* women at what appears to be an internet café, as well as a young child who embraces her teddy bear while she watches Lopez on "Internet TV" mimicking her every move. She is also being viewed by two women who appear to be Latina as well, but are envious (huge eye rolling) by what they are watching. As the main male voyeur is able to click into various parts of her "home" as well as enter her virtual multicultural dance routine, we see Lopez perform her dance routine while exclamating "papi!" at every beat break. As the video comes to a close, you are able to quickly catch the vouyer as he begins to touch his own body, as he watches Lopez in the shower (wet head and face only). The idea that Lopez is envied by all is fully embraced in this video. Girls are mad at her, guys are totally addicted to her, and small female children aspire to be just like her. Eventhough this is her first video, and the "ass" shot is minimal, her subsequent videos make sure to mention her body in its lyrics and/or give a visual reinforce-ment of it in the music video. Her song *Aint It Funny* (2001) with rapper JaRule opens with "It must be the ass, that got me like damn!" In *Jenny From The Block* (2002), she does not want you to be fooled by the "rocks that I got" while then boyfriend, Ben Affleck is caught in a brief clip in the video rubbing suntan oil/lotion onto her derriere and then briefly kissing it. Is Jennifer Lopez talented? Certainly. Beautiful? Quite clearly so. However, like many other female artists how does the choice to be "popular" and "admirable" make a b-line towards inspiring young women to emulate in a positive way? Stated by many journalists, enter-tainment and otherwise, Jennifer Lopez was rumored as to having insured her derreire for twenty-seven million dollars. She is not alone, but as much attention was given to that part of her body (talentless as it is), she represents more than just a Latina artist, she becomes a figure head on television, one that gives off examples of complex "beauty" as mentioned in the earlier chapter.

When Latinas grace our mainstream television programs these days, we are not watching exciting and riveting performances by Rita Moreno, Rita Hayworth, or Chita Rivera. An important dimension to add to Latinas and television is the

production of this image infused with language or bilingualism. Obviously, you can reach instant stardom if you speak English, or have a "sexy" accent, but it cannot be so heavy you are inaudible and need an interpreter. By having the accent, many Latinas can only be cast in Latina roles, but for those like Jennifer Lopez and Cameron Diaz (never having been cast as a Latina), it is easier to whiten them up as well as strip of them of Latina identity if the need arises. While Penelope Cruz (Spanish), Sofia Vergara (Colombian), Salma Hayek (Mexican), and Roslyn Sanchez (Puerto Rican) are all fine actresses, they are more "Latina" than hollywood is willing to accept for multiracial roles. The heavy Spanish accent that each Latina has, confines them to particular roles in Hollywood, but their "oversexualization" is not any less than their "clearer" speaking Latina counterparts.

Young Latina actresses are popping up on our television sets more regularly these days. While Jennifer Lopez has not been replaced and has since become a successful Latina mother, wife and role model, younger Latinas are also now taking the stage into our homes. America Ferrera (Honduran) got her big break as Ana Garcia in *Real Women Have Curves* (2002). In RWHC, Ferrera plays a Mexican-American teenager, similar to Jennifer Lopez playing Mexican-American singer Selena in 1997. While many found her performance amazing in the film, the questionable casting of Ferrera as a Mexican-American leaves audiences confused. Are all Latinas the same, and in such, it does not really matter who is cast into their role, as long as they are Latina or rather can affect a Spanish accent? Ultimately, was there no "undiscovered" Mexican-American teen that could have been cast as the Mexican-American teen "Ana Garcia?" The character, struggling with issues dealing with parental guidance or misguidance, images of beauty (she is cast as overweight), working in a sweatshop/factory resounds with many immigrant populations all across America. As the film progresses, Ana Garcia is offered the chance to attend Columbia University in New York, and loses her virginity to a young white male, that her mother disproves of. With these factors, she leaves the family behind to pursue a college degree at an Ivy League institution in New York City, losing her virginity to a clueless young white male, and being content with her weight is reinforced in the film as an example of her completing her process towards womanhood. Although, she later stars in the *Sisterhood of the Travelling Pants* (SOTTP) (2005, 2008), it is well worth to note that she too bears this mark of being remembered for her "body" or as the *Independent Movie Database* website notes, "her curvy figure" (IMDB). Because appearance is everything in Hollywood, similar to Lopez, it has also been said that Ferrera has had her smile insured for ten million dollars while being ranked at number eighty-four on the *Maxim* Hot List. Her response to image and beauty is as follows:

> I think Hispanic women are beautiful with their curves. I'm not sure who feels that way in Hollywood. I was never told to lose 50 pounds. If they think that they just don't bother with you. You just don't get the role and you never know why. That's still better than physically harming yourself and becoming unhealthy just to star in a movie (IMDB).

Her role in the SOTTP also warrants mention that her role is as a Puerto Rican female who struggles with her weight in comparison to her three thin, white girlfriends, and her father's new wife (also white), and her own daughters (thin and white). Although she makes this claim, and I am sure many young women have found it inspirational, especially in a community that holds voluptuousness in high-regards, Ferrera too has lost a considerable amount of weight since her comment to IMDB.

Jessica Alba, another young Latina (biracial) has been cast in many non-Latina roles, and has also made several of the "sexy" or "sexual" lists:
– Number one on the *Maxim's* "100 Hot Babe List" (2001),
– Number five on the Hollywood.com poll for "Sexiest Female Star" (2002),"
– Number four on the "Top Ten Sci-Fi Babes" List,
– Number 6 on the "FHM's Sexiest Girls of 2002 poll" (2002),
– Number twelve on the "102 Sexiest Women in the World" for *Stuff Magazine* (2002),
– One of fifty on the "50 Most Beautiful People List" for *People Magazine* (2005),
– Number seven "Hot 100 List" for *Maxim* (2005),
– Number three, on E Television's 2006 101 Sexiest Celebrity Bodies,
– Number one Top 99 Most Desirable Women of 2006, for askmen.com.

Exhausted yet? The list goes on and on with these recommendations, and *Internet Movie Database*, has them all recorded in chronological order. Quickly noted on the biography page of IMDB's profile for Alba, it states, "Despite her Mexican ancestry, she isn't fluent in Spanish. She hardly understands anything in that language" (IMDB). Worth a mention here, she had a brief bout with anorexia, and was reported as one of the worst actresses for two of her major roles in films.

Lopez, Alba, Ferrera, Eva Mendes and Eva Longoria and newcomer and reality star Jo De La Rosa (*Date My Ex*) are accurate representations of what is on our television screens in our contemporary time, but are they accurate representations of Latinidad? Perhaps the larger problem is how they are broadcasted, packaged and brought to the viewer. They are "sexy" first and everything else can come after. Rarely do they find themselves in the role of a schoolmarm or looking "frumpy" (except for "Ugly Betty"). Clearly, and similar to the world of hip hop and rap artists, these actresses have no real responsibility for living up to the expectations of those who aspire to be like them. For many, they make the choice to appear on the cover of *Playboy* or *Maxim* magazines and as a result bear some responsibility to young women of color. Ultimately, they are the key to Latinidad that most young women of color (in particular Latinas) have as a foundation for role modeling. The problem, like with many Rap and Hip Hop figureheads is the time and effort it takes the average young woman of color to research information about their "favorite." In relationship to this idea of representing Latinas, the beauty issue, similar to African American women or other women of color arises here as well. Many of these celebrities do not exude skill or talent, and for the most

part, we do not see them the same way we would Denzel Washington, Al Pacino, Helen Mirren or Angela Bassett in that they are absolutely amazing performers (be they male or female). Instead, we see these women as ideals of beauty, and the pressure to be thin and beautiful radiates off our radios and ITunes tracks, off our televisions and into the homes and lives of young women.

It is not an easy solution, nor good advice to simply tell or encourage young women of color to "turn the television off." In fact, a reasonable follow up would be to ask what good would that do? Television, like it or not, is informative; it provides information and perspectives that demand to be given, whether we agree or disagree with that particular perspective. In a more serious tone, television serves many a parent as a substitute babysitter, and sometimes the price of cable and its programs is much cheaper than a human babysitter or caretaker. Although the *latchkey kid* theory conjures up images of young boys of color, it can be applied to young women of color as well. Many young women of color in urban communities find their own way home from school, pick up something to eat along the same path, and check their snail mailboxes (for a variety of reasons). Once home, we cannot expect them to leave the television set alone and find other things to do (especially if they are not of working age). Parents know this as well, and feel comfortable in knowing that at least their children are safe and at home (even though they are watching a variety of programs, appropriate and inappropriate alike). Many cable stations have created "blocks" on specific channels, so that parents can monitor what their children watch, even when they themselves are not watching along with them. With access to Blockbuster, NetFlix, DVDs, and friends with access, most programs worthy of blocking from a child, proves useless. Remember, Disney and even commercials prove suspect in endangering the psyche of a young woman of color. Conversation and/or dialogue is key, awareness is the keyhole. Parents and caretakers have to be cognizant of all of these influences, and begin conversation with their young daughters about the images that they might and/or might not be receiving through their television screens. While there is no real responsibility placed on celebrities to think-before-they-act (literally), we cannot continue to blame entertainers like Jennifer Lopez for the effects of their work. It is worth a mention that fairytales do not only exist with Disney alone and so keeping in tune with what our girls are watching is vital. It is the after-message that is of most concern. Women are sometimes perceptive enough to swat away negative stereo-types when they head towards them, but what is the after effect? Do we walk away from any film thinking anything but how that same situation would affect us had we been cast in the film, or how that role in our own private lives would play out?

One key film to look towards to for this type of example is *Maid in Manhattan* (2002). In the film, Jennifer Lopez plays "Marisa Ventura" a single (Latina) mother who works as a maid at a posh hotel. Far from the truth? No. Many Latinas work in the hotel industry as house and groundskeepers (however, the term "maid" has not been used in years). We also confirm that the character Marisa Ventura is Latina as she refers to her son throughout the film as "papi" or "papo" (a Spanish slang used for "little man"). In short, she is found one day by a Senator (Hotel Guest) wearing an expensive piece of clothing in a guest room. The senator (Ralph

Fiennes) mistakes her for a guest and not the maid that she really is. He asks her on a date, they go, end up having sex, and eventually fall in love, as all the other "maids" cheer on her success (the fairytale ending). Worth a mention here is that many of Lopez's on-screen romances have been white males (except for the biopic *El Cantante*, but then Hector Lavoe was Puerto Rican in truth). In the film's trailer, the narrator states, "Now the girl that was invisible is all he [Ralph Fiennes as the Senator] can see." More quotes from the film include a fellow maid telling Ventura [Jennifer Lopez] that she is wrong to think her life is a lie, "tonight the maid is a lie, this is who you really are." "No matter who you are, destiny will find you," claims the narrator. This line gave me chills the first time I heard it. In my own fantasy, I wonder how Jennifer Lopez felt to play a role in which it was so nerve-wracking to put on a five thousand dollar Dolce and Gabana outfit, when she is quite capable of such all the time off-screen. I really like Jennifer Lopez, yet race, gender and who she is adds such a complexity in trying to truly understand these types of career decisions. The reality is that many maids do not end up with these types of "happy-endings" (securing an equal place in a white senator's bed; equally being the firm word here). Lastly, the Senator does not usually marry a maid, he may however, keep her "on the side." Lopez in this perspective is *La Cenicienta* (the Latina Cinderella). *Maid in Manhattan*, is the "happy" reverse from the *Bread and Roses* (2000) plot of two Latina sisters trying to unionize janitor workers. The housekeepers at the "Bedford" where *Maid in Manhattan* is set, seem jovial for the most part. They laugh, and enjoy fellowship between each other, even encourage each other to go for managerial positions. At one of the "finest" hotels in New York City, housekeepers make twenty-two dollars an hour, have full medical benefits and are represented by the Local 6 Union, and many housekeepers are Eastern European. Lopez's repeated response of "yes ma'am and no sir" relegates her character as equal to other women of color both as indentured servant working "in the house" and mammy taking care of her mistress. Lopez's character also does not muster up enough courage to respond to guests who claim "she hardly speaks English" or "she's' just a maid." Her character, both in a position of servitude and one that is silent or silenced forces this image of meekness onto many young women of color who resent housekeepers and in turn see them as weak. We do not see white women in these positions, she is who is invisible. To give herself some visibility, many women of color who work as housekeepers come into and leave work for the day dressed in cheap, but provocative clothing. The idea that she is still a woman beneath her maid uniform is important in her overall identity.

> Native-born white women employed in domestic service were not subjected to the negative aspects of racial hierarchy. White women working as 'help' reaped the benefits of egalitarian thought and obtained favorable working conditions, they sold labor services, not just time to employers. [...] White women's positions in the racial hierarchy helped them leave domestic work and obtain better paying jobs (Romero, 2002).

In these fiction-based films, young women look to other forms of "reality" for their voids in life, and thus the various productions of "reality television" programs

come into play. With women of color being cast on these shows, their situations are no different from the fictitious roles that they play on the bigger screen. Tiffany Pollard (aka New York) made her debut on *Flavor of Love*, a show who rewards the winning contestant with Flavor Flav as the grand prize. Not being chosen as his "first choice," Pollard is asked back as a second-time contestant on the show's second season; again, she is not chosen and is what appears to be humiliated. Suffering this humiliation for a second time and her fans exuding more sympathy for her, she is given two seasons of her own show. During the first season of *I Love New York* in her quest to find "true love," out of twenty contestants (men), she chooses one and he ultimately "dumps" her for "talking about his mama." The second season is born, and with this, the winner, a young white male, who has a daughter and an ex-wife, is selected to be her "true love." On national television, "Tailor Made" (named by Tiffany during her interviews with the contestants) proposes to her and she readily accepts. He was the only contestant who was notably wealthy, and exploited this characteristic by imposing incredibly expensive gifts onto Tiffany, to which she never denied. Months after the show's ending, "Tailor Made" (George Weisgerber III) broke off his engagement to Pollard. She went on to star in another reality television program called, *New York Goes to Hollywood* (2008), to which we can watch her try to navigate her way through avenues of Hollywood stardom. Pollard is not the only girl who has gone on to make a name for herself based off of a show that involved sex and "reality." The actual winner of *Flavor of Love* (season two), who also dumped Flavor Flav, went on to become a star with her hit single "rumpshaker" in which the infamous derriere makes it ugly appearance yet again.

What many of these girls have ended up doing is something in relationship to their body, and perhaps this is as close as we get to their "reality" (albiet many of these body parts are indeed surgically altered). For young women of color the images are tortourous. Young women of color are forced to accept these "of color" reality stars because of the word "reality." There is not much discussion among young women about the "fake" aspect of the various shows, and perhaps that does not even matter to many of the show's fans. For some reason, we are addicted to the fakeness and all of the drama that they exude and expose in each episode. The danger arrives yet again in emulation. Reality television has proven to be another outlet for mispresenting women of color. The sexy or oversexual image for the woman of color seeks to prompt keys for success. As mentioned, many of the VH1 reality television show stars have gone on to work on various projects involving their body and their sexual attributes. For Omaroseonee O. Manigault, and reality show/contestant on Donald Trump's *The Apprentice*, she was "fired" a number of times. What later resulted in her dismissal from the show and other employment opportunities has been her "attitude" (Silverman, 2004). It has been reported that she is a very difficult person to work with, and does not get along well with anyone. Sadly, the stereotype of the "angry black woman" is reinforced by not Omarosa herself, but those who perceive this behaviour by women of color as "typical". The fact that she is now working on doctoral degree in Political Science at Howard University is not something that has been marketed publicly (without

digging). Had she exposed her breasts and maybe her derriere she would be famous for being other than a "bitch." For other groups of women, this "bitchy" and/or aggressive attitude is seen as a positive attribute. More particularly, the "feisty" woman replaces the "angry black woman" when the woman is Latina.

A television set is in no way a replacement of a human being, no matter how "absent" we might be during crucial times of the day. Not afraid of sounding holier-than-thou, my father would also ask in a commanding way to me, "Why don't you turn that television off, and pick up a book instead?" Although this approach certainly warranted lots of eye rolling because I read equally as much as I watched television, it worked for a time. He was right. I had enough negative images in my "real world" without having television add to this claustrophobia-causing situation. Television, however, is not the same as what I had back in the 1970s-1980s, and is not even the same as what I had in 1990s. Looking at television through a critical lens, one that undoubtedly ontological, inspires one to think about what it is that one is watching and thus internally consuming. As I walk the streets of New York City, and am slapped by all the images of people wearing "Obama '08" t-shirts, I wonder how many people have watched him speak or deliver an address, and how many of those same people are actually registered to vote, or whether they are moved by all the television propaganda entering their homes.

ELLEN, THE L WORD AND GIRLS WHO QUESTION

LESBIANS OF COLOR AND IDENTITY

How can a straight, married woman talk about lesbian and/or bisexual identities? For years I was stereotyped in school, both early on and in graduate school, and later on in my place of work as a "dyke" and more readily a "lesbian." I was named the "Brown Ellen DeGeneres," and I loved it, every minute of it, as I love Ellen's wit, persona and style of dress, I simply took it as a compliment. The fact that Ellen is white, and I am multiracial leaves bigger questions for one in search of understanding their identity. One of my department chairs (at one of my multiple teaching jobs) commented on how "cute" I looked in my pantsuit and Adidas sneakers. It was "curious" that I did not wear skirts, or show my legs at work ever, or the fact that I did not flaunt my "lady lumps," including any upper body muscles from lifting laughable weights at home. My boss at the time even discouraged me from the continuous wearing of sneakers with my suit because "it gives off the wrong message, and your boyfriend looks like he's a beard not your boyfriend." It was clear that the environment was very heterosexual, and the "other" in this particular situation was not of color, but rather gay or lesbian. I should try to fit in and I should do so quickly, before "word gets out."

The first time I walked into my college gym to "work out," a group of girls standing next to me doing "female push ups" stopped, and started whispering between smiles of curiosity and "scandal." Although not a lesbian, I could only imagine what someone who had been struggling to understand their sexuality might have felt like, had they been in my shoes or worse at the time. What I could not understand was much of what I witnessed among my fellow college students, and even in junior high school where cliques are particularly important, was the fact that much of their "girly" activities were homo-social. As mentioned earlier, my junior high school was filled to the brim with white females, who bonded together at various lengths, and for a variety of reasons. They went to parties together, came to school together, ate lunch together, sat together in classroom(s), playfully grabbed each other's underwear and bra straps in the locker rooms, kissed each other on the lips, and spent most of their time in the halls and bathrooms of the school, together. Yet, with all this bonding, they were never stereotyped as being "lesbian" or "bisexual." It was not really a word or identity marker that was used throughout my time in junior high school for girls and their curious behavior. To be a loner-type of girl or anti-social around girls, while being a girl, was more a reason to be considered a "lesbian." Boys, however, called each other gay for a variety of reasons, as the term metro-sexual had not yet come about or become popular. I can remember single times that girls caught other girls staring a bit too hard or longer than what one would consider "normal" while getting changed in the

locker room creating an atmosphere of whispers. One of our gym teachers, a white female, was clearly what can be classified as a "butch." Every time she walked into the locker room, to drag us out from behind our open locker doors, someone would begin to hum Aerosmith's "Dude Looks Like a Lady." While the gym teacher did not seem to mind (if she knew the song, and if she knew it was directed at her), she did bear the brunt of lots of discriminating behavior from the girls who she presided over. Most of us were so afraid of her that I cannot fairly recall anyone remembering what she looked like up close (no one made eye contact with her). As soon as the girls would hear her enter the locker room, the putting on of their gym clothes was done almost double-time. Girls would shove things into their locker and if they knew she would be there that particular day, they would come to gym class already in their gym uniforms so that they would not have to change in front of her. It was interesting that every girl thought because she was a lesbian she would automatically be attracted to every girl she laid her eyes on, including minors. What was it about lesbians back then that scared these girls so much? While this example is my own, it is not creative, nor is it unpopular in its practice and/or existence. Similar examples can be read about and/or heard in many social circles. To support this, my example comes from the 1990s and author Mariana Romo-Carmona, writes of her own seventh grade experience back in 1967, very similar to my own as described. In her beautifully written essay, "How We Get That Way" in *Queer 13: Lesbian and Gay Writers Recall Seventh Grade* (1998), she writes of her gym experience:

> [...] All the shameless Americans stripped naked and jumped into the wide-open shower, draping miniscule towels around their breasts when they came out. All my years of female bonding had not prepared me for this, and from that day until the end of the school year, I made sure never to break a sweat in gym class because there was no way I was going to take a shower in that place" (10).

Without sounding as if I am using a cultural passport here, I have been surrounded by the company of gays, lesbians, bisexuals and individuals who live a life of questioning, throughout my life. Our struggles are shared it seems, and our only difference seems to be who we share our most intimate moments with (outside of junior high and high school locker rooms). A major difference would be that I had the luxury of marrying my spouse, and no matter how much my gay friends who are in committed relationships and are in love, if they live in New York City, they cannot close up the deal by marrying, legally, anyway. As briefly mentioned in chapter eight, homophobia in the black and Latino/a community is still running rampant. It does not help that gays and lesbians of color, are not accurately represented on television and/or in music either. It is almost a novelty when members of the straight population finds out "so and so" is gay or is a lesbian; "really? I had no idea." There is such a shock, similar to the shock, that naturally an educated person of color should be articulate. It is disgusting on both fronts, violent and vicious. None of this invisibility allows many young women of color to identify as lesbian and feel safe about doing so. For some, this means that they

celebrate their lifestyle in private along with their struggles, also in private. For fear of being rejected by "straight" circles, many young lesbians of color do not uncover or disclose their desires openly. It could be that many of them mention their sexuality in passing in hopes for some type of reaction to test whether or not the social waters are indeed welcoming and/or hostile.

As mentioned in chapter three, young lesbians of color in teen novels are demonized more often than not. The spaces they take up in young adult literature oftentimes, constitutes the development of a "bad" character. Ultimately, they are less than desirable and even less a model to try and emulate. Close the book and turn on the television, and you have Tila Tequila as the spokeswoman for being of color and bisexual. Tequila however, is not demonized like her teen counterparts but somewhat revered as the "desirable bisexual." Tequila's body is used to promote her bisexuality and thus she is desired by many, and becomes the model for much more. The dichotomy between what appears to be a good model and a bad model has a finely drawn line between the two. Are they like Maya St. Germain (of *PLL)*, devilishly pretty, a racial other, vindictive with bad ways about her, and perhaps even a murderer, or are they oversexualized and Betty Boop-ish like Tila Tequila? With the release of Katy Perry's *I Kissed A Girl* (2008), she gives her listeners a recount of a night out, among drinks, where she felt cocky enough to kiss a girl, and she notes this girl is part of her "curiosity." She goes on further to say, "don't mean I'm in love tonight." There are several interpretations to be found in Perry's song. It could mean that she is testing her sexuality, or rather questioning who she has more sexual fun with, or it could mean that she is urging young girls to try everything until they find their comfort. Either way, the song found its way onto the most controversial summer song list (there are more than one of these lists on the Internet). Perry's mother, Mary Hudson, a Christian Evangelical preacher, claimed,

It clearly promotes homosexuality and its message is shameful and disgusting. Katy knows how I feel. We are a very outspoken family and she knows how disappointed her father and I are. I can't even listen to that song. The first time I heard it I was in total shock. When it comes on the radio I bow my head and pray (Porter, 2008).

More important to note is not the backlash the song received, as it reached number one status in several countries, it is rather the fact that Perry is a white female. In her song, she is allowed to question her sexuality and test it out in public (see song lyrics for more information). Both her race and gender give her ample space to question the status of her sexuality and ultimately who she is, in a safe space. She is not condemned for her sexuality, but rather for spreading her fantasy, publicly and through song.

Getting past Don Imus's racist comment(s) regarding the African American female players on the Rutgers University Basketball team, the *Village Voice* also released an article about "aggressives" or "AGs" entitled, *Girls to Men* (Hillard, 2007). The article gives an inside into the lives of "butch" lesbians of color who patronize the Lab (a Brooklyn, New York nightclub) as prowlers. These, "manly"

lesbians of color (as they are identified) prowl the nightclub looking for feminine lesbians as "prey," in order to develop what could be a short-lived relationship based on conquering, and social control. "Your mission that entire night is to find the baddest femme in the club and make her your girl" (Hillard, 2007). In many ways, this group of lesbians or "AGs" are using the workings of aggressive "macho" men in order to conquer the more feminine group of girls who attend the nightclub. For many of these "AGs" they aspire to have what many hip hop and rap artists want, the "video honey." They have the same goals, and aspire to be exactly what they see when watching various music videos. The *Village Voice* article goes into more detail, using documentarian Daniel Peddle (*The Aggressives*) to explain that many women of color (in particular black and Latina) are not intermixing with "regular" gay and lesbian crowds. Hip hop and rap are used to support the "AGs" in their quest for relationships with other young women of color. The most complex issue for "AGs" is their emulation of men because there are no female lesbians of color they aspire to be like. (Hillard, 2007). Obviously, this leads to the return of the cyclical oppression that many young women of color face. Their bodies objectified by men, and women who aspire to be like men, only they are lesbians, so the comfort of being with another woman, who has all the characteristics of a man is the ticket. Within this crowd, there is the promotion of "negative black masculinity," sensationalized femininity, hip hop and rap (as an icon and model), and the continued objectification of a woman's body. There is also the promotion of the idea that gay and lesbian relationships are only built from sexual connections, and have little to nothing else to do with the development of a relationship not built from sex. Unfortunately, many believe that gays and lesbians are always having sex and that their relationships are solely founded on this premise, which creates more blockages to their gain for social access, and unfortunate stereotypes. In a generalized population, there are people who are more ready to accept negative stereotypes as confirmed information, in order to develop their own thoughts on the subject; than there are people who delve deeper into the topic and look at multiple perspectives of such examples through a critical lens.

Many of these young lesbians of color ("AGs") take to "hustling" and miniature criminal stints in order to "make it." These groups of women face backlash and torment at their schools, almost forcing them to drop out because of stereotypes and harassment they face from teachers and students alike. In addition, these women face critical discrimination in the job market, as they secretly aspire to get recording contracts that are geared and preserved for black male rappers. As many have said, including the *Village Voice* reporter, the idea of a female in Hip Hop is no longer Queen Latifah-like, men find her challenging but not sexually appealing. In this vein, hip hop as the vehicle to success for the AGs is bicultural and discriminatory. Hip Hop places females into particular confines within the culture of hip hop and men in another (the most dominant of roles and places). It gets difficult to place a woman, who dresses like a man, acts like a man, rhymes like a man, and likes women, just like a men do. They do not become appealing to a larger audience, particularly if young women are still hiding their sexuality from their families, and do not want to openly support rappers who represent them.

Moving away from the "AGs" and the influence that hip hop and rap seem to have on this particular group, we have to ask a larger question of where do young women of color who are lesbians find their representation and/or comfort zone; those who are not part of this circle? As with many other "underground" or subculture productions of experience that have to be kept "secret" or are silenced, being young, of color and a lesbian is not readily accepted by adults in their communities. The preference and/or sexual orientation dilemma is treated as some type of social ill where organizations have to be founded to help these teens to "live normal lives." While heterosexuals celebrate their privileges and freedoms such as marrying legally, gaining spousal insurance and similar benefits, young lesbians of color are triple threats and as such have limited support in these ways. Asian and South Asian women who identify as women of color also toll the multiple threat in their identity development. The fact that they fall under the "model minority" myths adds a greater weight of responsibility to be in fact, "a model minority." Being a lesbian does not strengthen the myth or the work towards becoming such, in our society it detracts from the excellence that any single person could have on their resume. Young women of color have much to combat, consider and confront at the time of their female, social and emotional development. With the pressures of the superwoman myth being ever present, young women of color find themselves torn against what is required of them, what they actually feel (socially and emotionally) and the acceptance of struggle into their communities.

One of the biggest problems facing gays and lesbians in our society is the stereotype that homosexual relationships are strictly sexual. Those who suffer from homophobia create images in their heads and minds of two men or two women together, and begin to believe these images to be true for every homosexual person or couple they might meet. Albeit, the image of two women together becomes of interest as their bodies in any kind of sexual relationship is a more easy fantasy to be had in a male-dominated society. Two men together begins to threaten the sexuality of heterosexual men, and the discomfort it causes when religious factors come into play. In this way, women, both gay and straight are still prone to having their bodies objectified and are quickly turned into sexual images. However, in this sensationalized image of lesbians, they are rarely if at all of color. These moments on television are condensed and compressed into blasting viewers with white girls (a la Britney Spears – Madonna – Christina Aguilera MTV Music Video Awards television kiss on the lips). Television shows are no help to breaking down this stereotype. In fact, many shows that focus on gay and lesbian relations and lifestyle(s) are centered around sex, and in many ways exclude bodies of color from their dialogue and/or story's center theme. The invisibility of women of color who are lesbians creates this environment where being a lesbian and of color at the same time is too much of a triple threat, and thus better exhibited through hushed tones or doublespeak. If lesbians of color are not represented on television (the gateway of information for many), then who do young lesbians of color use as role models to help them break out of any type of pull towards living a "secret life?" With the weight of religion and traditional influence(s) in households of color, it is less than easy to openly live a life that is centered on same-sex relationships and/or love.

Television, the devil and the angel for many, sure, serves a role into many homes as the tool for information and representation, but the side effects of misrepresentation could be more than just problematic. People look to television for a variety of reasons, but when does television life confuse real life experiences and expectations? Hearing stories from my gay and lesbian circle oftentimes does support the idea that gay and lesbian relationships were built around sex and less about sexuality. However, it was not more discussed in this circle than within any heterosexual circle I had been in. Only who each person talked about was different, but the content was the same. Some years ago, I caught Ellen DeGeneres's standup show "In the Beginning: Here and Now" on HBO. Of course, Ellen had recently "come out" and at first, I thought this must have been easy for her because she is white and female, and has a very supportive mother. It was not until the end of the show when an audience member (white female) was given the microphone and amidst tears, could barely express her gratitude for Ellen's activism and her coming out before the world, regardless of her fans or others who hold a type of power in critiquing. The audience member told Ellen that she was so grateful and thankful to Ellen for having done this, and by doing this, Ellen became her role model and gave her the strength to live freely and openly. I was moved by the comment, and by Ellen's reaction, to which she knelt down on stage, and embraced her fan. The audience member also claimed that Ellen gave her hope and promise that she too "can be normal, and fulfill her hopes and dreams." What an incredibly powerful statement. Ellen did what many do not have the courage to do. She is an example to be followed by all people, and all races. It empowered me to see her enact her agency for social change. Many who have the capacity and the social access to provoke change, do not do it, and while Ellen may have risked her fan membership (at the time), or her acceptance into Hollywood, she took the chance anyway, and I am sure it was more than a publicity stunt. In 2008, Ellen was legally married to Portia DeRossi, and shared on her show much of the festivity and sentiment of their day. Earlier, Ellen had Senator and Presidential Candidate John McCain on her show, cornering and pressing him into illustrating his anti-gay marriage beliefs and sentiments; another example of DeGeneres's exposing herself and her activism amidst unpopular waters.

Latina actress Michelle Rodriguez has done quite the opposite, when being prematurely and/or erroneously "outed" by *Curve* magazine, Rodriguez stated to *People* magazine, "There are certain things that can close doors between a celebrity and certain audiences. ... If I were Ellen [DeGeneres] I may get away with the 'I'm gay' level of exposure, but I'm not a comedian, I like men (real ones anyway) and I've only been in this business for seven years, not 20" (Norman, 2007). Although Rodriguez has what she calls, "a big lesbian following" (Norman, 2007) she does not confirm her sexuality one way or the other, but admits that she is not insulted by being called a lesbian. What kind of message can be taken from Rodriguez and her unwillingness to declare her sexuality on national television, even to her "big lesbian following?"

Television quite often is enough to ignite more stereotypes, or at least offers questionable, if not negative models to emulate. However, with these images,

young women of color who are confronting issues of sexuality, are receiving mixed if not warped messages. Perhaps the *L Word* would be less popular if there was less sex-on-screen, and the story lines would create too much of a similar platform of shows that are based on love and relationships but not considering homosexuality. In 1998, *Will and Grace*, aired on NBC for the first time. The show was an extension to Ellen's show *Ellen* which was cancelled prior to *Will and Grace*. Will is a gay lawyer, his best friend Grace is an interior designer, and they interact with two friends: Jack, a gay actor, and Karen, a very wealthy woman who finds herself socializing with important people more than anything else. In addition, the maid to which many of the characters befriend, is a Latina, which definitely reaffirms the Latina-as-a-maid or "cleaning lady" stereotype. Their lives are situated among the hustle and bustle of New York City. The absence of gays of color is stunning, and speaks volumes about the media's representation of the "othering" of particular people. Perhaps the show felt that being gay was the breakthrough for Will, already gay, should not complicate his role by having gay friends of color, including lesbians of color as well. Like many other shows set in New York City, it stands to argue that the invisibility of people of color on *Will and Grace*, adds another dimension to being singled out. In addition, this invisibility promotes the idea that gays and lesbians do not have diverse circles just as their straight white counterparts do not have diversity among their friends. This, many of us know, is false. There are particular bonds between gays and lesbians and social circles, whether small or large, are oftentimes quite diverse, especially when set against a metropolitan city and/or a diverse location such as New York City.

In 2003, reality television it seemed was smitten with the idea of having a show surrounded with gay men (even if all white). In line with its predecessors, the show *Queer Eye for the Straight Guy* (originally named *Queer Eye*) enforced the representation of the white gay male. Similar to many others, the show also fell victim to stereotyping gay men, in several ways: (1) Gay men are white, (2) Gay men know more about fashion than anyone else, except maybe Coco Chanel, and (3) Gay men can teach straight men (also white), about the ways to reinvent themselves and become more appealing to women. In this idea, it can be interpreted as gay men knowing what women want, because of their own "feminine" qualities in that they are able to make over "macho" men to appeal to the "feminine" woman. The show later aired a spinoff series entitled, *Queer Eye for the Straight Girl*, which did not do as well as *Queer Eye for the Straight Guy*. *Queer As Folk*, was the first show that ignited the stereotype of all three of the above characteristics, particularly reinforcing the stereotype that gay men are centered around themes of sex, not sexuality. With shows like these, it helps to push gays and lesbians further into several closets and identity boxes. Not being represented on television as openly gay and/or lesbian, young people of color, in particular, young women of color, are forced into hiding their lives, and their needs, wants and desires, and even their questions.

By 2005, LOGO, a cable channel owned by MTV networks came into the media scene. Broadcasting original shows, documentaries and other programs, LOGO is dedicated to bringing forth issues and perspectives of the LGBT community

(logoonline.com). One of the more popular and famous shows that LOGO hosts is *Noah's Arc*. *Noah's Arc*, debuted in 2005, highlighting the lives of six African American gay men living in Los Angeles. Not like many other shows that involved gay-centered themes, this show touched on the lives of these men dealing with important social issues such as HIV/AIDS, gay marriage, and gay parenthood. The show of course would not be complete if it did not involve issues surrounding love, intimacy, relationships, infidelity and subjects of this kind. Unfortunately, however, *Noah's Arc* displays the lives of extremely effeminate black gay men. From their style of dress to their mannerisms to their dealings with lovers, or potential mates, they carry on similar to women who are very "girly." While in the gay community, these men would be seen as just "queens," in the straight community, they can be easily cast as being members of any gay circle, thus the norm for homosexuality is (mis)interpreted as simply sexual. However, as with shows previously mentioned, *Noah's Arc* created invisibility for women of color and lesbian identities, as well. All of these shows create an idea that being a lesbian is easier to handle or deal with in society as opposed to being a gay male (and even more difficult if black and/or Latino, gay and male). In a male dominated society, it seems fitting that the show focused around gay themes that deals with masculinity, and/or manhood and sexuality, whether gay or straight. Lesbians have a more difficult time being visible on air.

Lesbian identities and/or relationships on television are not something we readily see unless we are investigating questions about "girl-on-girl" scenes in pornographic films. In addition, a lot of lesbian identities and/or relationships on television are left to be assumed by the viewer. Back in the 1980s, I remember sitting down in front of my television in my bedroom, and watching *Katie and Allie* (1984) and thinking, they never date, their lives are surrounded by each other, and each night they come home to only each other and their children, something is not right here. Why would they not just give more detail as to their relationship with one another? It is not like the show was a drama, it was a sitcom, and so throwing in a quasi-lesbian episode might make the public understand their "strange" relationship a bit better, albeit in a different perspective. In the second episode of season two, Katie and Allie decide to tell the landlady that they are a "gay couple" in order to evade a rent increase (The Landlady, 1984). To later dispel the rumors that the women were indeed a gay couple, producers of the show forced the girls to showcase themselves entering separate bedrooms at night (Wikipedia, 2008).

In 1995, *Xena: Warrior Princess* was aired, and instantly became popular as it showcased the "friendship" between *Xena* and her sidekick *Gabrielle*. The show never fully declared that the two women were in a lesbian relationship or were romantically involved, but like Katie and Allie, this show left the audience to assume that there was potentially something more to their "friendship." In a particular episode, Xena revives Gabrielle back to life with mouth to mouth, but the scene appeared sexual to many viewers, and sealed the deal that the two were definitely in a lesbian relationship.

> Despite an early crop of male love interests, the idea that there was something going on between the Warrior Princess and her young companion made the

rounds of Internet chat rooms and quickly got back to the show's producers. After the initial surprise, they began to play to this perception with deliberate sexual innuendo, from double entendres (when a love-struck villager asked Gabrielle if Xena had considered settling down, Gabrielle replied, 'No, she likes what I do,' then quickly corrected herself, 'She likes what she's doing') to scenes of the duo sharing a hot tub (Young, 2005).

Other shows like the popular *Roseann, Friends, Seinfeld, Entourage,* and *Dawson's Creek,* all showcase episodes dealing with gay and lesbian identity. Unfortunately, the shows all dealt with white gay and lesbian identities. Although gay and lesbian identities on television, regardless of race and class, may be a helpful way of introducing young women who are questioning in their social/emotional developments, they are quickly turned off by the lack of accurate reprensentation(s) and/or non-existent mirror images of themselves. Young women of color quickly realize that the issues being dealt with or insinuated on these various types of television programs, do not relate to their own lives.

When *The L Word* was released on Showtime, many supporters (both gay and straight, of color and not) waited with baited breath for what the show would represent. Would it be accurate? Would it misrepresent lesbians, and would there be lesbians of color who give other young women of color hope or inspiration that could not be found among the straight woman of color world? The show while touching on very important social issues, such as characters who end up choosing their sexual and/or private lives over their jobs in the United States military, the show did not fall short of stereotyping. All the women, incredibly sexual and if not overly sexual at times, face some type of issue in their lives not phantom in the lives of those who are not lesbians. Many straight couples face the issues faced by these characters, thus the appeal to the straight *L Word* audience as well. Unfortunately, however, the show used two non-Latinas and created them into Latina characters. This can be argued, as the dialect and surroundings of each of these characters (Carmen and Papi) are more Chicana than Latina, but no attempt to address this is every really brought to light in the show. On screen, in language and in attitude, they both were paid to "pass" as lesbian and Latina. One character, "Papi" (Eva 'Papi' Torres) played by Janina Gavankar, is a semi-masculine, but beautiful butch lesbian, who is hell bent on being a heartbreaker and home-wrecker, while working her "regular" job as a limousine driver. She is "macho," loose at the mouth, cocky, and beyond promiscuous. She is the female version of the Latino straight male who suffers from machismo.

In one episode, Carmen, played by Sarah Shahi (also known as Aahoo Jahansouz Shahi) is written as a character that is clearly a lesbian, but also lives, what some think to be a very a "traditional" Latina lifestyle. While many of the other characters on the show seem to fit very easily into the upper middle class (where socioeconomics trump race), we are taken to Carmen's neighborhood to meet her family. She obviously lives on the poorer side of the neighborhood that the girls frequent. Upon entering Carmen's house, the first thing we see is a huge crucifix on the wall of her family's kitchen, as we listen to the background of a

slow mariachi playing. In the house, along with Carmen's mother, you see all of the women in the household bustling around the kitchen, preparing some type of placesetting for a family meal. Among the traditional Latino/a family setting, Carmen's lover/girlfriend "Shane" (a white female), is questioned about her family. Carmen delivers this brief story that Shane is a product of foster care and does not really know the whereabouts of her family. Carmen's mother then leads into this lamenting of how sad for this "poor little girl" not to know her family. Carmen's spanish all through this is questionable, as she is forced to explain to masculine Shane what a quinceañera is. While most of the show deals with issues of love and sex, sometimes more sex than love, Carmen is always sexual, and always wants her lover to pay her some attention. It is the clear example of the Latina as both whore and Madonna. Religious enough to pay her mother any kind of fake homage as to being a "traditional" Latina and in her private life, the desire of a white butch lesbian.

Another character that is questionable in representation on the *L Word* is "Tasha Williams," played by African American actress, Rose Rollins. The good news about the character Rollins plays is that she is romantically involved with a white lesbian, thus bringing to the forefront of their relationship the issue of interracial relationships in the lesbian community. Some would argue that even though the show highlights a few women of color, in both character and the actress herself, she is confined to being a butch lesbian. Tasha is not exempt from this identification. Unlike many of the other women on the show, both Tasha and Papi are very masculine or hold more masculine qualities than their white female lesbian counterparts who host very "feminine" qualities. Jennifer Beals's character, Bette is also quite masculine in many ways, and is seen as aggressive and assertive in her sexuality, sexual relationships and sexual conquests. Tasha is an active member of the United States military, who has to hide her sexual preference or decide to leave the military completely in order to stay with her white girlfriend. Bette is biracial, has an adopted child with her white female ex-lover (who is bisexual and feminine), and then moves on to cheating on her new white female, and deaf girlfriend. Pam Grier, who was talked about in an earlier chapter (Foxy Brown), is also quite sexualized, involved in a relationship with a white male who cheats on her, and ends up taking up sexual advances offered from masculine Papi. The complex construction here is not only the representation of female characters of color being confined to being one type of lesbian (butch, or curious), but also not really being who they are cast to be. "Black lesbians trying to find out who we are both as women of color and as lesbians find the invisible wall we bump up against while trying to find access into the lesbian community even harder to bear" (Bland, 2007). These media faux pas create an atmosphere of further distancing of actual viewers who use these shows to support them in their daily quest for identity.

In 1996, South Asian director, Deepa Mehta released *Fire*, a story about two Indian women who find solace and love in one another, and break free from their husbands who serve in the role of their most dominant and apparent oppressors. After huge controversy among the Indian community (not being ready to accept homosexuality, much less lesbianism which would then hold women still at the

center but differently), including violent death threats against Mehta, she had the following to say:

> I wish people would believe me when I say that *Fire* is not about lesbianism. When you want to focus on something that is sensational, you make that the main part of the film. I've said it over and over again, and I should know since I made the film – *Fire* is not about lesbianism. It has a relationship, which is between two women, which evolves from emotional nurturing. It is not the definitive film about lesbianism. In fact, one of the things that detract from the film is that really the film is not fair to lesbians, because it shows that perhaps women turn to each other only if their marriages are bad. But people appropriate whatever they want to from the film (Haidar, 1998).

What *Fire* does that many other shows or rather American television does not do, is use appropriate people for the roles and does not infuse the film and/or show with heavy ladling of sex. In agreement with Mehta, the film is not about lesbianism, it is about what many South Asian women go through in their lives throughout womanhood. In fact, the film could be interpreted as being more about the struggles of South Asian feminism as opposed to two women who "just end up being lesbians." Actress Nandita Das who plays "Sita" in *Fire*, while not a lesbian, not only took on the role of Sita because of a career move, but she is noted as a controversial actress because of all of her roles. In a film industry such as Bollywood, that works to support the stereotyping of women of color (South Asian) as weak, constantly in love, full of song and dance, and superiorly feminine (enter running through the fields), much of Das's roles are quite opposite.

> Das continues making independent films not because she doesn't want to sell out to 'Bollywood' but because she enjoys their themes, she said. Initially her family feared her taking on these controversial roles, such as a recent role in a small film Sandstorm, in which she plays a woman who is gang-raped. But she said she will continue to use film to defend certain causes and make social statements. Although Das regularly faces opposition in India, she remains optimistic about freedom of expression in the country, which she said gradually is making strides. Students said they were impressed by Das' commitment to social progress (Jacobson, 2001)

As a first year doctoral student, I began working on my research of South Asian female identity and experience. Through my research efforts, I made Phoolan Devi into a heroine, almost overnight. I began working on a short documentary based on the lives of Indian women and the feminist icons we as American women of color are closed off to knowing and/or bringing to light. Before screening it in class, I required all the participants of the documentary (the women I interviewed and several South Asian organizations) to serve as a critique group in the role of the native informant. Although I used *Fire* and *Bandit Queen* (Phoolan Devi) only as a brief mention in my documentary's overall theme, I caught hell from the organizations as opposed to the women who agreed to be in the documentary that were extremely supportive of my research and the work that lay ahead. The

representatives from the organizations found my making of Devi into a heroine a "negative blow" to the South Asian community, along with my use of *Fire* as a "sensationalized" version of the South Asian woman's identity. "Some of us are not abused, and are not illiterate" were one of the comments I was given as feedback to my documentary work. In my retort, "granted indeed, however, many South Asian women do not have the luxury that you have by running an organization to help South Asian women break free from much of their oppression, particularly in their native countries, hence why you founded such a place." They were not satisfied with these types of answers. In fact, they were very angry by my documentary that displayed South Asian women as lesbians, as abused, in loveless marriages, as vigilantes, and as women who were in search of a representative voice. They placed so much fear into many of my project's participants that eventually the documentary was shelved instead of showcased. While they signed a release to have the film screened in classrooms only, they were not willing to sign any more releases to submit the film to larger audiences, such as a film festival. The idea of no representation or misrepresentation seems to be more readily accepted as opposed to accurate representation. Many years later, a representative from one of the same South Asian women's organizations that condemned me and my documentary, contacted me asking me for a copy of the video to show their new recruits. Agreeing not to further "demonize" women of color who were actually experiencing the traumatic situations that I discussed in the documentary, I did not offer up my video for further viewing.

Similar and different in many ways to *Fire*, is Mira Nair's *Kama Sutra: A Tale of Love* (1996). To hold steadfast to the idea that South Asian women are subjected to a man's desire, or the workings of pleasure for a male dominated society one that is rich in culture and ancient secrets, *Kama Sutra*, has a split second moment of lesbian identity. Two women, childhood best friends who later become bitter rivals are given a moment on-screen to become sexual teacher and student. Not knowing how to please her husband (a Prince), Tara (Princess) played by Sarita Choudhury falls victim to her husband's, (Raj Singh played by Naveen Andrews) taking of a courtesan, Maya, played by Indira Varma. Not wanting to continue the rivalry, and Maya herself being torn between her profession as courtesan and her real love for her own male lover, she decides to teach Tara the secrets to pleasing her husband (courtesan-style). In this scene, Maya bites Tara and states, "He'll know a woman made these marks, and it'll excite him" (*Kama Sutra*, 1996). The sexual moment between the two women is not classified as a lesbian experience because it is in lesson-format, and the end result of the experience is to excite Tara's husband, not to please herself. Their exchange of same-sex relations is for the sole purpose of enticing a man in a loveless and sexless marriage, and does not consider the loveless feelings of Tara herself. Some would also say that the scene itself it to entice the male audience, although the film is about women coming into their adult sexuality, be it lesbian or straight.

As far as we can see, television leaves much to be desired, when it comes to representation and/or helping young women of color answer questions about their "curious" sexuality and sexual preference. Forced to accept images of the black

superwoman, the oversexed biracial or multiracial woman, and thirty-second lesbian experience, or overly sexual bisexual women on MTV, the path to healthy identities of sexuality are lost. For many, the turn from television leads into the search for sexual identity by way of literature, and later conscious curriculum by dedicated educators who fight for inclusivity of all of their students.

Throughout my time teaching college students, thus far, I have encountered and have made friendships with several students who identify as lesbians of color. It has been an interesting travel to watch them use either identity marker at a time, interchange them, or put one before the other; all of this depending on how they are addressing a particular topic, or who they are speaking to and with. If not obvious in class, or as they would say "a butch," any time they identify themselves as lesbian and/or bisexual, most of the students will turn around to look at them. It is the first time students recognize "difference" in the room, which represent sameness in a variety of ways (race, ethnicity or nationality, skin color, socioeconomics, and/or gender). Because there are so few that are outwardly open about their sexuality and sexual preference, other students (who identify as straight) put pressure on these handful of lesbian students to serve in the role as a native informant. They become the accurate representation of all things lesbian and/or bisexual. In many ways, my lesbian students of color become immediately exoticized and/or essentialized, and their experience(s) with sexuality become "foreign." Most of the time, my classroom is a "safe" space, where people share their most intimate of experience(s), or what I have classified as *therapeutic sessions*. Students divulge information between our academic walls more than they would at home in the "comfort" of family. Not having a large and outward openly population of lesbians of color in my classes, many students find that their "expertise" in the life, or in the experience of being a lesbian and/or bisexual offers them a voice, whether positive or negative. Unfortunately, for many of these students, the declaration "I'm a lesbian," or "I'm bisexual" comes as a response to the population of students who are against gay marriage and/or are homophobic. The first time a student came back after a summer vacation declaring that she and her wife had spent their honeymoon in the Caribbean, it silenced the rest of the population in the room. No one wanted to comment and/or ask follow up questions of her experience. In their minds, "I never thought *she* was a lesbian." For a large number of students, being a lesbian and/or bisexual is always curious. There are certain characteristics that students look for when trying to figure out whether someone is gay or "straight." For some women, the characteristic of the "black butch," or the "lipstick Latina lesbian" is where their "gaydar" seems to work fastest. In this experience, I find the television programs previously mentioned, guilty for promoting the idea that lesbians of color come in only these variations and fashions. Other students never declare their sexuality or sexual preference openly to the class, but in private student-professor appointments, they will let me know—I am then in turn, not allowed to disclose this information to the rest of the class or to anyone the student knows well. Students who indentify as "straight" never find the need to declare as such because they see themselves as the norm. When in fact straight students do find themselves in situations of declaring their

status as straight, it is in response to supporting gays and lesbians, and gay marriage; "Don't get me wrong, I'm straight, but…"

The fact is, that many young women of color face images on a daily basis that continue to misrepresent them in a number of ways. Sexuality being a large factor in this misrepresentation, many young women of color who identify, as lesbian and/or bisexual do not see themselves in popular magazines, and/or on popular television shows (unless hyper-sexualized or oversexualized). They are also quite misrepresented in schools, where they face various types of discrimination(s) and in the worst case but not rare, physical violence and hallway harassment. They find themselves in classrooms that do not represent them either, whether through the course materials, course dialogue or the teacher's stance on sexuality (if this is even present). I have been told countless stories from students of color who have been told by other professors that their sexual orientation has no place in the discussion of the particular class. If these are the politics of pedagogical practice, young women of color will continue to be icons of sexuality but sexless at the same time. Educators must hold firm in their support of each student's identity, and treat these individual experiences as personal narratives, whether expert or not. If young women of color who identify their sexual orientation and/or preference are encouraged to do so whether as native informant, or questioning, the learning process of other students will increase. Furthermore, the students who represent the native informant would be more likely to share in the discussion and find connections to the course and readings on a larger scale. Unfortunately, not all educators practice this, nor is it encouraged in many schools. There are a slew of courses being taught on the experience(s) of women of color throughout the world, and while sexuality is discussed in terms of pregnancy, reproductive and sexual health, her preference and orientation remains invisible.

> While some teachers and administrators harass, ridicule, and unfairly punish gay students, or those 'suspected' or 'accused' of being gay, the predominant feature of the discriminatory school environment for gay youth is failure of school officials to provide protection from peer harassment and violence. Counselors, who should provide confidential, supportive counseling to gay/lesbian youth, often do not do so for a number of reasons: too busy; themselves uncomfortable with homosexuality; not trained to deal with it; afraid of controversy; or worse yet, strongly homophobic themselves (Pohan and Bailey, 1998).

In 2002, a fourteen-year-old lesbian of color, named Natalie Young, was suspended from her school in Queens, New York for wearing a t-shirt that stated, "Barbie is a Lesbian" (CNN, 2003). Although Natalie is openly gay, and was so at the time, she was made to remove "rainbow colored beads" from her braids prior to the t-shirt incident (CNN, 2003). A year later, and through a court battle, Natalie was awarded $30,000.00 for the violating of her "right to express her views" (Reuters, 2004). The school was also mandated to having to take sensitivity courses "to improve relations with gay and lesbian students" (Reuters, 2004). These kinds of cases happen all too often. As members of the triple threat, they

also suffer multiple acts of being silenced and attempts at invisibility. With teachers and schools that enact these types of bigotry, many young women of color find no solace at school nor at home with families of color who are steeped in religious beliefs that homosexuality is a sin and/or wrong.

While early work on homophobia was based on the assumption that the fear of black gays and lesbians, was justified because homosexuality was either a disease or a strategy of European domination, the latest research starts with the recognition that gays and lesbians are a significant part of the black community (Battle and Bennett, 2000).

While there is a call for the of color lesbian dialogue to take place in college classrooms, we have to look to the start of the sensitive situation. In colleges and their classrooms, the comfort in such classroom(s) must be an installment that begins with the teacher. To begin understanding how to create safe spaces in classrooms, it must begin with educators requiring students to either write or narrate an introduction of themselves. Personally, I quite welcome controversy in the classroom. Controversial topics stimulate heated debates that provide an expressive atmosphere for learning. However, as mentioned in the last chapter of this book, you will understand why I do not provide more options for educators. In short, what works for some may not work for all but should be at least considered if we really are caring for the minds of our young and intellectually stimulated.

For lesbians and bisexual women of color, the empowerment they must feel when included in the feminist dialogue and Diaspora must come from the self and interactions with those who are in likeminded positions of seeking various forms of liberation. Many find comfort in silence, and while sometimes things are indeed best unspoken, forms of oppression should never be included on the list. When beginning to try and understand multiple identities whether we are ourselves questioning, or hosting a population that is lesbian and/or bisexual, there must be an emphasis put on self-responsibility. Media representations will always be somewhat off color, literally and figuratively. Although we can hope that native informants are part of large and small think tanks that come up with television show plots, we cannot expect that authenticity will trump capital. While many of us wait for accurate representation on television, we have other sources in the meantime. Representation comes in many formats, some less accessible than a popular television show, and some that requires a bit of legwork, and an "audacity of hope" (Obama, 2004). There are a barrage of lesbian authors that are of color, who write about their experiences that many young lesbian and/or bisexual women may find as important contributors in their own personal findings within sexuality. Unfortunately, there is still the invisibility of many of these authors in college classrooms, unless "ethnic specific" studies or other more concentrated areas regarding people of color studies. In reading the narratives of others, we begin to understand how to breakdown stereotypes and practices of discrimination and oppression. Jewell Gomez writes,

Of the one hundred women included [in *Contemporary Lesbian Writers of the United States* (1993)], sixteen are black; furthermore, three of those have passed on. Again, most of the black lesbians included have not been published

by mainstream presses; and those who have been, such as Jacqueline Woodson, have not traditionally been known for fiction primarily grounded in the lesbian context or community. [...] Their narratives have, with some exceptions, taken place in a nonlesbian context, which means that their reputations are more likely to be as black writers than as lesbian writers (Gomez, 2005).

While some television programs do more to reinforce stereotypes, alternatives are offered up by way of finding existing and creating new literature. We cannot expect that college classrooms be the only avenues for accessing literature that is multicultural and/or diverse. In fact, what should be asked for and taken away from the college classroom experience are researching skills, and the knowledge of and desire for rigorous intellectual inquiry. Private research, for self-awareness and social development, could be as simple as a Google search or as extensive as walking through every aisle of a bookstore...twice. Looking for authors via the Internet that write on the lesbian of color experience will no doubt produce tons of pornography. After wading through these offensive and less-than-artistic images and messages, the collection of authors' names and platforms or writing(s) can be developed. I do understand that many libraries all over the United States either suffer great amount of issues when it comes to access. Little to no funding requires libraries to close early, or not open on weekends, when most young people have the opportunity to access materials and library services. Libraries also run up against economic issues when it comes to acquisition, and simply other libraries do not encounter the demand to house books of particular genres. This is where individual responsibility comes into play. Authors like Audre Lorde, Alice Walker, Ann Allen Shockley, Pat Parker, Barbara Smith and Cheryl Clarke are both available and invisible depending on where one is trying to locate their materials and groundbreaking writing(s). If bookstores near where you live do not offer the material that you need, requests should be made to bookstores both major and independent. The request here is simple and difficult at the same time. It requires the reader or one in search of knowledge and/or shared experience to dig deeper. To require libraries and bookstores to begin carrying materials that are needed or that you want to make popular, is a beginning. If you find something relative to your life experience, readers should be encouraged to form and join book clubs in local neighborhoods; this is a great way of sharing experiences, as well as bringing to light much of what will continue to go uncovered unless dialogue surrounding the topic takes place. Furthermore, this analysis is a call for responses in that I urge young women of color to begin writing and documenting their own experiences and narratives. How they are later shared, after being written would be up to the composer, but much of the time to simply write about one's personal and/or lived experience, is both liberating as well as therapeutic and offers insight for the author as well.

I also encourage young women of color to not only learn about the narratives of shared and/or similar experience(s) with sexuality, but to read and become familiar with the experience of other women of color. The broadening of the sexual horizon is further than we are able to see through any Internet search engine. The broadening it begins with the self at the center, and at the tentacles of intellectual inquiry.

CHAPTER SEVEN

HOW TO DETOX

TEACHING AND EMPOWERING GIRLS IN THE COLLEGE CLASSROOM

As a college educator, you are given a window into the lives of many young people's experiences. Whether that educator opens the shade, is up to them. College educators that are more interested in students' lives outside of the school, are given a reclining loveseat into the living room of those experiences and how they present themselves. For the last six years or so, I have been teaching both undergraduate and graduate students. While many of my graduate students have been predominantly white, female, affluent and a bit on the non-confrontational side, my undergraduate students are a large mix of Black, Caribbean/West Indian, Latino/a, White, Asian, South Asian, Bi-Racial, male and female, gay, straight, bisexual, and "bicurious" (a la Tila Tequila). During my early experiences as an educator, I would come home, exhausted, wordless, motionless but hosting an air of excitement in me that only my students were able to see. More recently, I am still exhausted, wordless at the end of the day, emotional, disturbed, worried, fearful, anxious, excited, and full of life. Each semester there are defining moments of why I teach. My students have reminded me that there is equal footing in teaching; I am there for them, and they are there for me among other reasons why they exist in my academic circle.

In the halls, and out of the mouths of students, I hear more negatives about educators than I do positive, I hear more horror stories of professors not attending to the needs of their students, but carrying out Freire's theory of banking education (Freire, 1970). This process of "banking" has set up a constant them versus us approach to education, where professor's methods are seen as the key to a student's success. Students are not the center of the course, needless to mention, their experiences outside of the classroom are not seen as valid or consequential to their understanding of the course material and/or concept. Unless in a class based on race, where the professor is of color, and is deemed (by the students) as having understood the needs of the population they are teaching, professors, I have been told, do not want to talk about race. It is almost as though they do not want to hear how much race does matter in *everything* the students experience and how they learn. Throw gender into the mix, and there is a different kind of approach to teaching and learning altogether. The difficulty in these situations are professors who are ill informed and suffer from guilt (white guilt) and accept excuses for a lack of better understanding. The process of feeling sorry for students and their experiences and/or social lives is more dangerous than not teaching them at all. Do I take into account that a student is exhausted because they have been working all day and attending my course at night and have to attend to a family when they return home, in order to do it all again in the morning? Yes! Do I make exceptions

121

for failure? No! All of these factors can attribute to academic failure, but some responsibility is needed from the educator to make sure these factors are seen as pluses and not minuses. When my students complain about the amount of reading that I assign, I remind them it was not so long ago that it was illegal for black men and women to learn how to read and write. While it may not be the best method of getting them to read, as there has to be some genuine interest in the material, I do know that the reactionary comment provokes thought.

I have seen plenty students of color (female and male) leave school for more than just a semester, or completely drop out because they have become pregnant somewhere between the ages of 19–21. I have seen a couple more students "leave school" because they are forced to find jobs and financially contribute to the stability of their families. They later attempt and fail at re-enrolling, or continue completing their degree requirements while disconnected to the experience of learning. I have seen and come to know others who have landed successful jobs before graduation and skip the completion of their degree altogether, having been enticed by corporate America money. The problem, as we are now facing in the United States is the dip in the economy and the closing of major investment banks. The lack of completing their degree and the closing of job opportunities creates this sensation of hopelessness, where paranoia oftentimes sets in, if not this desire to "hustle" on many fronts. The amount of tears I have wiped away from faces and my shoulder fails me in recalling. During office hours, students hardly pay visits to talk directly about an assignment or difficulties faced with the class. Instead, many of the visits are indeed about their lives outside of the walls of their university. The top five dilemmas I have heard have have been: (1) I can't find a job, and don't know what I'm going to do now. (2) I have to leave school because my parents want to move back to our home country. (3) Professor Bernard, I have a sexually transmitted disease, and the guy doesn't want to admit he gave it to me. (4) Professor Bernard, I'm pregnant and can't stay in school, and (5) Professor Bernard I am so depressed, and I don't see life getting any better, or (5a) valid and sincere deaths in the family that rock the family's stability to the point of where the student either enters a place of deep depression or just cannot cope with life. However, I have also encountered many more who graduate with honors in their major(s), maintain a job or two and have great attendance records at school and work, many who have very young children while they themselves by social standards are "very young" and still work extremely hard in order to obtain their ever-chased "piece of paper!" Many have swept past my door as the first in their family to graduate from college and with the hope that they too may attend graduate school. I have also seen many extreme transformations, of students cutting themselves off from the typical college social life to gear themselves into a more strict focus of not only graduating, but also the goal is with an extremely high and competitive GPA for graduate school. With all of the good and bad experiences, what do we know about the lives of young women of color in college?

The lifestyles of many female of color students would allow any quantitative specialist or scientist to easily predict failure. From the way they dress, to the way they speak, to their multiple jobs, multiple bedmates and terrible eating habits, I

too worry, but it is easier to predict failure than to work towards social change. My undergraduate students once asked, when you write a book Professor Bernard, how will you tell the story of good things and still make money? They are not used to reading good things about themselves and/or their communities, and in particular, they are not normally assigned readings written by academics of color, unless they are in an "ethnic" studies course. They are very aware that many of the sociological works that they are exposed to tell the story of blacks and Latino/as that struggle with socioeconomic disenfranchisement, teen pregnancy, terminal illnesses, homelessness, or hopelessness. While many academics both of color and not, ask their students to look at the material critically, what is missing is the investigation of these materials within the social dynamics. Many young women of color both organic and traditional intellectual alike, are aware of how race, class, gender, sexual orientation and/or positionality offer different ways of understanding the world. For years, they have been made into examples of terms in sociological studies and narratives, and the story continues where if blacks and Latino/as are successful, they are famous athletes, rappers, entertainers of sorts, but they are not academics. Who then, will tell their story of how they came to their successes *after* encountering so many socially failing experiences? Yes, many do not have enough to eat during the day, and are exhausted by the time they get to class, but it does not last forever for all of them. I worry that our lives are skewed, our perspectives not equally voiced, and who we are is different from how we are exposed on the page. So here has been my attempt to indicate that change is progress, and progress is not easy.

Almost Teaching

I first started out my teaching career in my childhood bedroom. I cleared up space on my bureau, collected all my stuff animals, and lined them up in neat rows along the top of the dresser and smaller set of drawers. I had a small chalkboard that my mom had purchased for me but it would prove to lack space for my extensive notes that I would have to give to my "class." I taped a piece of cardboard to the chalkboard's extension and felt complete. My kindergarten teacher had several complaints about me for my mom, none of which I had for my "students." I did tell them often to "stop talking" as my teacher would tell me during the day, but that was the extent of my needing them to focus. I gave lessons on the alphabet and had them recite along with me their basic numbers (from one-one hundred). My mom also bought me a pointer and thus I would go back over letters that were difficult for them and numbers they could not pronounce "properly." My class would consist of close to two hours going over the same lesson. Towards the tail end of the "class session" I would call for current events. No one ever had any, so I repeated to them what I had heard from when my father would watch the evening news. I was not sure what I was repeating, but obviously not one of my students would contest or object.

This went on for some time, until I found myself with real friends in my neighborhood to play "school" with. Most of them went to catholic school, and our

lessons not the same, particularly because they were younger than me, and spent a lot of time at their own schools learning religious information. What I did not know nor wanted to talk about, for example, was the "catechism," I would let one of the students (my friends) talk about it. We would then go into playing a game we called "church" and in this way I could possibly gain a better understanding of why they needed to learn about this, and why would this make them "smart." I still have no clue. I always felt though, that there was a difference. My non-Catholic school friends and I at our public school were learning the same thing, but the girls across the street were learning about the catechism, and so I felt like someone had an advantage over me. Their catholic-based school was also public, and directly across the street from my public school, so why were the lessons so different? Don't all children have a "Sacred Heart?"

Years came to pass and I did not teach my "animals" any longer. I was too busy, but I never forgot how it made me feel. Empowered because I had reviewed the day's material, and taught a group of "people" something new. Now they (my stuffed animals) would not feel like I felt because they did not have a teacher and I did (similar to the catholic school across the street from me). I did receive "release time" from school to attend Catholic Church classes on Wednesday afternoons for lessons. I had begged my mom, and although she protested for a while, against the idea that I would be missing regular classes, she let me spread my mental wings and provided me the freedom to learn multiple things, and essentially anything I wanted. I soon got tired of leaving school in the middle of something (a lesson or free time) on Wednesdays, and found "church release time" to be disruptive, and begged her to let me stop attending. She did as well.

As mentioned, I had my own bouts with public education, and had been tested as "gifted" several times, but my mom parents wanted me to continue on the "normal" path and enjoy my school experience. Teachers suggested to my parents that I be skipped from grade to grade, but part of me wanted to go and part of me wanted to stay. Although many faces just a blur now, a handful of my elementary school teachers made huge impacts, but they never really inspired me to teach, only to learn. Kids were "too bad." They made "too much noise," never stopped talking, always whining, and seemed to have short attention spans (prior to the popularity of medicating children who are deemed ADD). No one was neat, everyone very helter skelter, and yet I walked into the classroom and felt it my own every time I did. When I was in fifth grade, my teacher told the class that we would have to share our history books among three students because there simply were not enough books. That night, at home with my family, I began to cry. I explained to my family my confusion and frustration. Why are we sharing among three? Why are there not enough books? How can three people read the same thing, when everyone reads at a different pace? What if I never get my turn? I was genuinely upset, in particular because I was part of a group with a bully and a girl who never spoke...ever. My sister bought my book. I had my own. I could read it at my leisure. I would not have to wait on anyone, and I could do my homework on time, and be up to date. I would not need anyone to help me because I would be on time.

I was forever grateful. However, the questions of why kids had to share such important materials like books proved to still need answers, even today.

Time passed and I became a full-fledged student. In junior high school and high school but by eighth grade, I had a job, so I shared my brain between my school responsibilities and work requests. I would not revisit teaching for some time. None of my friends found it "fun" to go to the library on weekends to see "what new novel had been released" and as resentful as I had become, I was too shy to beg them to do so. Finding a permanent part time job while in high school at the library (a new place to go after school), I was able to call the library my second "home."

The warmer months before I graduated with my Master's degree from Columbia University, I was offered an opportunity to TA (teaching assistant) for a great professor. They normally only allowed PhD students and/or candidates to TA and so I would have to do this for free, if I still wanted the opportunity. Without hesitation, she assigned me a massive amount of work that left me feeling empowered. I had tons of papers to look over and issue a preliminary grade (she would grade it in final) and I had to make sure I read all the books and materials well before the students, so I could more than participate in class. I was writing my thesis at the time and felt suffocated by all the work, but refused to give off anything less than eager. I did not want her to think I could not do it. Being around so many PhDs at Columbia University was the first time I had heard "that kind" of talk outside of my home. Getting a PhD in the future had entered and exited my mind like a quick strike of lightning. I did not have my heart set on it, and law school was where I wanted to be instead. However, there was something about that long-term thinking process that my PhD "friends" would engage in. How many books would you need to read for an oral? How many pages is a regular dissertation? How many classes? I felt cocky. I had completed my Masters in nine months (actually two semesters) and my thesis was longer than any dissertation that any of my friends were working on and I only had a Christmas break to do it. I could do this. The aspect of teaching college students this time around appealed to me and standardized tests frightened me (still do), and I was the biggest thinker in my own world. I would do this.

Teaching

My first teaching experience was exciting and dreadful all at once. My graduate history professor connected me with my first adjunct job, which to her, I am forever grateful for. She exposed me to a world shared by her (female and of color teaching white graduate students). She had no doubt I would be fantastic and create a dynamic in the room that had been lacking in the halls of that place for so long. I tried my best each time, as I knew her recommending reputation would be at stake. I entered the classroom with one light-skinned face of color (female) among thirty other students who were white (male and female). As soon as I entered the room, a student said, "You have got to be kidding me." "It is a class on diversity in the classroom, did you expect someone white?" I asked. So stunned she dropped the class that afternoon. The class remained with the same tone throughout the

semester. They did not appreciate talking about confrontational issues on race. It proved difficult and awkward for students who explained that they had joined a program to teach "inner city children" ideally because it was a job that allocated free summers. Many of them did care, and did dedicate themselves to learning and teaching. They wanted to be good teachers, and they wanted to learn how to do that. Unfortunately, I began to realize that one probably cannot teach this skill, but rather teach how to develop criteria for one's own pedagogical preparation. I went through hell from that day on, but every week I returned, and felt rewarded. Someday they would understand why "diversity" is so important. I found myself creating examples centered around the idea that these students were white females, and would be entering classrooms full of black and Latino/a children who are of low socioeconomic backgrounds and that live in less-than desirable neighborhoods to which my students normally would not travel to unless for work. Them understanding what that meant in a larger social context was more important than doing all of the assigned reading or designing ven- diagrams, which distracts the student from the actual topic.

I realized that either three people in administration loved me, or someone was in desperate need for adjuncts at the time, because every semester I was asked to return. Shockingly, at this particular school, I received high marks on my teaching evaluations; higher than every other faculty member in the department including those with tenure. This made for many an enemy (or so I have been told) and many a snark at faculty meetings (which adjuncts did not usually attend). I spent countless hours in the Dean's office as well as my department chair's office explaining my pedagogy. I defended the use of books like *Pedagogy of the Oppressed*, as key and central, but some students claimed I was not preaching to the choir but instead "promulgating communist propaganda." I began to teach select chapters of the book rather than the whole book. Maybe it was the red cover jacket of the book that had everyone's underwear in a bunch. The selected readings seemed to work, but the level of discourse within its pages proved for another problem. Students were angry that they had to read "such a hard book," and felt as though they were wasting their time by using the dictionary to get through a chapter. Looking up my background (I imagine) a student claimed, "We aren't your Columbia students." I explained to her that I went to Columbia and that I had not taught classes there. They did not seem to care. I was being unfair and selfish, and my assigning "these types of books" was very "pompous" of me, or so I was told. My heart ached at the anti-intellectual sentiments of these students. When I returned to friends to repeat the story, many of them asked, "these are black students right?" They were shocked when I said, "no, they are white and female." There was an expectation of my own friends that the students who complained about "hard work" were of color and young.

Many months later, a student (white and female) continued to use the "Nigger" to describe an analogy in class. She was irate that I had used the term "mental" (complete with air quotes) to describe individuals with mental problems, and equated this use of mental to the use of someone white using "Nigger." Many students jumped in and stated that they were uncomfortable with her use of the

word in the classroom, but she refused to let up. She continued use the word, repeatedly, no matter how many people were shifting in their seats. Finally, I asked whether or not she was using the word in my presence because she felt that I would personally be hurt, or rather was she calling me "a Nigger." She said, "Yes. You people can't just say whatever you want and think we can't either." After my laughter at her comment, and the shock of the classroom. Students began to get up and walk out. They whispered to me "Professor Bernard, this is absolutely wrong and we're not going to sit around and give her the freedom." I eventually walked out when the classroom was empty. She stayed behind, buried her head in a newspaper and rejected all of us. I repeated the story to administration who took it very lightly, claiming that her paperwork indicates that she may have a "disability." What does a disability have to do with calling someone a Nigger? They had no answers. They asked whether I felt the need to be apologized to, and I said no. Apologies would not have helped a classroom built on social change and the construction of such, that she attempted to destroy in a matter of minutes, and an apology would certainly not help any of the kids she was bound to teach, many of them black and Latino/a. What would sorry do? If given the opportunity to teach, she would be the last person to be sorry, it would be her students and their parents.

The dean apologized, (another useless attempt to make me feel better) and eventually the student apologized (pointless). I had my hand twisted into accepting her apology. She paid for her semester there, and I guess they could not afford to lose that chunk of money all at once. "Dollars for Niggers" seemed to be the sentiment they were perpetuating. How the world has not changed much, but I would be damned if I would take this out on students by walking out mid-semester. I dutifully returned to class the following week, but she did not. Apparently, she never came back to any of her classes. Shame is a terrible thing, and oftentimes eats people alive. There could have been future opportunities for this particular student to learn something or two about people of color, but instead she refused as she had already made up her mind about what we were/are in her eyes. The rest of the class appreciated my return and we kept our learning continuous without mention of her ever again. Ultimately I left the school for other reasons, but this episode surely did not help my decision to stay. The constant questioning of my pedagogical skills and tools exhausted me. I exhausted my family by recounting the stories that night. I was tired of students asking me, "do you have a PhD?" and it being a questioning of my intellectual capacity not in admiration or the desire to talk to me about a process they were interested in.

All the while teaching graduate students, I was also teaching undergraduates at another school. I had multiple jobs, no stranger to any adjunct's quality of life. At one point, I was teaching six classes and taking five of my own and working on my dissertation, but teaching had consumed me and became everything I wanted to do with my life, and so I continued. I was too far into my intellectual development to return to many of the non-teaching jobs I had had in the past. My bosses would not respect me still, and I simply could not take orders from anyone without a loss in translation it seemed.

The undergraduates were full of life. They were active members in various social, cultural, and economic clubs. They were presidents of the student body and they asserted their power well, wielding and yielding for all the things, they sought after as important. They held campus talks on important topics, they worked full time and part time at a variety of jobs, and it seemed almost everyone had a "hustle." My first and all subsequent semesters I assigned *Pedagogy of the Oppressed* (1970). It did not matter what class I was assigned (sometimes three or four different ones all in the same semester) I taught the same book as the standard or crux for the course's topic. Truth be told, I heard the very same complaints that I heard from my graduate students. The book was "too difficult" and why was it so "wordy," and was there "no other book" I could have assigned among the five others for the course that would say the same thing differently. Truth is, no there isn't. There was no other book that does quite what Freire's *Pedagogy of the Oppressed* (1970) and Kincheloe's *Contextualizing Teaching* (1999) can do to the minds of young people who engage in a war against oppression and liberation throughout their daily lives. It seemed although the black males in the class would state they have the hardest time staying alive and doing well in the United States, particularly in New York, they found the book the least relevant and applicable. The black females in the class found the book immediately relative, and began to tote it around like a Bible. Students would see fellow students with a copy of the book in their hands, and ask, "Oh, are you taking Professor Bernard too?" It would become a joke among the young people of color on campus.

Although resistant at first or within the early stages of the semester, students began to find *Pedagogy of Oppressed,* resonating with their daily lives. They understood the "banking concept" of education as they entered their science and math classes weekly and would use these two particular types of classes as examples as to why they were stagnant in their learning. This idea of students as receptacles or empty vessels having relevant and irrelevant materials deposited into their minds would conjure up in loud unified voices "we're banked!" The struggle to try and achieve or get a barely-passing grade would suffocate them, depress them, and sometimes lead to their leaving school altogether. It was even too much for me to handle. I felt the tears well in my throat each time a student would visit me and say something in a version of, "I just wanted to say goodbye. I can't do this anymore." I would coax, encourage, push, get mad, and sometimes this would work, and other times I would add to their disgruntled feeling, by them now knowing they had disappointed not only themselves but their "favorite professor" as well.

WOMEN OF COLOR

I have since devoted my last two years strictly to teaching courses on the black and Latino/a Diaspora and a course on Women of Color (WOC). In this chapter, I will recount much of what took place in the WOC class(es) and how the teaching of the woman of color's life is important to the overall functioning of the female student of color. I had proposed the course to my then-chair and he happily agreed to let me teach it. I warned him that I would be changing around the course a bit, as I did

not believe, as the course description would have it, that the lives of women of color begins at slavery. He smiled and sent me on my way. That was enough of a green light for me. I had previously taught a course on Latinas, but it was not enough. The black females who registered for the course dropped it, because they did not feel the title of the course was representative of them, even though I tried to explain the role that the Afro-Latina would play in the course. The encapsulating title of WOC seemed to address most of the population, but then the Asians students did not feel that way either. I did not write them off completely, even though the course was being offered through the department of black and Latino/a studies. I tried to include narrative pieces as well on Asians and South Asians, but the black and Latino/a students reminded them that they (Asians) had courses completely dedicated to "their studies" within the school's offerings. My inclusion of narrative pieces on various groups of women of color both American and transnational (multicultural) had to include something that was representative in the room. Not knowing the full roster of all the students (most were students I taught before for other courses), I waited until a few weeks into the semester to begin assigning supplemental readings that were again representative of who was registered and attending the course.

The class was jammed with students in every possible corner that a chair with an attached desk would fit. There were forty students in this course, whereas in every other course the cap had been set at thirty-five. Everyone knew that if administration gave a green light for an over-tally in Professor Bernard's class, then Professor Bernard would certainly allow an extra body. During this time, I was a substitute assistant professor, and the course load under my contract required me to teach four courses at a time, none of them were duplicates. Syllabi were standard, but students knew to expect different readings as well as different assignments any time they took my class. My assigned books could not be bought off prior students, and my exams not floating among the hallways waiting to be sold or exchanged. Everything was fresh and knew. Although everyone has a different way of pre-senting their pedagogy, mine required then and still requires me to "switch it up." My books have to be somewhat different from the prior semester because I too have to continue learning; I find it to be difficult teaching the same book(s) repeatedly. The assignments have to change as well. Developing assignments allows my own creativity to continue growing semester after semester, and the results are amazing work of textual and contextual analyses, interesting and passionate dialogue and original submission of technology-based productions of knowledge (documentaries, infomercials, commercials and short films). There was not a single Scantron to be found in any of my courses, and in return my students rebelled against other courses that used it, confined by four to five choices on an exam, and there being only one right answer served as a semester-based oppression for many. This can be seen as the lack of epistemological investigation.

One of the first writing assignments that I always assign but in different formats is the *Personal Narrative*. In these narratives, I ask students to take a weekend and begin composing an essay of no more than a single page describing their lives in as much colorful detail as possible. Students are allowed to use any form of language

they prefer, whether they want to present themselves to me in poem format, or in a letter written to me, or in some other way they felt most comfortable. Although many male students submitted amazing entries, for the purposes of this chapter, I will focus on particular entries written by my female students of color.

Many of the female personal narratives included dreams, hopes, and aspirations, but also included reflection(s) on their lived experience as women of color. I read entries on rape, sexual preference and the confusion within the search for who they should love and be attracted to because of societal standards. I received entries that were crying out for help or at least requesting that I provide some sort of navigational device for them so they too could find their way among their responsibilities (work/school/children) and still enjoy their existence. These women lamented over their forty-hour work weeks, their childcare situation, their classes, their bills, the men in their lives, and all the struggles they encountered daily. However, they always left a few last lines to include their goal once they obtain their degree. Every semester I am engulfed by emotion at the start of the term, but at least I feel more informed than the professor who does not find it relative to ask his/her students about themselves. What was the point of the *personal narrative*? Knowing a bit more about the student's lived experience as they had been living it and hope to live in the future, gave me a window into their perspective on various things. I know why when we talk about rape and/or incest a particular student begins to cry, or gets up, and walks out of the room. This has happened twice, and I have since instituted a rule that if we witness a student who undergoes this type of emotion and leaves the room, a fellow student is to follow to make sure they are okay (while I continue to teach). For many of these girls, this topic is not just another course, it is not a simple elective, it is an academic detailing of their lives, and they feel validated to know their lives are relative to a course they are taking in college.

The *personal narrative* allows me to tweak the conversation. I ask in the assignment's requirement that the student include particular areas they would like to see touched upon during the course of the semester in this particular course. In return, I spend a few hours at home, or in my office looking up anything that I could not include on the syllabus, and thus assign supplemental reading(s) and/or additional assignments. Accurate representation is key and all students in the room must feel like their life is worth the time we take to talk about it.

Some of the books that I have assigned have been *Push: A Novel* (2007) by Sapphire, *Black Feminist Thought: Knowledge, Consciousness, and Politics of Empowerment* (2000) by leading black feminist Patricia Hill Collins, *Women, Race and Class* (1983) by ex Black Panther and activist, Angela Davis, *Colonize This! Young Women of Color on Today's Feminism* (2002) by Daisy Hernandez, *When Chickenheads Come Home To Roost: A Hip-Hop Feminist Breaks It Down* (2000) by Joan Morgan, and *Full Frontal Feminism: A Young Women's Guide to Why Feminism Matters* (2007) by Jessica Valenti. Selected readings have come from: *The Feminist Mystique* (2001) by Betty Friedan, *The Latinas Bible: The Nueva Latina's Guide to Love, Spirituality, Family, and La Vida,* (2002) by Sandra Guzman, *Soledad* (2002) by Angie Cruz, and of course, as mentioned no semester is complete without selections from *Pedagogy of the Oppressed,* (1970) by Paulo

Freire (if not read in its entirety). The list however, is ever growing and evolving. More currently, I have assigned, *Tomorrow's Tomorrow: The Black Woman* (1995) by Joyce Ladner, and *What's Love Got To Do With It: Transnational Desires and Sex Tourism in the Dominican Republic* (2004) by Denise Brennan. Selected readings also have to with topics on sexuality, lesbian identities and bi-cultural analysis of gender.

For many years, students were also asked in part of the course's requirement to work on a group-based technological production of knowledge. The results absolutely amazing. Many times, I have given out awards, prizes, and trophies, as I have learned that students absolutely love to compete against one another in a healthy environment. The university does not host many undergraduate conferences, awards for best senior theses, nor best essay written, so in this way, their lived experience is also displayed in the work that they produce. They are never told what the prize will be and so it is important to understand that the production of their technologically based projects have only academic and intellectual requirements and goals. Their goal is to have the best project, not to win the prize, for they are completely unaware of what the prize is. Prizes have ranged from trophies, to being taken out for dinner where we can spend time outside of the university walls and engage in free discussion that is intellectually stimulating.

Among topics researched for their multimedia projects were issues like: sex work in the Dominican Republic, teen pregnancy in low-income neighborhoods throughout New York City, misrepresentation of the black woman's body and beauty through media, there was a group that chose to work on violence against South American women as well. Interestingly enough, the group of South American women defenders were the smallest of the class teams. They had two males (one Latino, one Filipino) and a Latina. The group's determination to be the best, but have the best presentation on this less-than talked about problem in the world hit home for many. Although many of the audience participants could not directly relate to the crisis that was being presented, there was an immediate empathy for the women the team presented. Handouts were given to the audience, along with a packet created for people to find out more information by way of what they had put together along with an exhausting list of resources, easily accessible. When the lights were turned on, three women sitting next to me as I gleamed with pride for my students, were wiping tears from their faces. My students had delivered their point successfully. They delivered a message of grime and grit, of hope and desire, and a call for freedom, and all the while helped to hold each and everyone accountable for doing more or talking about it so that people would not forget about this particular group of women. However, it was too simple to present a topic, create awareness, and sit back down and wait for the audience to ask questions. I required all students while working on their projects to create a resolution to the problem they were proposing. The creation of the resolution had to be something that if necessary, included a governmental involvement; it had to also include a financial analysis or budget breakdown for the team's resolution. This resolution was not only to be based on the successful completion of a course assignment, but it had to be valid and it had to work, and everyone had to

understand the many obstacles the team would face if actually implemented. This particular team among many others was voted "best" by their classmates along with the audience as the best topic, presentation, delivery of information and most feasible resolution.

Although many of the other teams were fantastic and their presentations dynamic, no one walked away feeling defeated, as though their work was for naught if they were not the winners of the "prize." Competing teams learned about topics from each other, and the room was completely in awe of all the issues surrounding women of color in the world that goes unmentioned and unnoticed.

In another semester, we decided to have a larger base with our presentation. The class and I decided to create a campus-based event, to which we named, *Seeking Knowledge: An Evening of Dinner, Intellectualism and Awareness*. Without the offering of a prize, the students were asked to do much of the same, but this time to present their technological works before an audience of over a hundred guests, complete with formal seating and dining. Many of the academic departments were interested in the idea, and offered matching support of any monies that we collected. Student clubs on campus committed between fifty and one hundred dollars to cover the cost of food and supplies. All of the students were asked to dress "appropriately" as they were representing themselves, and the topics they were to present would be a reflection of their social activism. The night before the event, our larger "supporter" and/or "funding source" pulled their financial contribution of seven hundred dollars" plus, to which we needed to pay our vendors. The word had been put out, over one hundred attendees had registered to attend, and all the vending orders had been placed and/or purchased upon credit by the "honor system." There was no excuse given to neither my students nor to me as to why our funding source was yanking their contribution, and in fact, they would not return our calls nor email inquiries. I called an immediate meeting with my students and presidents of clubs (who were my students at the time). After the rage among the students had passed, we decided we would fund it ourselves. Two students extracted equal amounts (totaling nine hundred dollars) of money and paid for the vendors, the next week; I reimbursed each one of them out of pocket. Many asked why I did not just pull the event from the schedule, and shut down production completely when our promised financials did not happen. My students had worked six months on their projects, and had given endless amounts of dedication to their research, and to the learning of new technology (which was not a requirement for the course). They believed so much in their topic they ran out everywhere they could to obtain interviews from "famous" people. Cancelling the event was not an option. Many of the topics that would be presented at that event consisted of the lives, struggles and triumphs of women of color, how could an academic woman of color cancel this type of event. What tone would be set for the students that she taught? What lesson would the students receive in my backing out of this commitment to them? What then would they do when in financial crisis, as many of them had been in before at some point in their lives? Run? This I have claimed repeatedly while running the risk of sounding very "preachy" to them, was not then and never would be a valid option.

More recently, the teaching of women of color has struck up many a controversial remark from both students of color and my white students. Many of the students (mostly females of color) claimed that many of the books, such as *Tomorrow's Tomorrow* by Joyce Ladner gave too much of an old perspective and it seemed all about poverty which is just one portion of the black female population. Other students (white females) claimed that the book gave examples of womanhood that were applicable to white women as well, and it did not seem fair to cast the analysis around black women only. Another white student claimed that if someone really narrow-minded read the book, they would walk away thinking that the black female experience is about poverty and living in "ghetto" neighborhoods. I will say, that this provides a challenge in the classroom. Bad news and similar effects are like venom and because they are air-borne, they begin to affect everyone around them. Not many students defended Ladner's work, so I felt responsibility to provide a dual perspective. Clearly, the book written in the 1970s had a different approach than what the third wave of feminism can offer young women, but it was and still is important to read and understand contextual analysis from a variety of places and perspectives. When it comes to analyzing the future of the narrow-minded, this is something that Freire deems as a process of combat. This is the process of humanization and of praxis both at constant play and at work. As Freire explains, when one is oppressed, s/he will only become aware of this when they are ready, and begin to have an exchange of dialogue with like-minded people (Freire, 1970). By the student's comment that people will tend to categorize all black women as poor if they stop their critical analysis at *Tomorrow's Tomorrow*, what do her fellow female students, that are of color, and I myself as her "educator" represent? In the meantime, she along with the rest of the students were warned against putting a halt to their reading experiences. Just because this particular student is a white female, I urged her to continue reading books written about the black experience, both male and female (with a warning about urban street literature selections). For students that expressed concerns about books being written solely on the negatives of the black woman's experience, I urged them to begin telling their own positive life experience stories. I asked them what their dependency was on authors to tell the stories that *they* wanted to hear. As a people, we seem comfortable in waiting for others to do the work we expect of ourselves. If they were unhappy about the current scholarship on black women and the lived experience of women of color, Ladner alone cannot be blamed for this. Students should turn their *personal narratives* into manuscripts. Albeit it is a hard battle to fight, and the war has many enemies to wage against. With the contradictory examples and stereotypes of the woman of color and her existence and/or misrepresented body image(s), many young women of color, particularly in college fall into the cracks of feminist identity and/or feminine ideological practices. The subscription to lyrics that degrade and misrepresent, women of color are unclear as to their own identities. They want to be able to listen to and enjoy the music that represents their youth and their "femininity" but they do not want to be categorized as such. As explained earlier, many white male musicians do not talk about women in the same

way that hip-hop does, and so for many people the closeness they feel to women of color is through lyrics that expose them in negative ways.

The young woman of color's experience is unlike any other, but amongst each other, the struggles and triumphs are shared. Every semester it seems the "myth of the black superwoman" comes up, and I ask students to question whether the stereotype is negative or positive in their own perspectives. It seems that this particular concept, more than topics surrounding hip hop have become increasingly important to many of the women of color in my classroom(s). Here again, the superwoman or black female superhero is sexless or asexual, but there was a reason for her sexual absence (except with white slave masters) (Wallace, 1999):

> She was too domineering, too strong, too aggressive, too outspoken, too castrating, and too masculine. She was one of the main reasons the black man had never been properly able to take hold of his situation and his country (Wallace, 91)

My students that are women of color continue to be much of the same. They are very strong, very aggressive (verbally), very outspoken, and oftentimes, their commentaries in class and performance when it comes to supporting ideas around race and gender are castrating-like. Where is all this aggression coming from, and is it wrong? The answer is dependent upon many factors. Factors like race combined with gender in connection to socioeconomic living spaces, and their daily lives, all contribute to how they relate to other women, and men alike. Color complexity is a big issue when investigating why my female students of color respond the way that they do to both men and women, white, black and/or Latina. Many young black males in class have stated that they too are guilty, but are not sure if they should be guilty, or rather exercising their preference for female counterparts. While not all, many have stated that they are more prone to being interested in and/or dating lighter skinned black women. To be involved in a romantic relationship with Latinas, is to date interracially, and for many, while not problematic to them, they do find themselves answering larger questions at home, among family members about choices. Thus, this exemplified example pits both black women and Latinas against one another. Much of the analysis provided in this chapter came from over two years worth of my own personal journal entries, to which after teaching a class during the week, I would return to documenting my observational experience working with this group.

When reading sections of *Tomorrow's Tomorrow* (1971), we dissected a brief history of the black woman as slave. While male slaves were transported from place to place, or rather sold from owner to owner, his presence within the structure of the black family, most times, was limited if at all there. The female slave would not be head of her household either, for many times her body was used as a breeding machine, and she would not be able to keep the children she bore. Her offspring also sold. Marriages, as many of us know, between African slaves was prohibited by law, and as punishment to many male slaves, masters or slave owners would rape female slaves in front of male slaves. While being threatened with violence or death, many male slaves also limited how much they would do to

save the female from being raped before his eyes. Hence, his early experience with castration, dehumanization and emasculation. Many female slaves took child rearing to many heights including the killing of their own spawn in order to prevent them from being taken away from them and sold into slavery. She is left with nothing. There is still no man in this framework. She is alone. Some have argued that many male slaves in being sold from plantation to plantation and being ripped from the family, has trickled down to our contemporary times in that they do not stay with their families today either. The black man is not to be blamed alone for the breakdown of the black family. Daniel Moynihan released his report, *The Negro Family: The Case for National Action*, (1965) and blamed the breakdown of the black family on black women. In his perspective, no black family could survive and thrive well in a household structured around the parentage of a single mother, a black single mother.

After reading these two pieces, it seemed to enrage female students of color. They accused their black male counterparts of not being able to regain their manhood, of being affected still by what bell hooks calls "Plantation Patriarchy" (hooks, 2003). Female students go on further in their rage to accuse these men of deserting their families when they are needed the most, and when "threatened" by a black woman's strength, they run. In the perspective of these female students, they see their black male counterparts not being able to handle the myth of the superwoman, not knowing their place as "boyfriends" and "husbands." They were also accused of interracially dating to escape the hardships that the unity of a black man and woman would bring in American society. "It would be a lot easier," they would claim, "if black men would continue to date and marry black women, instead of looking for the easy way out." They found white women, Latinas, and Asians to be examples of "the easy way out." These interracial/international relationships were not respected, unfortunately, and thus became a breeding ground for unfiltered anger. It is also important to note here that black female students had no major issue with black men from the Caribbean or West Indies, who dated interracially, (but they still had to be women from the same island). Their focus was black American men with any race outside of black American women. If two people from the same island dated or married each other, they were safe from these firing squads. The complaints were very American centered, and reasons were based on the American legacy of slavery.

Many of the female students reduced their ideas on the black superwoman to looking at their bodies and lives well before the ideals of marriage or long-term relationships, and oftentimes these ideals included a capitalistic or socioeconomic centered approach. While socioeconomics was/is important to them, they aspired to reach their own financial goals, without the help of their male partners, but still required lots of chivalry from these potential males and/or partners. When asked whether or not the practice of chivalry has always been important in the woman of color's community, many of the black women in the class said "no," and many of the Latinas interchanged the term "chivalry" with "machismo" seeing the two as the same. The female students wanted men to support their academic goals, whether or not the men were in school as well. They wanted a man to treat them

like a lady, "buy me a drink when you can," "take me out, when you can, even if I have to pay the first time," "if you invite me out, we are not going dutch," and sometimes "I like flowers," but mostly "be a man." What does this mean? Be a man? In retort, the male students hit the girls with "then be a woman." In their perspective, they were asking women to tame themselves, and not be so aggressively vocal in their opinions. This context of "be a woman," was a hard blow to many of the female students. Many decided they would continue their search for the "ideal black man" one that could "handle them" outside the college classroom. At twenty and twenty one, if not younger, these girls felt as though they had time to search, and there was no real rush in trying to find "the one." However, while the search for "the one" continues for many of them, so does promiscuity on a larger scale.

Here is where one, alarmingly returns to the chapter on beauty. As outspoken as both the men and women are in my class, men agreed that they wanted to date someone like "Buffie the Body" but did not exactly want to bring her home to meet his family. The Madonna and the Whore would have to be found in his single choice, but it would take many a woman for him to go through to be able to locate this type of girl and many a girl to oblige. Many of the women of color recapped their oral narratives in angry and sad tones. They reflected upon experiences of being "played" and/or "used" by guys. They, while not defining it as such, were confusing love for lust and vice versa. Many girls idealize the characters on *Sex in the City*, in fact, I absolutely love "Carrie." Not sure whether I love Carrie or Sarah Jessica Parker more, but the fact remains, that many of my students adore the show, and secretly aspire to live freely as the four women on the show do. The separation between reality and the lengths one has to go to emulate are both interesting and dangerous, as many of them require a lot of work, if not life-altering experiences.

It seems that every semester, the heterosexual struggle of finding the "perfect man," one that understands the complexity of the woman of color, trumps many other issues that is talked about in class. For many of my female black students (heterosexual), it seems the struggle to find a long-term partner; one that connects with their own struggle is indeed similar to other groups of women. While classified as a group of "man haters," the girls of color in this vein found solidarity with white women who also were identified as the same, because of their attitude towards and attributes of independence. For one reason or another, the white female "man hater" was seen as more independent, whereas the "man hater" of color had to fight off not only this stereotype, but also one of being "unattainable" or "hard to please." Many more of the black males in the several semesters of teaching "women of color" as a course, found their joys in relationships with women who were not black, whereas, many of the women of color seemed to remain in waiting.

Latinas were just as outspoken, but as perpetuated by the media, they were more desirable than their black female counterparts when it came to dating. As opposed to the negative connotations of being "man hating," they too were seen as "fiery" or "spicy," which for the heterosexual male was more appealing to them. However, only particular Latinas would fit this description for many of the men. Although

not called "superwoman," Latinas also faced and continue to face much of the same problems with their social spaces being dominated by men. However, as expressed by several readings as well as the girls themselves, much of this male domination was attributed to "machismo" and was accepted as cultural. This added some complexity to their narratives they seemed to want to support a cultural argument more than a gendered one. Other non-Latina students could not combat what is considered "cultural," nor review much of what Latinas were experiencing, they could only testify to its truth. Many of the Latinas lamented on their male siblings' experiences, claiming unfair practices when it came to gender in the household. One student told me that she has several curfews depending on the day of the week (she is twenty one), and her brother has none. In fact, her mother requires her to do household chores that her brother has left behind while out "running the streets." Another student made claim that her mother always forces her to learn how to cook the things her boyfriend likes to eat, because this will give way to either him marrying my student or another woman. How claustrophobic; the pressure of having to learn how to cook or someone will take your boyfriend away from you. While the woman is required to develop a new skill (cooking), the man sits back in this framework, and passes judgment (she cooks well or is an atrocious cook), and this judgment decides their future together. In her essay, "In the Beginning He Wouldn't Even Lift a Spoon: The Division of Household Labor," (1993) Beatríz M. Pesquera, writes of the experience of Chicana women who struggle to find balance between their day jobs and their household responsibilities at home.

> Men use stalling tactics and perform tasks in a slipshod manner to avoid domestic work. They attempt to compare their wives to other women, as a means of social control and in order to discredit their wives' requests. Women also utilize a variety of strategies in their daily struggle; they retain, coach, and praise husbands for a job well done. At times, they resort to slowdowns or work stoppages, so that eventually men are forced to contribute more to household labor (Pesquera, 191).

For many Latinas, more than the struggle over finding the ideal mate, they were set in competing with each other (as structured by their families) for the "ideal mate" to find them. Many of them had requirements (of who they would like their male partners to be) as well, but they were less spoken about as opposed to how black women in the course identified their needs and wants. Latinas in the course argued their progression of work towards getting a bachelor's degree, prompted fights against and with their parents' demands and sly remarks. Many of them claimed that they have had their parents tell them not to be "too educated" because no "real man" wants that for a wife. Ariel the mermaid is not alone in her struggle to be talkative, it seems many young up and coming (educated) Latinas are fighting this as well. Household labor seemed to trump any type of employment outside of the home, or any endeavor to further their goals once outside of their front door. These girls were treated as defiant by their attendance at college, and were coming home too "lippy" when they had their Women of Color class twice a week, and many,

angered their male counterparts by taking my course. Repeatedly, I asked these young girls, both black and Latina to bring their male counterparts to class so we can have a rich discussion. Of all the years teaching this course, only one of the boyfriends attended. This young man (African American) was indeed quite attentive, and had much to share, but held firm that a woman (his woman) should not make more than him nor be smarter than him. I quietly and selfishly pitied my student, and had hoped silently that one day she would find someone else; her equal, not her would-be oppressor. They seemed too young to confront such an adultified circumstance; that which is domestic.

There were stories from female students who struggled with body image (many of the white females) and while they were not after Jennifer Lopez or Buffie the Body's body, they were sure that that body type attracted their boyfriends (Latino, white and black men). They struggled with skin color and the complexity of such. Some girls struggled with being characterized as, "pretty for a dark-skinned girl" or "high yellow." These characterizations came from fellow women, along with the men who they are attracted to.

As mentioned, many of the female students of color, struggle with issues of love, intimacy and relationships as well as self-image, including beauty, body shape and type, skin color, and hair. This is what separates them from unifying their feminist voices. Still, in 2008, many young women of color do not want to associate themselves with, or define themselves as "feminists." They are attributing much of the characteristics of "feminism" with issues of female whiteness or white females themselves. They are still struggling to rid themselves of the stereotypes that feminists do not shave, are all lesbians (and the homophobia in communities of color are still running quite rampant), and are all a bunch of man-haters. While we know this all to be false, it strays them away from being unified and having a voice of solidarity. As they are assigned to read bell hooks, Alice Walker, Michelle Wallace, Patricia Hill Collins, and contemporary feminists like Joan Morgan and Jessica Valenti, they are still not convinced they fit within the term. They feel some sort of solidarity with the text, and the perspective of many of these scholars and authors, but proudly and vocally indicating that they too are "feminist," yet it does not seem to have made its way into their personal lives. For many of them, being a feminist prohibits them from being feminine, and asking of men for basic attention is seen as chivalrous. As much as I would like to promote that chivalry is not dead but rather only exists if we let it, it does not seem to work for every population.

Feminism, like so many other authors have said, is not a "dirty" word, and can and should be described as any act in that which a woman supports the progress of herself and fellow women in immediate areas as well as internationally. We cannot at the same time critique women who wear vocal shirts: "This Is What a Feminist Looks Like," but who do not march in protest for women's rights. We can critique however, women who pit women against each other and allow oppressors, both male and female, of any race and creed that are dead set against us unifying our voices as we look to fair and equal treatment. For young women of color, some need direction, and others already have direction but are not sure which of those directions to take. There are so many winding roads to liberation, and much of the

time along the way oppressive stops as well. Some would critique this chapter in that I provide no readymade solutions or tips on how to teach women of color about themselves. This is understandable, yet oftentimes foolish for people to do. It grows difficult to teach teachers how to teach the way that works best for them and their classroom(s). Every educator is different and so is the population that they serve. We can only take bits and pieces of what is taught to us and learned by us in order to perfect our own pedagogies. For example, the *Personal Narrative* is only a starting point and/or stepping-stone to liberatory education. Pedagogy is like a wardrobe with many different styles and tastes, depending on the day and where you are headed. To wear the same pedagogical outfit everyday classifies you as not being fresh in ideas, and repetitive. Sure, I use *Pedagogy of the Oppressed*, or as my students call it "The Red POTO" every semester, but this is the foundation, from which I generate new pedagogies for and alongside them.

While we investigate, understand, and begin to articulate established theories, I also look upon students to develop their own. For example, one semester, during the analysis of "The Matrix of Domination" a student reinterpreted the theory based on her own life experiences. She gave the existing theoretical definition a much more personal and contemporary illustration, and thus I renamed the existing theory, as an addendum or rather a new theory, and used her last name for such. Much of the time we give, what I call, extensions of existing theories, a lot of air time in the theory's developmental process. Once formally developed, defined, and easily understood by way of textual analysis and illustration, we rename the theory (according to the student who came up with it), and the rest of the class is tested on these particular theories. In this way, students begin to see each other as experts, and use existing and established theories as intellectual support. Simply, it also proves easier for students to mentally file theoretical information and pull them out when asked. Again, this is not to say that this pedagogical tool would work in every class, but for much of my teaching, it has been an excellent tool, and more importantly, students develop a newfound respect for one another, as well as for me.

An abundance of female students of color find my courses therapeutic. Whether therapy-like sessions are the goal is not at the forefront of my concern, but I am concerned with how well the students relate to the material and how easily the students are able to digest information. I have heard many colleagues complain that "their" students are not up to par, they simply "don't get it" or "my [their own] class is too hard for them." However, they continue to teach in the same ways, while complaining. How then is it the students' fault, when we ask them to think outside the box, but we do not give them the courage to do so by examples we set ourselves? A variety of colleagues I have spoken to find "teaching off the cuff" to be a workable example for classroom success. I disagree. Students, for the most part, like structure. They like deadlines and knowing exactly how to achieve the best possible grade. Free-styling in particular classes, for many leads to chaos and confusion, and something I personally stay well away from when it produces negative results very early on. On the other hand, freestyle teaching is much more saleable than Scantron type learning. A few years ago, I was told that I have to be "completely insane" to create midterm examinations that are essay-based. I should

be utilizing my time to devote to my research and my writing not creating exams. This was hard to swallow. After everything I have learned from great pedagogues like my graduate history professor and my two academic mentors during my doctoral work, I could no longer apply this to my own pedagogy? I could not find it within myself to create such a disturbing piece of pedagogy. In this method, not only are students treated like robots, but we as educators become robots as well. They sit and bubble in answers, unsure of the "gotcha" questions, and we in turn sit back using an anti-epistemological approach to grading them. How can the lived experience of a large group of people, like women of color be tested with only one right answer to define so many facets of these diverse experiences? I have spent months trying to figure out whether I will "make" it in academia. If everyone will expect me to "teach to the test," I will find myself unemployed more often than employed, and less than respected by my colleagues as well. I would not gain fame among my present colleagues, but at least I know my students have walked away with something more than a grade and a grade point average. Our lives already have so many numbers that identify us by, so many boxes that people wish to place us in, it is not possible to stomach another number (GPA) that seeks to divide us further.

Teaching women of color in population as well as the subject and/or topic has been a life changing experience. Many of the young women of color that I have taught have been small particles representing my own lived experience. Much of their experiences have reminded me of my own growing up, although we are at the least, ten years apart in age difference. They remember the songs I used to listen to, we watch the same television shows, and sometimes through reading groups, and or book clubs, and blogs, many of us read the same books (those not assigned to a class). I keep long friendships with my female students, and being a female of color creates a closely knitted family structure for many of them who live outside of their family's guidelines, rules and regulations. I have been awoken in the middle of the night by phone calls of questions, tragedies and great news, all from students. I have sat back and chatted over various instant messengers with many of them, through late night conversations. I have dried tears, as they have dried mine. In fact, I spend more time with them in a day, than I do with anyone else all week long. I do not separate myself from them. We oftentimes meet up and have lunch together, walk to class together, ride together on the same bus or train, to and from school, meet up after class to talk about the session's content, and hug and laugh until our bones hurt...together. In this way, my pedagogy continues to grow stronger and multifaceted. I only found this kinship among professors and students when I myself was a student. However, I did not encounter it until I entered graduate school, and not for my masters at twenty-one, but rather, during my work as a doctoral student, at twenty four/twenty five. Until then, I had always been made to feel as though my struggles and triumphs were less than important, and because my experiences had never been noted, I have always been made to feel less than valid, if not rebellious in my thinking.

Being the youngest one among many of my colleagues, oftentimes my teaching methods are written off as inexperienced or still young and fresh, and the hope that

I too will become jaded by plantation-like treatment on campus, and/or by administration will eventually break me down. It has been close to seven years, and I still have not come close to extraction of my hope. When we forget that our students depend on us, we have failed them, and when they do not do well, we have failed them, and mostly, when we separate ourselves and our pedagogies from the lives they live, failing to understand who they are, and who they represent, we are failed and continue to fail them. It becomes a downward spiral of oppression, and we are preparing them for a long life of oppression continued. When students use life examples to contribute or participate in class, and if it is not sufficiently academic of a response, I let them know that I appreciate their personal examples, but ask how is it connected to the reading and/or the larger social spaces of what our class is about. They soon find another way in using their life examples, but the goal here is that they know that they can do so. They can use their life examples, and still flex their intellectual muscles, all in one breath.

A LETTER TO MY FEMALE STUDENTS

Dear Young Woman of Color,

It is my hope that you have found this book inspiring and worth a re-read. I wrote this book for you, and for me. Over the last several years of my existence, I have witnessed some atrocious crimes against the women that we are, and the women that we represent, and while I weep at the destruction of our humanity, I also have hope. I have hope that we will continue to grow stronger, remember our histories and create new and inspiring futures, one that is healthy, intellectually rich, and full of authentically organic discovery.

Growing up in Hell's Kitchen was by far my best experience throughout this particular event we call life. It is where I became a girl, a lady, and eventually a woman. When I left, I felt a sense of detachment from my girls, my "friends," and my life source, but I have grown. I have grown to understand that in order to see things clearly, we must oftentimes break away and see things from a distance, even if we miss them as if they were gone forever without notice. The lessons we will learn in life will not be easy, not by a long shot. Many of us are scorned by others who host privilege after privilege, who take away our right(s), yet these experiences should lead us to our own development and creation of a new privilege, for no one has the privilege and the honor of being you.

I have been surrounded by some great women of color in my lifetime that helped to shape the woman that I became, and the woman I am destined to alter, redefine and eventually become. This might take a lifetime, but it is all that we really have...a lifetime. My mother, the strongest woman of color I know gave me example after example of what it means to have strength, desire, drive, hope, and use all of these skills to hope for more, and desire all that my heart and mind can handle, and still have the power and creativity to dream big. She is me, and I am her. My sister in her own development taught me how to see things from multiple perspectives, and her strength to carry out her own life's situations gives me a will to continue striving and succeeding. While I cannot share them with you, I can however, offer and share myself. Like learning to play a new jazz piano riff, they helped me through my lessons, going over and over the times I made mistakes, big and small. My mom taught me everything I know about being an educator, and continues to teach me long and strong today. From her will to be, I teach others, and still dream very big.

I see many of you in the hallways at school, and am pleased at first sight. I see you attending class, but not just going through the motion. Many of you are engaging in intellectually stimulating, and academically rigorous pedagogy yourselves, as well as

educating many of the professors that preside over you. I have seen many of you change, like a leaf during the fall season, more golden in your strides, and more beautiful everyday, promising me and yourselves that you will continue to strive for great things despite any threat against your race, class, gender and/or your sexual preference and/or orientation. As I turn on and off my television, I see many of you doing the same. I am so glad that many of you no longer depend on television programs to dictate what it means to be a woman of color anywhere, but rather you create your own visions and follow your own lessons, and thus eventually teaching others from your strength. Some "pedagogues" visualize you only by number(s), a variety of numbers, but I hear you in my private moments like a favorite song that I can play repeatedly, and never get tired of hearing, by its name, your name.

I once had a student who questioned her beauty because of her skin color. Some days she was positive about how she looked, and other days she would be experiencing unequivocal amounts of hurt. In retelling her story of struggle, she cried. Her lips quivered, and her face turned into something of pain. As she spoke, she held her head high, but I could see behind the vocals, that a feeling of displacement had taken over. While my heart ached for days, and the tears welled up when she recounted her stories of questioning, I held back my own quivering lips, but tears streamed down my cheeks like black and brown waves. A few years later, I became friends with that student who was at that point, an entirely different person. Something happened to her that we never quite talked about openly, but suddenly a new flower had sprouted from such an overlooked bud. Stronger than most other girls her age that I have taught, and know, it was the last time I had seen her cry (that moment in class). I found a friendship with her that touched me so deeply, I was scarred forever, and look forward to her growing each and every single day. Today, she knows just how beautiful she is inside and outside and does not settle for anything less. Close to college graduate status, she understands just how cliché but true it is to believe that beauty is only skin deep, no matter how deep that may go.

Other young women of color who have come into my life like turned pages from my favorite book, prove difficult for me to let go of. I protect them at all costs, just as my mother bear has protected her three cubs from any and everything. A handful of you have become part of my non-academic social circles. You ladies keep me young, and remind me every day why my work is so important, and why I must continue, despite all the adversarial types of experiences I may encounter. Although I am close to ten years your senior if not more, we learn together, we love together, and I learn from you, as much as you say you learn from me because I am your professor, but know more than this, I am your friend.

When I first began teaching, I was immersed in an environment of tight-fitting clothing, loose language, and sexually explicit behavior, and my heart ached. Years later, I am in the same environment, the young women of color are carrying themselves much more relaxed and individually different. Still very feminine, those that are such understand the promise they are indeed required to make with themselves. I take no credit for their transformation, but I do thank them, for it is

they who make the job I do worthwhile. People will often tell you that change cannot happen overnight. In this instant, they have lied to you. I have seen the change and while the final form will not take place over a night, the process should arrive by dawn of new days. I have seen women shed their skin in the space of several hours and begin to rejuvenate their womanhood from there on. You only have to host a desire to enact a praxis of social change.

Many of us succumb to social pressures and ideals set forth by oppressors for us to model ourselves after. It is understandable. Pressures without a strong base are easy and oftentimes seem welcoming. What we have to remember is that we are stronger than what most would have others and sometimes even ourselves believe. It is much harder to be ourselves than it is to try and be someone else, but that does not mean we have to give in. Remember the time in class when I said that "men are an accessory not a necessity" to who we really are and all the guys in the class were up in arms and pissed off? They were not recognizing the space they take up in our lives, whether we are homo or heterosexual or simply want to examine our own selves on our own time and at a pace, we set for ourselves. The dominant elite would have us understand that it is a man who paves the way for us and thus we should find our social spaces through their requirements. In no way was I disrespecting the males in the class, in fact, I have some very special men in my own life, but what needs to be understood in our own development is that they have no major role. They have power in the roles we place them in and this goes for the roles we are given for ourselves as well. It is more than race, and or a race.

We do not have to engage in practices that society's rules have created as our culturally representative categories. Just because we are of color, we do not have to listen to hip hop, and if we do not listen to hip hop but rather we listen to other forms of music, we are not "selling out" in fact we are broadening our scopes and our horizons. We know music is transformative, and thus we must allow it to understand this transformation, but not transform who we are. This goes for our bodies as well and what we deem a socially acceptable versus who we really are. Just because we have curvy figures, it does not mean we should aspire to be "video honeys." A woman once told me, "beauty fades, but dumb is forever." I never forgot that comment she made, and I never will. It did not accuse anyone of being particularly "dumb" but rather it made me understand to have both is not a challenge, but it does require work, and no other person can teach us this, but ourselves, through a lived experience.

When I walk into a classroom and see so many of you in your seats, awaiting a barrage of information to be delivered, I still get goosebumps all up and down my brown arms. Your success is part of my sunshine. Yet, I ask that you not forget about other women of color that do not have opportunities that perhaps have been present in your own life. Remember that once you reach your top, wherever that may be, give another ledge to the ladder you claimed, for any woman that may need a helping hand, be she helping herself already, or waiting on you to show her the way. As agents of social change, your behavior affects others, and your messages strongly received by those you have not met yet.

I ask of you to remember your bodies and take good care of them. While we all have our vices, and I know I have a few as well, I ask that you protect your bodies at every opportunity that you have. The next time any person wishes to get near to your body, remember the body they so desire, only belongs to you, and sharing of this, must be your choice only. It is a gift that you can obviously give multiple times and to multiple people, but to do so, you must be cognizant of your social and emotional health thereafter. The next time anyone lodges a remark about the shape of our body, whether courteous or offensively, take a moment and remember Sara Baartman. If the words "I love you" were uttered in your ear and made you feel warm and needed, but it was followed by a touch you found less than loving, let it go and find your solace elsewhere. When your boyfriend and/or girlfriend physically hurts you and wipes the bruises away with "I'm sorry, It'll never happen again" or other forms of begging for forgiveness it is not okay. It is not your fault. No, you did not ask for it, and no, they may not ever change. Know that what you are engaging in if you consider to "repair" this person that "loves you" in this abusive way, is a game where your life's decision is the prize. Either you win it or you give it to someone else, who will do with it as they see fit. Please, I beg of you, to tell someone. Tell anyone. Tell everyone. There is no shame in someone who abused or abuses you; it is they who should be shamed for their brazen cowardice. To suffer silently, hoping and praying that you won't ever have to experience that again, is truthfully what should be looked at as shameful. Don't even consider for a moment who will be angry with you, it doesn't matter. In time, they will come to understand just why your heart led you there and why now you ask for their help and their understanding.

Hold steadfast and stick yourselves like glue to the things that inspire you, make you smile, allow you to walk lightly and your heart full of promise. Let go, and break free from the things that oppress you and give you no sign of ever feeling free and/or liberated. How many times in our classes, did we not have a woman of color break down and cry ferociously because she was consumed by her struggle? Remember when I cried as well? I need for you now to feel her, understand her, and not only put yourself in her shoes, but rather offer her a physical or verbal embrace, even if you don't know her. I'm sure she wouldn't turn away from you. I am more than sure, I am absolutely certain. Our lives are too uncertain to be dependant on the things that make others happy and in turn should make us happy simultaneously. If you are in search of the "perfect you," look to yourself as the example, and those who surround you with their beauty and their confidence. Learn from them as you develop your own strengths, but never fall short of trying to achieve and obtain the things you deem necessary to keep you happy and alive. As we encounter our tough days, and even tougher nights, the loneliness we feel on certain days, know that it doesn't last forever. Look to tomorrow, when you have an opportunity to start fresh each day that passes with promise.

As you close the final pages of this book, take a deep breath, and exhale. Know that it is going to be okay, because there is not other way but up, but on the way through this travelling journey that we call life, we must activate all of our positives. Put yourself at the center of all your life's decisions, and reflect on every

bad experience you have ever had, but have them only as memories and lessons learned. Keep living, keep learning, keep reading, keep writing, keep talking, keep listening, and most importantly keep fighting, but all the while being the lady that you are not the one someone else told you, you should be.

I write for you and for me.

With Love,

Professor Bernard

NOTES

ⁱ One of the most popular social groups at my high school whose members were solely Black and female, and for some odd reason, very tall girls.

ⁱⁱ Chicana translation for Lesbian.

ⁱⁱⁱ All students attending the High School were no longer allowed to eat off premises. Everyone, no matter the crowd had to remain in the school cafeteria during their designated lunch period.

^{iv} "Injuring yourself on purpose by making scratches or cuts on your body with a sharp object — enough to break the skin and make it bleed — is called cutting. Cutting is a type of self-injury, or SI. Most people who cut are girls. Cutting is a way some people try to cope with the pain of strong emotions, intense pressure, or upsetting relationship problems. They may be dealing with feelings that seem too difficult to bear, or bad situations they think can't change" (kidshealth.org, 2008).

REFERENCES

(1955). *How to be a good wife*. Retrieved April 15, 2008, from snopes.com Web site http://www. snopes.com/language/document/goodwife.asp

(2005) *National Diabetes Fact Sheet*. Retrieved December 1, 2008, from cdc.gov Web site http://www.cdc.gov/DIABETES/pubs/pdf/ndfs_2005.pdf

(2006). *Do men really want wives like June Cleaver*. Retrieved April 15, 2008, from Today MSNBC Interactive Web site http://www.msnbc.msn.com/id/15039140/

(2006). *U.S. Air force regulations*. Retrieved January 13, 2009, from Service Dress, Dress, Battle Dress, and Standardized Functional Uniforms Web site http://www.e-publishing.af.mil/shared/media/ epubs/afi36-2903.pdf

Alcott, L. M. (1898). *Little women, or, Meg, Jo, Beth, and Amy*. Boston: Robert Bros.

Asika, U. (2002, March 29). Black America and the Oscars: A one-night stand? *Salon.Net Arts and Entertainment*. Retrieved January 1, 2008, from http://archive.salon.com/ent/movies/feature/2002/03/29/ black_oscars/print.html

Battle, J., & Bennett, M. (2000). Research on lesbian and gay populations within the African American community: What have we learned? *African American Research Perspectives, 6*(2), 35–47.

Backensto, Amanda (2001) Wedding makeup tips for black women. Expertvillage.com Retrieved July 7, 2008, from http://www.expertvillage.com/video/32555_weddings-makeup-concealer.htm

Benshoff, H. M. (2004). *America on film: Representing race, class, gender, and sexuality at the movies*. Malden, MA: Blackwell Publishers.

Berger, M. (Ed.). (2006). *We don't need another wave: Dispatches from the next generation of feminists*. Emeryville, CA: Seal Press.

Bland, A. (2007, March 13). Tasha, "The L Word," and Black Butch lesbians in film and television. *AfterEllen.com*. Retrieved April 15, 2007, from http://www.afterellen.com/TV/2007/3/ blackbutchlesbians?page=1%2C2

Blume, J. (1975). *Forever: A novel*. Scarsdale, NY: Bradbury Press.

Booty pop! Retrieved May 15, 2007, from Booty Pop Panties Web site http://www.bootypoppanties. com/shop/

Bourgois, P. (1995). *In search of respect: Selling crack in El Barrio*. Cambridge, NY: Cambridge University Press.

Breitman, G. (Ed.). (1966). *Malcolm X speaks: Selected speeches and statements*. London: Secker & Warburg.

Brennan, D. (2004). *What's love got to do with it: transnational desires and sex tourism in the Dominican Republic*. Durham, NC: Duke University Press.

Buckhanon, K. (2005). *Upstate*. New York, New York: St. Martin's Press.

Buffie, for my sisters. Retrieved May 15, 2007, from Buffie the Body Web site http://buffiethebody. com/sisters.shtml

Chase, C. (Ed.). (1998). *Queer 13: Lesbian and gay writers recall seventh grade*. New York: Rob Weisbach Books.

Child, L. M. (Ed.). (2000). *Incidents in the life of a slave girl: Written by herself*. Cambridge, MA: Harvard University Press.

Chunichi. (2007). *A gangster's girl: A novel*. Dix Hills, NY: Urban Books.

Collins, P. H. (1990). *Black feminist thought: Knowledge, consciousness, and the politics of empowerment*. Boston: Unwin Hyman.

Collins, Y., & Rideout, S. (2000). *Totally me: The teenage girl's survival guide*. Holbrook, MA: Adams Media Corp.

Company lifestyle. Retrieved November 12, 2007, from Apple Bottoms Web site http://lifestyle.applebottoms. com/company.asp

Crenshaw, K. (1995). *Critical race theory: The key writings that formed the movement*. New York: New Press. Distributed by W.W. Norton & Co.

REFERENCES

Cruz, A. (2001). *Soledad*. New York: Simon & Schuster.

Daly, M. (1942). *Seventeenth summer*. New York: Dodd, Mead.

Davis, A. (1983). *Women, race and class*. New York: Vintage Books.

Doyle, M. (2002). Tough girls: fiction for African American urban teens. *Voices of Youth Advocate (VOYA)*. Retrieved July 3, 2008, from http://pdfs.voya.com/Af/ric/AfricanAmerFiction.pdf

Drill, E., McDonald, H., & Odes, R. (1999). *Deal with it! A whole new approach to your body, brain, and life as a gurl*. New York: Pocket Books.

Freidan, B. (1963). *The feminine mystique*. New York: Norton.

Freire, P. (1970). *Pedagogy of the oppressed*. New York: Herder and Herder.

Giroux, H. A. (2004). Are Disney movies good for your kids. In *Kinderculture: The corporate construction of childhood*. Boulder, CO: Westview Press.

Gomez, J. (2005). But some of us are brave lesbians: The absence of black lesbian fiction. In E. P. Johnson & M. G. Henderson (Eds.), *Black queer studies: A critical anthology* (pp. 289–297). Durham, NC: Duke University Press.

Guzman, S. (2002). *The Latina's bible: The nueva latina's guide to love, sex, spirituality, and la vida*. New York: Three Rivers Press.

Haidar, S. (1998, December 10). What's wrong with my film? Why are people making such a big fuss? Deepa Mehta defends her film, Fire. *Rediff on the Net*. Retrieved March 1, 2007, from http://www.rediff.com/entertai/1998/dec/10fire.htm

Hernandez, D., & Rehman, B. (Eds.). (2002). *Colonize this! Young women of color on today's feminism*. New York: Seal Press.

Hillard, C. A. (2007, April 3). Girls to men: Young lesbians in Brooklyn find that a thug's life gets them more women. *Village Voice*. Retrieved February 26, 2008, from http://www.villagevoice.com/2007-04-03/nyc-life/girls-to-men/

Hine, D. (2004). *The future of black women's history*. Retrieved October 1, 2008, from Radcliffe Institute for Advanced Study Web site http://athome.harvard.edu/programs/gar/gar_video/gar_4.html

Holmes, S. (2001). *B-more careful: A novel*. New York: Meow Meow Productions.

Holmes, M., & Hutchison, P. (2005). *Girlology: A girl's guide to stuff that matters: Relationships, bodytalk & girl power!* Deerfield Beach, FL: Health Communications.

Honig, M. (2008). Takin' it to the street: Teens and street lit. *Voices of Youth Advocate (VOYA)*. Retrieved October 12, 2008, from http://pdfs.voya.com/Vo/yaT/VoyaTakinItToTheStreets.pdf

hooks, b. (1994). *Outlaw culture: Resisting representations*. New York: Routledge.

hooks, b. (2004). *We real cool: Black men and masculinity*. New York: Routledge.

How to look sexy. *WikiHow*. Retrieved September 1, 2008, from http://www.wikihow.com/Look-Sexy

Jacob, I. (2002). *My sisters' voices: Teenage girls of color speak out*. New York: Henry Holt.

Jacobson, K. (2001, November 27). Controversial Indian actress uses film to provoke, critique. *The Daily Northwestern*. Retrieved April 15, 2007, from http://media.www.dailynorthwestern.com/media/storage/paper853/news/2001/11/27/Campus/Controversial.Indian.Actress.Uses.Film.To.Prov oke.Critique-1908219.shtml

Kimble, L. (2001). I too serve America: African American women war workers in Chicago, 1940-1945. *Journal of the Illinois State Historical Society*, Retrieved September 23, 2008, from http://findarticles.com/p/articles/mi_qa3945/is_200001/ai_n8880587/pg_14?tag=content;col1

Kincheloe, J.L., & Steinberg, S.R. (1994). *Changing Multiculturalism:*.Philadelphia, PA: Open University Press.

Kincheloe, J.L., Slattery, P., & Steinberg, S.R. (1999). Contextualing Teaching:introduction to education and educational foundations. New York: Longman.

Kincheloe, J.L. (2001). Getting beyond the facts: teaching social studies/social sciences in the twenty-first century. New York, New York: Peter Lang.

Kincheloe, J. L., & Steinberg, S. R. (Eds.). (2004). *Kinderculture: The corporate construction of childhood*. Boulder, CO: Westview Press.

Ladner, J. (1995). *Tomorrow's tomorrow: The Black woman*. Lincoln, NE: University of Nebraska Press.

Lanson, L. (1975). *From woman to woman: A gynecologist answers questions about you and your body.* New York: Knopf: Distributed by Random House.

Larsen, N. (1969). *Passing.* New York. Arno Press

Lynch, T. (2006). *Whore.* Triple Crown Publications.

Meenakshi, J., & Ramakrishnan, K. M. (2005). Etiology and management of ear lobule keloid in south India. *Plastic Reconstruction Surgery.* Retrieved April 15, 2008, from http://www.abateit.com/keloidscar/review/

Morgan, J. (1999). *When chickenheads come home to roost: My life as a hip-hop feminist.* New York: Simon & Schuster.

Morrison, T. (1970). *The bluest eye: A novel.* New York: Holt, Rinehart and Winston.

Morrison, T. (1987). *Beloved: A novel.* New York: Plume.

Moynihan, D. (1965). *U.S. department of labor.* Retrieved January 17, 2009, from The Negro Family: The Case for National Action Web site http://www.dol.gov/oasam/programs/history/webid-meynihan.htm

Muntañer, F. N. (2004). *Boricua pop: Puerto Ricans and the latinization of American culture.* New York: New York University Press.

Myers, W. D. (1975). *Fast sam, cool clyde, and stuff.* New York: Viking Press.

Norman, P. (2007, May 4). Michelle Rodriguez talks about being 'Outed'. *People Magazine.* Retrieved July 2, 2008, from http://www.people.com/people/article/0,,20037867,00.html

Obama, B. (2008). *The audacity of hope: Thoughts on reclaiming the American dream.* New York: Vintage.

Pascal, F. (1983). *Double love.* Toronto; New York: Bantam Books.

Pesquera, B. M. (1993). In the beginning he wouldn't even lift a spoon: The division of household labor. In L. Lamphere, H. Ragone, & P. Zavella (Eds.), *Situated lives: Gender and culture in everyday life* (pp. 208–222). New York: Routledge.

Pohan, C. A., & Bailey, N. J. (1998). Including gays in multiculturalism. *Education Digest, 63*(5), 52–56.

Pough, G. (2004). *Check it while I wreck it: Black womanhood, hip-hop culture, and the public sphere.* Boston: Northeastern University Press.

Porter, K. (2008, August 18). I kissed a girl, and mom didn't like it. *MSN CelebEdge.* Retrived August 20, 2008, from http://celebedge.ca/dramarama/contentpostingdramarama3column?newsitemid=5a7d8067-c278-48f3-b40c-0d5efe7cf439&feedname=ryan_porter_gossip&show=false&number=0&showbyline=true&subtitle=&detect=&abc=abc&date=true&paginationenabled=false

Reuters. (2003, June 20). Teen sues over 'lesbian Barbie' shirt ban. *CNN.com/Education.* Retrieved April 15, 2007, from http://www.cnn.com/2003/EDUCATION/06/20/life.barbie.reut/index.html

Romero, M. (2002). *Maid in the U.S.A.* New York: Routledge.

Rowling, J. K. (1998). *Harry potter and the sorcerer's stone.* New York: A.A. Levine Books.

Sapphire. (1996). *Push: A novel.* New York: Alfred A. Knopf: Distributed by Random House.

Shepard, S. (2006). *Pretty little liars.* New York: HarperTempest.

Shepard, S. (2006). *Flawless: A pretty little liars novel.* New York: HarperTeen.

Silverman, S. M. (2004, April 13). Oprah fans outraged by Omarosa segment. *People.* Retrieved September 3, 2007, from http://www.people.com/people/article/0,,628084,00.html

Souljah, S. (1996). *No disrespect.* New York: Time Books.

Souljah, S. (1999). *The coldest winter ever: A novel.* New York: Pocket Books.

Souljah, S. (2008). *Midnight: A gangster love story.* New York: Atria Books.

Treasured locks, help needed-hair discrimination in the military. Retrieved July 23, 2008, from Treasured Locks Web site http://blog.treasuredlocks.com/2007/11/16/help-needed-hair-discrimination-in-the-military/

Truth, S. (1851). *Aint I a woman.* Retrieved November 2, 2007, from feminist.com Web site http://www.feminist.com/resources/artspeech/genwom/sojour.htm

Turner, N. (2003). *A hustler's wife.* Triple Crown Publications.

Tyree, O. (1996). *Flyy girl.* New York: Simon & Schuster.

Valenti, J. (2007). *Full frontal feminism: A young woman's guide to why feminism matters.* Emeryville, CA: Seal Press.

REFERENCES

Venable, M. (2004). It's urban, it's real, but is this literature? Controversy rages over a new genre whose sales are headed off the charts. *Black Issues Book Review, Find Articles.com.* Retrieved October 1, 2007, from http://findarticles.com/p/articles/mi_m0HST/is_5_6?pnum=5&opg=n6276344&tag=artBody;col1

Von Ziegesar, C. (2002). *Gossip girl: A novel.* Boston: Little Brown.

Von Zeigesar, C., & Vestry, A. (2008). *Gossip girl: The carlyles #1.* New York: Little, Brown Books for Young Readers.

Walker, A. (1982). *The color purple: A novel.* New York: Harcourt Brace Jovanovich.

Wallace, M. (1990). *Black macho and the myth of superwoman.* London; New York: Verso.

White, E. (2002). *Fast girls: Teenage tribes and the myth of the slut.* New York: Scribner.

Williams, K., Joy, & Turner, N. (2005). *Girls from da hood. 2.* Dix Hills, NY: Urban Books.

Wolf, N. (1991). *The beauty myth: How images of beauty are used against women.* New York: W. Morrow.

Young, C. (2005, September 15). What we Owe Xena. *Salon.com Arts and Entertainment.* Retrieved March 1, 2007, from http://archive.salon.com/ent/movies/feature/2002/03/29/black_oscars/print.html

FILM, TELEVISION AND MUSIC

Abrego, C., & Cronin, M. (Producers). (2006). *Flavor of love* [Television series]. United States: VH1 MTV Networks.

Abrego, C., & Cronin, M. (Producers). (2007). *I love New York* [Television series]. United States: VH1 MTV Networks.

Abrego, C., & Cronin, M. (Producers). (2008). *New York goes to hollywood* [Television series]. United States: VH1 MTV Networks.

Albucher, L. Y. (Producer). (1999). *Introducing Dorothy Dandridge* [Motion picture]. United States: Home Box Office.

Artis, K. & 50 Cent (2003) P.I.M.P. [50 Cent] On Get Rich Or Die Tryin' [CD] Aftermath, Interscope, Shady Records.

Bass, R., & McMillan, T. (Producers). (1998). *What's how Stella got her groove back* [Motion picture]. United States: Twentieth Century Fox.

Bell, W. (Executive Producer). (1994). *Ellen* [Television series]. United States: American Broadcasting Company.

Berman, B. (Producer). (2001). *Training day* [Motion picture]. United States: Warner Bros. Pictures.

Bernard, M. (2005) So Seductive [Tony Yayo] On Thoughts of a Predicate Felon [CD] G-Unit Records.

Bernhard, H. (Producer). (1973). *The Mack* [Motion picture]. United States: New Line Cinema.

Blake, G. (Producer). (1988). *What's school daze* [Motion picture]. United States: Columbia Pictures.

Blohm, J. (Producer). (2005). *Mulan II* [Motion picture]. United States: Walt Disney Home Entertainment.

Bridges, C. & Williams, P. (2000). Southern Hospitality [Ludacris] On *Back for the First Time* [CD] Def Jam.

Broadus, C. & Williams, P. (2002). Beautiful [Snoop Dogg] On Paid tha Cost to Be da Bo$$ [CD] Priority/Capitol/EMI Reecords.

Brown, D. (Producer). (1974). *Willie dynamite* [Motion picture]. United States: Universal Pictures.

Brown, S. & Simmons, D. (1996). In My Bed [Dru Hill] On Dru Hill. Island Black Records.

Bryan, J. (Writer), & Shea, J. (Director). (1979). *Every night fever* [Television series episode]. In K. S. Bright (Producer), *The Jeffersons*. California: Columbia Broadcasting Company.

Burnett, M., & Trump, D. J. (Producers). (2004). *The apprentice* [Television series]. United States: National Broadcasting Company.

Burnett, M., & Trump, D. J. (Producers). (2004). *The apprentice* [Television series]. United States: National Broadcasting Company.

Cardoso, P. (Director). (2002). *Real women have curves* [Motion picture]. United States: Home Box Office.

Caro, J. (Producer). (2007). *El Cantante* [Motion picture]. United States: New Line Cinema.

Carsey, M. (Producer). (1984). *The Cosby show* [Television series]. United States: National Broadcasting System.

Chaiken, I. (Executive Producer). (2004) *The L word* [Television series]. United States: Showtime Networks, Inc.

Chang, W. L. (Director). (2005). *My super sweet 16* [Television series]. United States: Music Television.

Chase, D. M. (Producer). (2005). *Sisterhood of the traveling pants* [Motion picture]. United States: Warner Bros Pictures.

Cohan, M. (Producer). (1979). *Diff'rent strokes* [Television series]. United States: National Broadcasting Company.

Clements, R. (Producer). (1989). *The little mermaid* [Motion picture]. United States: Walt Disney Pictures.

Clements, R. (Producer). (1992). *Aladdin* [Motion picture]. United States: Walt Disney Pictures.

Coats, P. (Producer). (1998). *Mulan* [Motion picture]. United States: Walt Disney Pictures.

Coben, S. (Producer). (1984). *Kate and Allie* [Television series]. United States: Columbia Broadcasting System.

Collins, D., & Meltzer, D. (Executive Producers). (2003). *Queer eye for the straight guy* [Television series]. United States: Bravo Media.

Collins, D., & Meltzer, D. (Executive Producers). (2005). *Queer eye for the straight girl* [Television series]. United States: Bravo Media.

Cooke, S. (1963). A Change is Gonna Come [Sam Cooke] On Otis Blue [7 Inch Single] RCA Victor.

Cowen, R., & Lipman, D. (Producers). (2000). *Queer as folk* [Television series]. United States: Showtime Networks, Inc.

Crane, D. (Executive Producer). (1994). *Friends* [Television series]. Burbank, CA: National Broadcasting Company.

Daniels, L. (Producer), & Forster, M. (Director). (2001). *Monster's ball* [Motion picture]. United States: Lions Gate Films.

David, L. (Executive Producer). (1989). *Seinfeld* [Television series]. New York: National Broadcasting Company.

Davis, R. (Executive Producer). (1993). *What's love got to do with it* [Motion picture]. United States: Touchstone Pictures.

DeGeneres, E. (Executive Producer). (2003). *Here and now* [Television broadcast]. United States: Home Box Office.

Dennis, C. (2008). I Kissed a Girl [Katy Perry] On *One of the Boys* [CD] CAP.

Ellin, D. (Producer). (2004) *Entourage* [Television series]. United States: Home Box Office.

Feitshans, B. (Producer). (1974). *Foxy Brown* [Motion picture]. United States: American International Pictures.

Felsberg, U. (Producer). (2001). *Bread and roses* [Motion picture]. United Kingdom: Parallax Pictures.

Finerman, W. (Producer) (2006). *The Devil Wears Prada* [Motion picture]. New York: 20th Century Fox.

Friedman, H. (Executive Producer). (1964). *Three's company* [Television series]. United States: National Broadcasting Company.

Gallen, J. (Director). (2003). *Ellen DeGeneres: Here and Now* [Stand Up Comedy]. United States: Home Box Office.

Goldsmith, J. & Wilder, M. (1998) Honor to Us All [Beth Fowler, Marni Nixon & Lea Salonga] On *Mulan: A Walt Disney Original Soundtrack* [CD] Walt Disney Records.

Gray, F. G. (Producer). (1996). *Set it off* [Motion picture]. United States: New Line Cinema.

Hahn, D. (Producer). (1994). *The lion king* [Motion picture]. United States: Walt Disney Pictures.

Hahn, D. (Producer). (1991). *Beauty and the beast* [Motion picture]. United States: Walt Disney Pictures.

Hayek, S. (Producer). (2006). *Ugly betty* [Television Series]. Los Angeles: American Broadcasting Company.

Henkels, A. (Producer). (1997). *Love Jones* [Motion picture]. United States: New Line Cinema.

Houston, W. (Producer). (1997). *Cinderella (Musical)* [Motion picture]. United States: Walt Disney Productions.

Jerkins, R. (1999). If You Had My Love [J. Lopez]. On *On the 6* [CD] Epic Records.

Kelly, R. & Maxwell (1999) Fortunate [Maxwell] On *Life* [Original Motion Picture Soundtrack] [CD] Columbia Records.

Kilik, J. (Producer). (1989). *Do the right thing* [Motion picture]. United States: Universal Pictures.

Kim, L. & Sisqo (2000) How Many Licks [Lil' Kim] On The Notorious K.I.M. [CD] Atlantic Records/Queen Bee Entertainment

Lear, N. (Producer). (1972). *Sanford and son* [Television series]. United States: National Broadcasting System.

Lear, N. (Producer). (1974). *Good times* [Television series]. United States: Columbia Broadcasting System.

Lear, N. (Producer). (1975). *The Jeffersons* [Television series]. United States: Columbia Broadcasting System.

Lear, N. (Producer). (1979). *Facts of life* [Television series]. United States: National Broadcasting Company.

Lee, S. (Producer). (1990). *Mo' better blues* [Motion picture]. United States: Universal Pictures.

Lee, S. (Producer). (1991). *Jungle fever* [Motion picture]. United States: Universal Pictures.

Lee, S. (Producer). (1992). *Malcolm X* [Motion picture]. United States: Walt Bros. Pictures.

Lee, C. (Producer). (1994). *Crooklyn* [Motion picture]. United States: Universal Pictures.

Levenson, L., & Fleiss, M. (Executive Producers). (2002). *The Bachelor* [Television series]. California American Broadcasting Company.

Matthewman, S., & Maxwell (1996). Til The Cops Come Knockin' [Maxwell] On *Maxwell's Urban Hang Suite* [CD] Columbia Records.

Mosley, T. & Elliot, M. (1998). Hot Boyz [Missy Elliot] on *Da Real World* [CD] Goldmind/Elektra

Mehta, D. (Director). (1996). *Fire* [Motion picture]. United States and United Kingdom: Zeitgeist Films.

Nair, M. (Producer). (1997). *Kama sutra: A tale of love* [Motion picture]. United States: Trimark Pictures.

Nicholl, D. (Producer). (1976). *Three's* [Television series]. California: National Broadcasting Company.

Nicolaides, S. (Producer). (1991). *Boyz N the hood* [Motion picture]. United States: Columbia Pictures.

Orenstein, B. (Producer). (1976). *What's happening!!* [Television series]. California: American Broadcasting Company.

Paramount Productions. "I'm No Angel" October 6, 1933. Online video clip. *Star Wars Official Site*. Retrieved April 2, 2008, from http://starwars.com/episode-i/news/trailer/

Paul, P. (Producer). (1999). *Chris Rock: Bigger & Blacker* [Stand Up Comedy]. New York: Dreamworks/Home Box Office

Pentecost, J. (Producer). (1994). *Pocahontas* [Motion picture]. United States: Walt Disney Pictures.

Perry, J., & Tyler, S. (1987). Dude looks like a lady [Aerosmith] on *Permanent Vacation* [CD] Geffen Records.

Polk, P. I. (Producer). (2005). *Noah's arc* [Television series]. United States and Canada: LOGO Network.

Rooney, C., & Lopez, J. (2001). Ain't It Funny [J. Lopez] On *J.LO* [CD] Epic Records.

Rose, A. & Slash (1987) Welcome to the Jungle [Guns N' Roses] On Appetite for Destruction [CD] Geffen Records

Ross, D. (Producer). (2008). *Date my ex: Joe & Slade* [Television series]. United States: Bravo Media.

Salsano, S. A. (Producer). (2008). *A shot at love with Tila Tequila* [Television series]. United States: MTV Networks.

Schwartz, J. (Executive Producer). (2007). *Gossip girl* [Television series]. United States: The CW Television Network.

Sears, S. L. (Supervising Producer). (1995). *Xena: Warrior princess* [Television series]. United States: Home Box Office.

Shore, S. (Producer). (1972). *Superfly* [Motion picture]. United States: Warner Bros. Pictures.

Simon, L. A. (Producer). (2003). *Chasing Papi* [Motion picture]. United States: Twentieth Century Fox.

Singleton, J. (Producer). (2001). *Baby boy* [Motion picture]. United States: Columbia Pictures.

Spelling, A. (Producer). (1990). *Beverly Hills 90210* [Television series]. United States: FOX Broadcasting Company.

Star, D. (Producer). (1998) *Sex in the City* [Television series]. United States and New Zealand: Pacific Renaissance Pictures Ltd.

Stern, J. (Producer). (1997). *B*A*P*S* [Motion picture]. United States: New Line Cinema.

Sweat, K. & Murray, R. (1993) Freak Me [Silk] On Another Level [CD] NWS/BMG Records.

Swing, D. (1991) Forever My Lady [Jodeci] On Forever My Lady [CD] Uptown/MCA Records.

Thomas, E. G. (Producer). (2002). *Maid in Manhattan* [Motion picture]. United States: Sony Entertainment Pictures.

Weiner, D. (Executive Producer). (2000). *Who wants to marry a millionaire?* [Television series]. Las Vegas, NA: FOX Broadcasting Company.

Wilder, M. & Zippel, D. (1998). Reflection [Christina Aguilera] On Mulan: An Original Walt Disney Records Soundtrack [CD] Hollywood Records.

FILM, TELEVISION AND MUSIC

Williamson, K. (Producer). (1998) *Dawson's creek* [Television series]. United States: The WB Television Network.

Williams, M. (Producer). (1998). *Roseann* [Television series]. United States: American Broadcasting Company.

Wise, R., & Robbins, J. (Directors). (1961). *West side story* [Motion picture]. United States: United Artists.

CPSIA information can be obtained at www.ICGtesting.com
Printed in the USA
LVOW07s1519060813

346579LV00005B/190/P